THE HORSE
IN ART AND HISTORY

Copyright June 1978 by New English Library

All rights reserved under International and
Pan American Copyright Convention. Published
in the United States by Mayflower Books, Inc.,
New York, New York 10022.

Originally published in England by New
English Library, Barnard's Inn, Holborn,
London, EC1N 2JR.

Library of Congress Cataloging In Publication
Data
Seth-Smith, Michael, Editor
1. Title
2. Horse in Art and History

ISBN 0-8317-4550-9

Manufactured in Italy by Fratelli Spada,
Ciampino, Rome.

FIRST AMERICAN EDITION 1978

THE HORSE

EDITED BY MICHAEL SETH-SMITH

IN ART AND HISTORY

MAYFLOWER BOOKS
NEW YORK

Introduction

NO animal has so inspired the creative instincts of man as the horse. Stone Age cave drawings, Egyptian friezes, and Greek bronzes, terracotta reliefs and equestrian marble statues contribute visually to our knowledge of the horse's relationship with man in early times. At a later date the great Athenian general, historian and philosopher, Xenophon, vividly described the exploits of horses and cavalry in the wars in which he served, and wrote his treatises on Horsemanship. The truth is that the horse has shared man's triumphs and failures, hopes and frustrations, since prehistoric eras. Indeed, until the advent of the Machine Age, the horse was man's constant and indispensable companion, servant and friend. It is natural that the artists of many nations who have immortalised the horse's place in reality and mythology have found him a great and worthy subject.

During the past thousand years the horse has been the centrepiece of countless paintings, and the genius of artists as renowned as Uccello, Velazquez, Stubbs, Degas and Munnings has given us unsurpassable illustrations of the horse in the pride, pomp and circumstance of war, and in the excitement and thrill of hunting and racing, whilst in the imagery of fiction and fable who could fail to be fascinated by Tiepolo's great paintings of the Wooden Horse of Troy, or Raphael's superb 'St George and the Dragon'? Kings and emperors, knights, soldiers, huntsmen and jockeys have been faithfully portrayed to provide a graphic commentary upon the customs and fashions of the eras in which they lived. In my opinion, painters have contributed much to our enjoyment and appreciation of history, and no creature has been more praised and honoured on canvas than the gallant, courageous and beautiful animal – the horse.

Michael Felt. Smith.

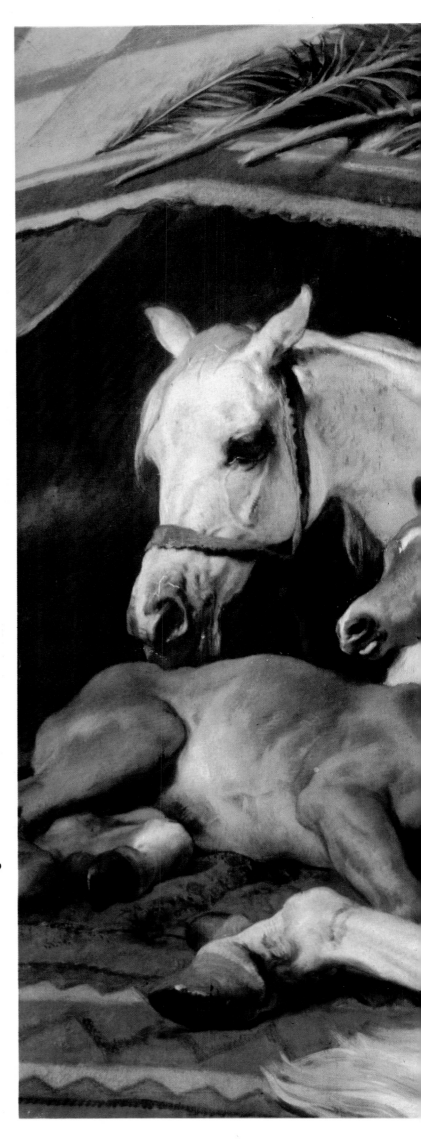

Right: Detail from 'The Arab Tent' by Sir Edwin Landseer, a late work that was exhibited at the Royal Academy in 1866 and was purchased from the Prince of Wales by Sir Richard Wallace.
BY KIND PERMISSION OF THE TRUSTEES OF THE WALLACE COLLECTION.
PHOTOGRAPH: JOHN FREEMAN AND CO LTD

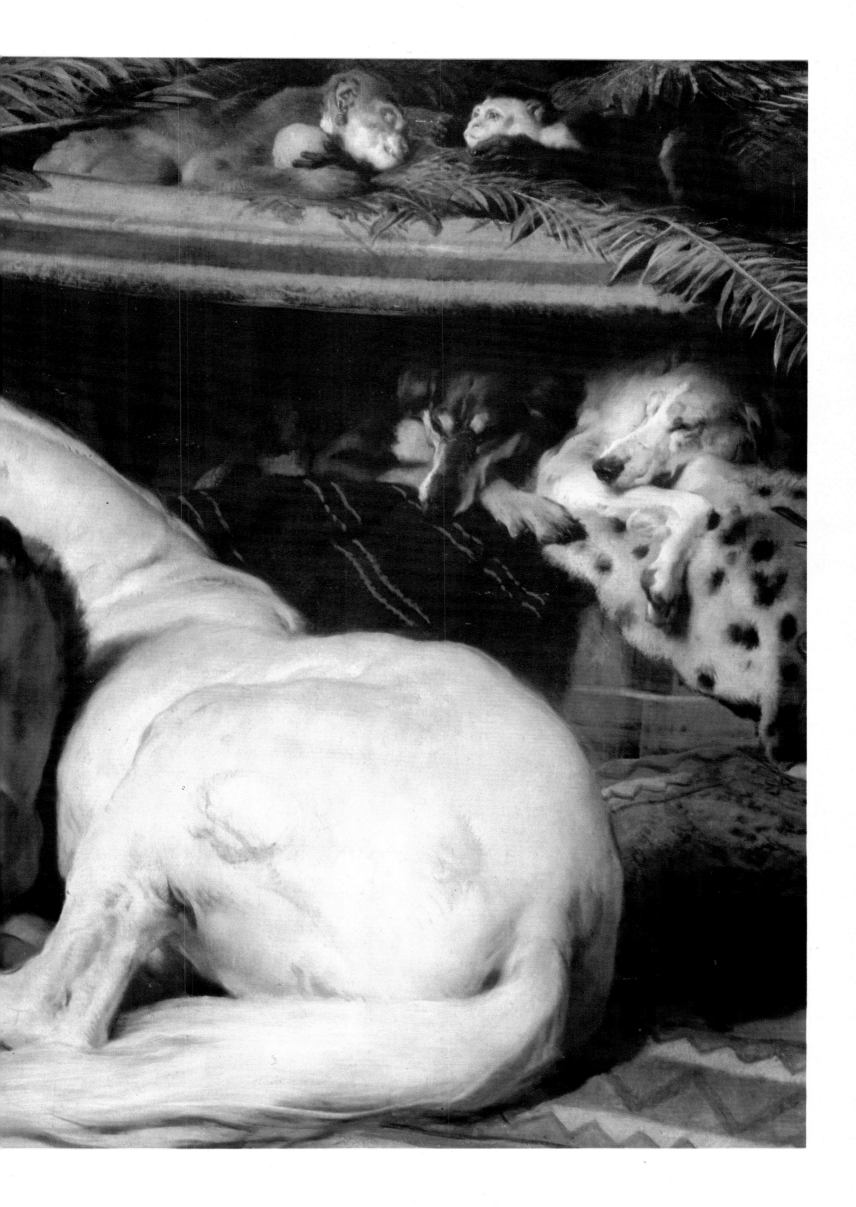

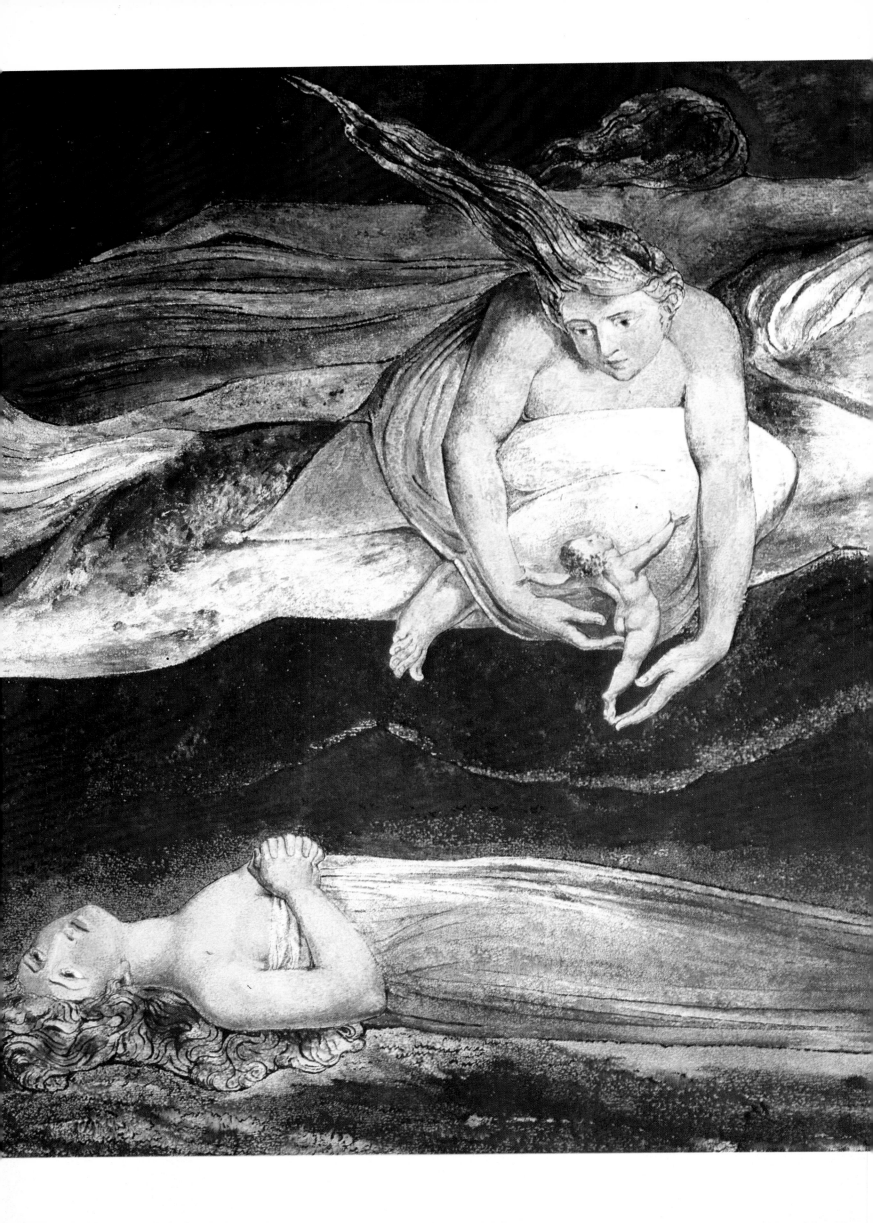

Contents

Left: 'Pity' by William Blake, which has been related to lines from 'Macbeth':
. . . pity, like a naked new-born babe,
Striding the blast, or heaven's cherubim, hors'd
Upon the sightless couriers of the air . . .
TATE GALLERY, LONDON

The Horse in Ancient Times

TRACES OF A small creature called *Eohippus* that had feet with four toes and the suggestion of a fifth toe, and was not unlike a little fox, have been found in rocks believed to be 50,000,000 years old. In the course of time, *Eohippus* started a line of animals that culminated in *Equus caballus* – the true horse.

The remains of the true horse have been found in all parts of the world except Australasia, although it became extinct in the American continent before historical times and was not known there again until it was introduced by Hernando Cortes in the late Middle Ages.

In the middens of Palaeolithic peoples great quantities of horse bones have been discovered and horses are well represented in the cave paintings of the times; indeed, the horse appears to have been the primitive people's staple diet. In the later settlements of the Neolithic period, horse remains are very rare. It seems that the number of horses had greatly diminished by then and that, but for their domestication, the horses of the Old World might have shared the fate of those of the New.

At the dawn of history the Aryans, a great horse-using people,

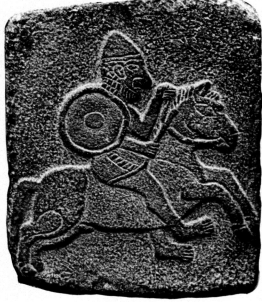

swept down from the north. Many of their names, like those of the Greeks in later years, were compounds of the word 'horse'. They drove chariots and offered the gods great horse-sacrifices, often a hundred horses at a time. This was not as wasteful as it seems: the gods in most religions did badly out of the sacrifices made to them, having only some of the entrails burned in their honour while the rest of the carcasses were used to provide a feast for their worshippers. The Aryans were a horse-eating race. The eating of horses continued amongst the people of the north

long into Christian times, although it was very much discouraged by the Church, perhaps because horses had been such a favourite offering to the pagan gods.

In the earliest historical times throughout the Old World, from Britain to China, the horse was seldom ridden but was used to draw chariots. This was not due to ignorance of riding, for there is a clay figure of a man riding a horse which is attributed to the fourth millenium BC; and in the *Iliad* Odysseus and his companion, when stealing the horses of Rhesus, jumped on their backs and rode off. The probable reason for the use of chariots was that the horses then existing were too small to carry an armed man any distance. However, Tiglath-Pileser the Assyrian (circa 1165-1102 BC) in his invasions of mountainous country was constantly having to abandon his chariots and advance on foot, for the area where chariots could be used was limited. In consequence, as the size of horses increased, chariots gave way to cavalry.

In the east they proved ineffective against trained infantry, as can be seen by Xenophon's account of an attack by Persian chariots against his Greek infantry (401 BC). The Greeks frightened the chariots' horses by clashing their weapons on their shields and most of the chariots fled back through the ranks of their own troops. Since

Left: Iron horse-shoe (hipposandal) of the Roman period; a type which seems to have been fitted to a horse's foot if the going was rough.
BRITISH MUSEUM, LONDON

Top: Tell Halef (c 850 BC). North Syrian warrior on horseback.
BRITISH MUSEUM, LONDON

Right: Greek, 700-600 BC, terracotta statuette of horseman.
BRITISH MUSEUM, LONDON

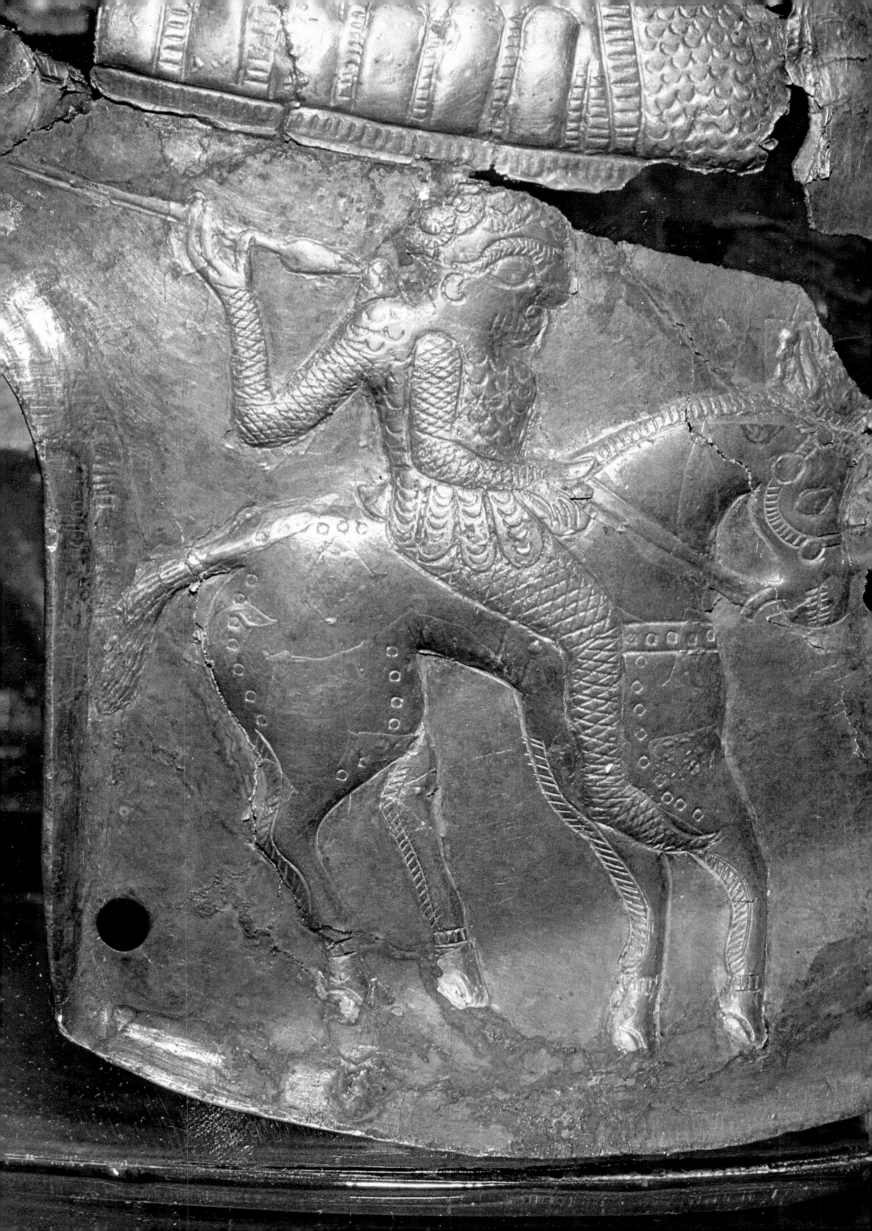

most of those that reached the Greeks had lost their charioteers, the Greeks opened their ranks as they saw them coming and let them through.

In Britain also, chariots survived in addition to cavalry. They opposed Julius Caesar's landing in 55 BC, and he gives an interesting account of their skill.

'They hurled their spears in all directions', he says, 'throwing the enemy into confusion by the terror inspired by their horses and the noise of their wheels.' When the chariot-borne fighting men penetrated the ranks of the opposing cavalry, they sprang to the ground: the chariots meanwhile retired and waited in case they should need to retreat, giving them the mobility of cavalry and the stability of infantry. Chariots could be galloped down steep places without losing control and their horses could be checked and wheeled in a flash. The charioteers used to run along the chariot pole, stand on the yoke and dart back into the chariot.

Cassivellaunus's chariots (he had 4,000 of them) the following year so intimidated the Roman cavalry that they were prevented from foraging.

One of the last occasions that chariots were used in warfare was in AD 231-3 when the later Artaxerxes (the founder of the dynasty of the Sassanidae) and his army, which included 1,700 scythe chariots, were defeated by Alexander Severus. Scythe chariots were common in the east but do not appear to have been used in Britain. Chariots, of course, remained in use for centuries for racing.

The cavalry of the ancients was of three main classes. The chief weapons of the ordinary cavalrymen were the javelin and the lance, although they also carried a sword or sabre. They often carried round shields and both man and horse were frequently partly armoured.

The second class were the horse archers, whose form of warfare originated amongst the nomads of the steppes. Their favourite trick was to shoot over their horses' tails as they fled, making them dangerous to pursue and giving rise to the phrase 'a Parthian shot' because of the Parthians' reputation for this manoeuvre. Their great weakness was that they used to run out of arrows, until a Persian general called Sarenas (53 BC) had the brilliant idea of attaching a corps of 1,000 camels loaded with arrows to his horse archers. From these camels the archers could replenish their arrows when necessary. Thereafter the horse archer became almost invincible against troops not similarly armed.

The third class of cavalry were the cataphracti, in which both men and horses were clad in complete scale armour. This needed a powerful horse to carry the weight, so it is not surprising that the Persians with their large Nisaean horses had such cavalry from early times. The cataphracti were adopted by other nations only when, much later, they had improved their own breeds of horses. Although the Sarmatians, a people of the northern frontier of the Roman Empire, used scale armour, they made the scales from cut-up horse hooves as they were short of metal. Pausanias (250 BC), who saw one of their corselets, said it resembled the scales of a dragon or the overlapping seeds of a green fir cone. It was sword- and arrow-proof.

There were in historical times four main types of horse: the coarse heavy-headed horse of the northern plains which, apart from increasing in size from selective breeding, did not change very much; its cousin the Celtic forest pony, which was

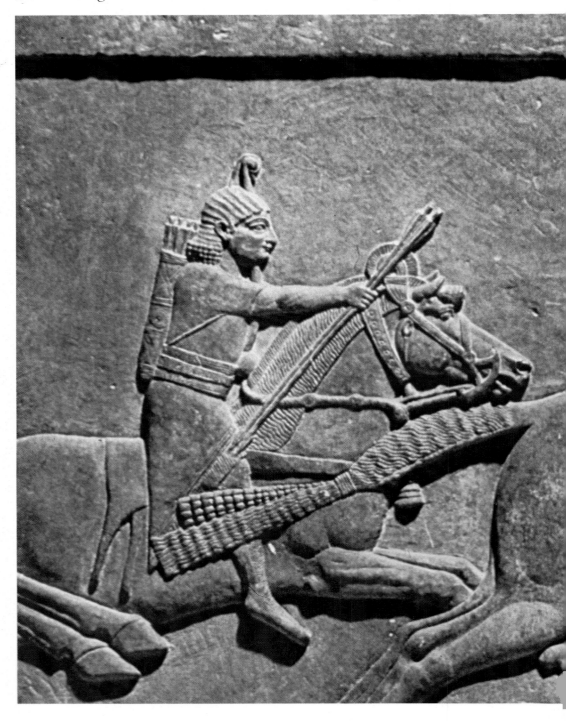

continually being improved by the introduction of imported blood; the Libyan horse, from which the Arab horse and later the Thoroughbred are almost certainly descended; and the Nisaean breed of Persia, the largest and most highly prized of all the horses of antiquity.

The home of the Nisaean breed was the vast plains of Media and Upper Armenia, where lucerne was cultivated to supplement its fodder. The Persian King had a stud of 50,000 mares and the Satrap of Greater Armenia used to send a regular tribute of 20,000 foals. The Nisaean horses were never common and were reserved for kings and high nobility, although inferior and cross-bred Nisaeans were no doubt used by the heavy cavalry.

Shortly before Alexander the Great's conquest of Persia (331 BC) the Persian royal stud consisted of 150,000 mares, but by the time Alexander reached the breeding areas only 50,000 remained, the rest having been stolen by robbers. The tide of invasion swept some of these horses into the far province of Sogdiana, situated east of the modern Bohara, and a stud was formed at a place called Irshi by the Chinese.

Herodotus (c 485-c 425 BC) says that the Libyans drove four-horse chariots and even taught the Greeks this art, but the Libyans were better known as horsemen. The Libyan horses were easy to control and were ridden without bits, being guided with a small switch even in battle. Strabo (c 60 BC-c AD 21) wrote that the horses were small and swift and were led by ropes attached to collars of wood or plaited hair, but that many of them followed like dogs without being led at all.

Aelianus (c AD 170-230) says: 'the Libyans are the swiftest of horses and know little or nothing of fatigue, they are lightly made and not well fleshed, and well fitted to endure the neglect of their masters, who neither groom them nor feed them but, at the end of a journey, just turn them out loose to graze.' Aelianus adds that the Libyans themselves were lightly made and dirty like their horses. The horses of the Germantes, neighbours of

Below: Assyrian relief of hunting scene from the palace of Ashurnasipal – Nineveh c 640 BC.

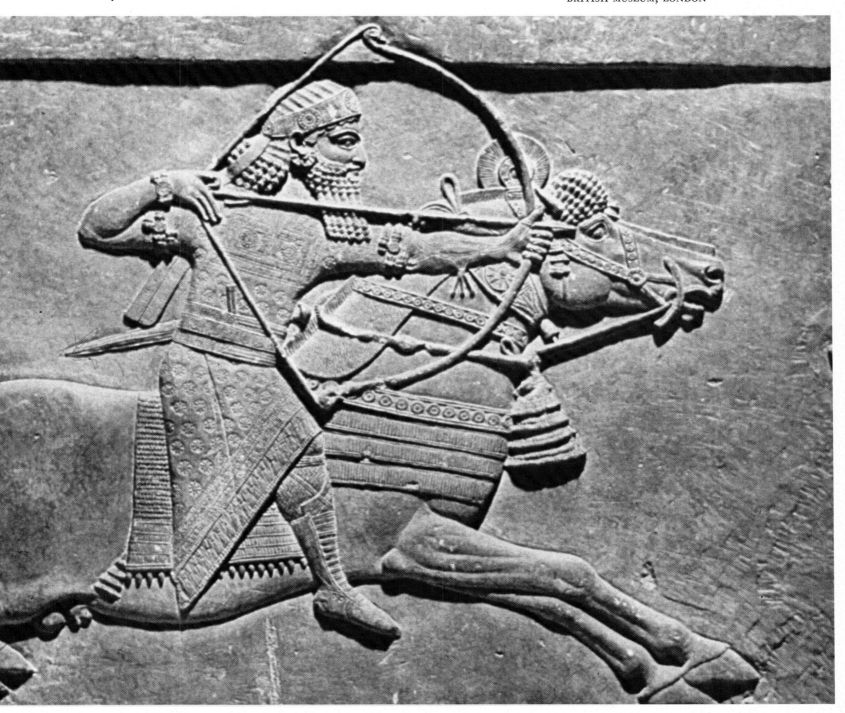

the Libyans, are said to have had larger necks than other horses, and their kings bred 100,000 foals a year.

There is an interesting account in Livy (59 BC-AD 16) of the Libyan cavalry breaking out when the Roman army to which they were attached was trapped in a pass. The horses and men were small and lightly made, the riders unarmed except for javelins, the horses unbitted and moving in an ugly fashion with their necks unbent and their heads straight out. As they advanced, the riders were playing the fool, falling off their horses and pretending the mounts were out of control; but when they reached the neck of the pass, they applied spurs to their horses and broke straight through the enemy outposts.

The steppe horse was not really appreciated until the sixth century AD, when Vegetius, in his book on the veterinary art, stated that the Hunnish horse was the best warhorse because he had been taught to be patient and to endure toil, cold and hunger. The Hunnish horse, as Vegetius describes him, was certainly no beauty. His head was large with a Roman nose, his eyes prominent, his neck straight with a long mane flowing down below his knees; he had a bushy tail and good bone, but his body was angular and very long in the back, with no surplus fat or muscle. With his good bone, and pleasing thinness, his very bad points gave him a kind of beauty, and he was temperate and clever and very enduring when wounded.

The Persian horse of the period did not differ much in size or appearance from the other horses but was famous for his smooth paces, which were natural, not the result of training.

The Persians first invented a post system in the time of Cyrus (600-529 BC). Post houses were built along all the main roads at distances that a horse could travel in a day, ridden fast but not so as to founder it. At each post house there were relays of men and horses so that a letter could be handed to a fresh courier. They travelled by night as well as by day and it was, says Xenophon, the fastest overland

travelling on earth. The later Roman emperors instituted a similar system, but it was never as efficient as that of the Persians.

The bit was, rather surprisingly, a very early invention, probably almost contemporary with the first taming of the horse. The earliest were straight barred bits made of horn or wood and later of bronze. By 1000 BC jointed bits had come into use, and these were advocated by Xenophon (c 445-c 355 BC). The bits of Xenophon's period had a short chain of rings attached to the bit for the horse to play with, similar to present-day mouthing bits.

The bits were of two kinds, smooth and rough, the latter having small blunt spikes on the mouthpiece, serving the same purpose as the twisted snaffle. In its more severe form the spikes were sharp – a cruel bit. The single rein curb seems to have appeared around 100 BC. The Moors rode with bits made of rushes, and the Libyans, as has been mentioned, with no bits at all.

The saddle developed gradually, from the cloth thrown across the horse's back for the rider to sit upon, to an increasingly heavily padded saddle. Xenophon explained that the quilting of the saddlecloth should give the rider a safer seat and prevent the horse from getting galled; it should also give some protection to the horse's belly in battle. The Germans in Caesar's time regarded the use of a saddle as disgraceful and lazy on the part of the horseman.

A great advance came with the invention of the stirrup. It is an astonishing thing that this was so long delayed. The first mention of it in literature is in the writing of a Chinese officer who lived about AD 477, and archaeology and sculpture do not give any indication that stirrups were used before that date.

It would seem that the stirrup was invented by the Juan-Juan, a nomadic people who lived and raided along the northern borders of China in the middle of the fifth century AD, and it was soon adopted by the Chinese. The

Juan-Juan were later pushed westward and, known by this time as Avars, invaded Europe. Stirrups have been found in Avar graves in Hungary, dating from about AD 560. The stirrup was soon adopted by the Avars' opponents and it is first mentioned in western literature in the military manual of Maurice Tiberius (AD 582-602). Horses with stirrups are shown on the Mausoleum of the Chinese Emperor T'ai Tsung (AD 627-648).

The word stirrup is said to be derived from the Old English *stigrap* – a mounting strap. This is denied by some, but the Latin word for stirrups is *scalae* (a ladder).

Although the use of spurs when jumping was recommended by Xenophon in the fourth or fifth century BC, the oldest spurs to survive date only from the third century AD. They are made of bronze; they have a plain spike, usually about half an inch long, with short sides not projecting forward on the foot more than about two inches, and with so narrow a spread that they could only have fitted a bare heel. The original spur had a button-like stud on which the strap could be fixed by making a hole in the leather. However, before the Christian era, this form gave way to an oblong hole through which the strap could run. This type of spur continued in use for centuries.

Gradually the length and spread of the sides and the length of the spike increased until, in the fifth and sixth centuries AD, the spike became four or five inches long and was liable to do serious damage to the horse in the event of a fall. Later a form of guard was introduced, the earliest method being to cut off the sharp end of the spur and insert a spike, not more than half an inch long, in the blunt surface.

Archaeological evidence shows that the horseshoe fixed with nails was invented amongst the Celtic people during the first century BC. Numerous horseshoes have been dug up in France and Switzerland, and a smaller number in Britain.

These shoes are all of the same type; they are light in weight and

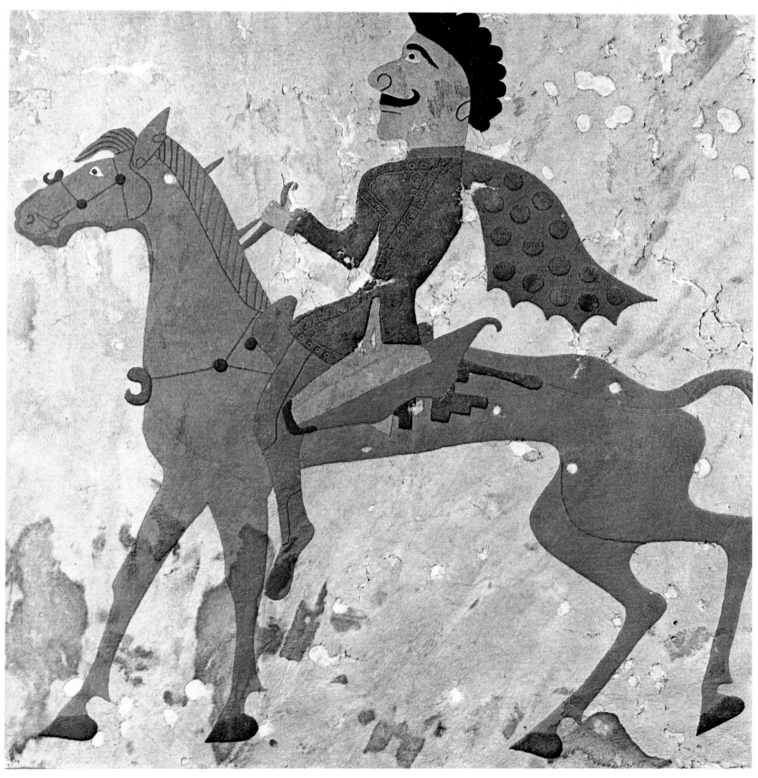

Above: Fragment of felt carpet with coloured appliqué work, c 300 BC, depicting a horseman. Found in the excavations of the Pazyryk mound and now in the Hermitage Museum, Leningrad.

NOVOSTI PRESS AGENCY, MOSCOW

have no toe clip, but a great many of them have the ends turned over to form calkins. There are usually six nail holes, although eight are very occasionally found. Each nail hole has a long oval cavity intended to give partial lodgement to the nail, with the nail hole punched in the centre of it. These large cavities force the edge of the shoe outwards to present a wavy outline on the outside edge. This characteristic is the easiest way of recognising a shoe of the Roman period. The nails had flat T-shaped heads, which projected about a quarter of an inch from the surface of the shoe, helping to give grip.

The earliest monument showing horseshoes was discovered at Vaison in France and is believed to date from the second century AD. The Romans were very slow to use nailed horseshoes, perhaps because smithery was a guild secret of the Druids. The Romans used wickerwork sandals which they tied on the feet of their work beasts, and also metal-soled sandals which were not nailed but attached by straps to the foot. The so-called hipposandals sometimes seen in museums were described by earlier archaeologists as lamp holders.

Writers on veterinary medicine were numerous amongst the

ancients. A fragment of an Assyrian veterinary work has survived and there is also a Mittanian treatise on chariot horses dating from about 1350 BC, known as the Kikkule text. A number of texts of Greek and Latin authors have been published, but many still remain in manuscript. It would be of great interest to see more of them translated.

A game of polo: Li-Lin
1635. Handroll,
watercolour on silk;
probably based on the
style of the Yuan
dynasty.
VICTORIA AND ALBERT
MUSEUM, LONDON

The War-horses of Genghis Khan

GENGHIS KHAN, one of the great conquerors in the history of the world, was born in the year AD 1162. His father, Yesukai, was a powerful Mongol overlord who ruled a vast barren region to the west of the Great Wall of China. On the death of his father the young Genghis Khan – still known as Temujin, the name that he retained for another thirty years – was involved for three years in tribal wars against those who refused to show him allegiance. Lacking support, he was compelled to retire to Karakhoum (Karakorum), capital city of Toghrul Khan whose daughter he married. Toghrul appointed him commander of his army, but Genghis proved so successful a general that his father-in-law and his courtiers, jealous of his growing reputation, attempted to assassinate him. He fled, but later returned at the head of an army 5,000 strong, routed Toghrul and seized his dominions. Within a year Genghis Khan was ruler of all Mongolia.

His brilliance as a leader was confirmed to the tribesmen in AD 1206 when a priest announced that it had been ordained that Genghis Khan should govern the entire earth. Five years later he prepared to attack China, raised an army which included 30,000 cavalry, and crossed the Great Wall. After three years of fierce fighting Peking was captured by his Mongol hordes and the Emperor fled. Genghis Khan became the supreme master of the entire North Chinese territory from Mongolia to Korea. He next turned his attention to the west claiming, 'there cannot be two suns in the heaven, nor two Kha-Khans upon the earth'. Determined to vanquish his supposed enemies he invaded Persia, Afghanistan and the lands to the north of these countries. In the first year of a campaign which

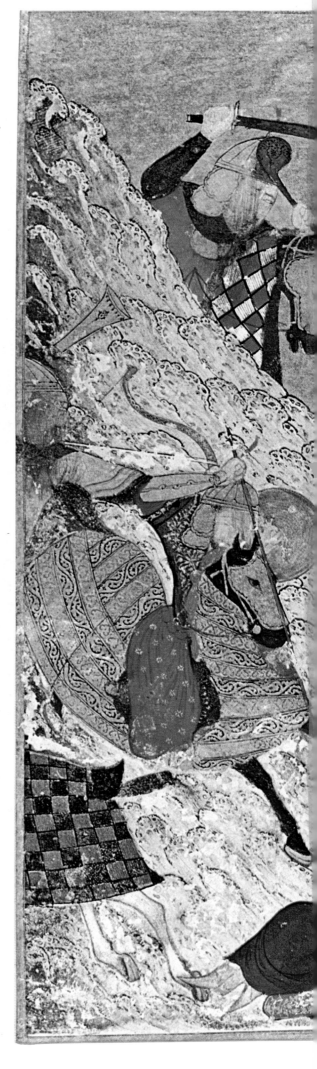

was to last for seven years he captured Bokhara and Samarkand, before ordering his hordes to march further westwards to the shores of the Caspian sea. His armies subjugated the Caucasus and, penetrated deep into Russia.

The administration of his vast empire stretched his resources to the limit. He built roads and at twenty-five mile intervals erected station forts. Almost ten thousand of these forts were established, from where teams of dispatch riders could gallop their hardy ponies over the rugged mountainous roads delivering messages and news of war. Most of these ponies, small and sturdy with coarse heads and thick necks, were bred in the plains to the north of the Gobi desert. The Mongol warriors captured them by the primitive method of lassoing them around the neck, and following them on horseback until their captives became exhausted. Although merciless in time of war, the Mongolians treated their horses with care and devotion. When a great Mongolian horse died his owner pulled some of the hairs from his mane and tail and used them as strings on a musical instrument with which he would travel far, singing songs of praise about his horse.

Despite the fact that Genghis Khan was reputed to have massacred five million people at the hands of his barbaric followers who showed no mercy to their defeated enemies, he was considered a great administrator. He exempted priests and physicians from taxes and military service, and created severe laws against theft. Exhausted by years of toil and conquest he died in 1227 after being thrown from his horse whilst hunting the wild horses of Arbukha. One of his last acts before he died was to order the execution of a defeated chieftain.

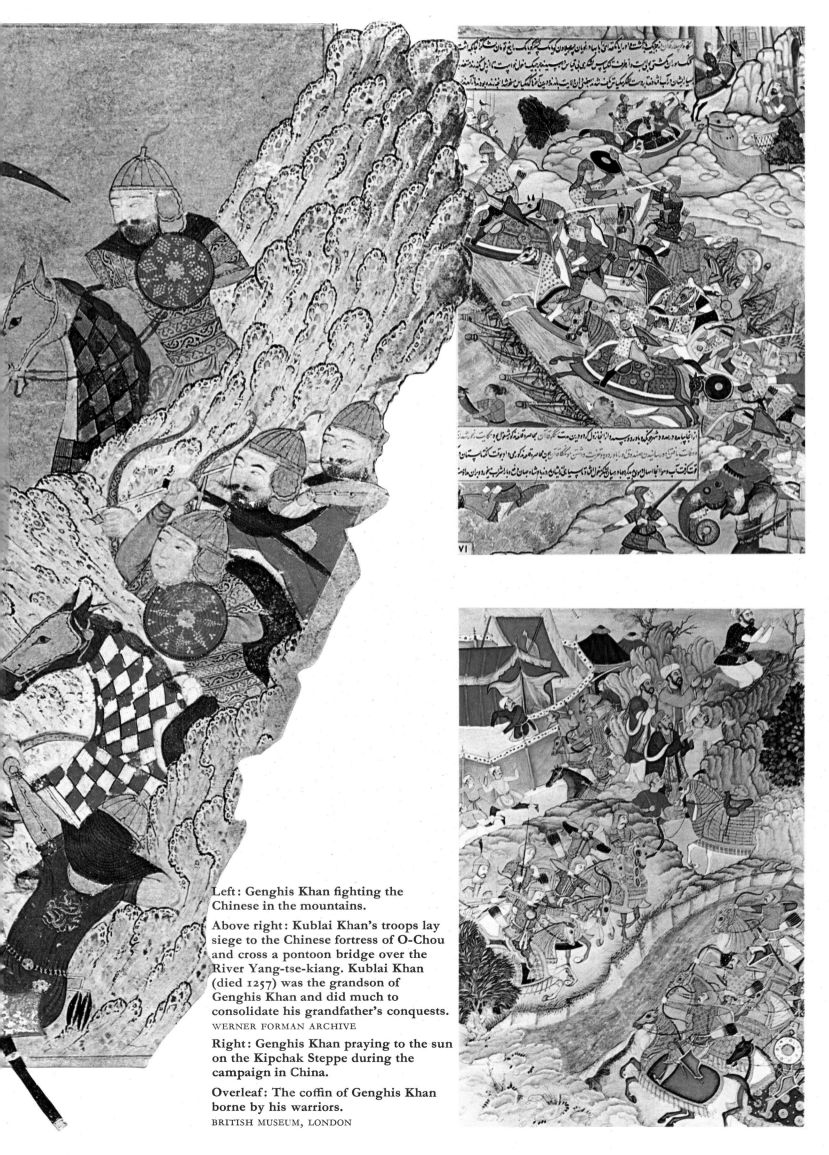

Left: Genghis Khan fighting the
Chinese in the mountains.

Above right: Kublai Khan's troops lay
siege to the Chinese fortress of O-Chou
and cross a pontoon bridge over the
River Yang-tse-kiang. Kublai Khan
(died 1257) was the grandson of
Genghis Khan and did much to
consolidate his grandfather's conquests.
WERNER FORMAN ARCHIVE

Right: Genghis Khan praying to the sun
on the Kipchak Steppe during the
campaign in China.

Overleaf: The coffin of Genghis Khan
borne by his warriors.
BRITISH MUSEUM, LONDON

Vishnu in his tenth
(future) re-incarnation as
the white horse Kalki.
Painting from Bilaspur,
1710-20.
VICTORIA AND ALBERT
MUSEUM, LONDON.
PHOTOGRAPH:
PHOTORESOURCES

Horses of Ancient Greece

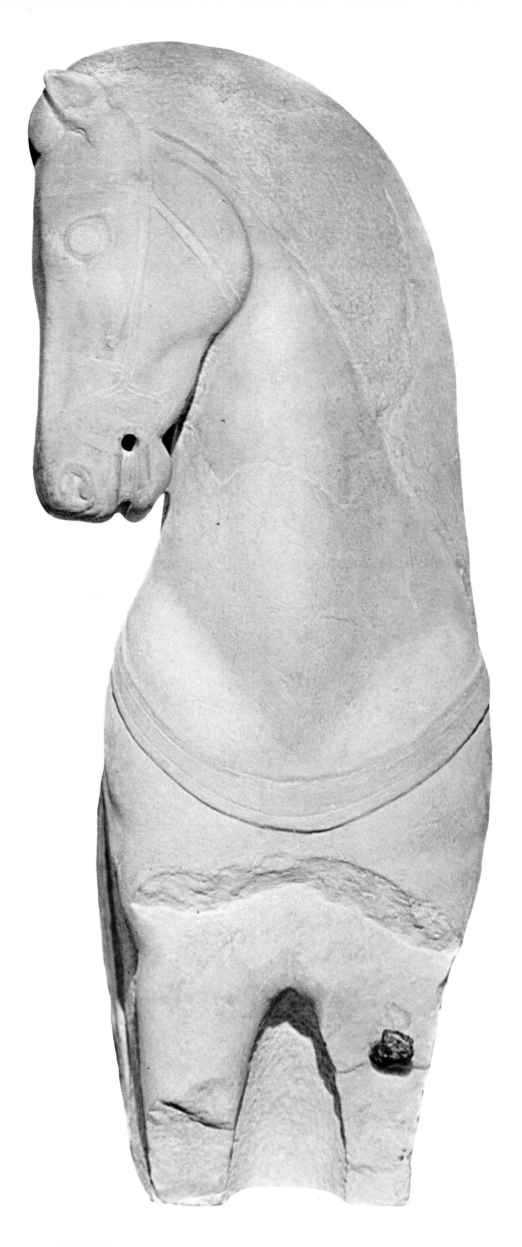

THE EARLIEST accounts of horses in Greece are to be found in the *Iliad*, which was most probably written at c 800 BC. One of the parts of Greece which is mentioned as being a good horse-breeding area is Argos in Peloponnesus which carries the epithet 'horsepasturing'. Further to the west, but still in Peloponnesus, another place mentioned was Elis which owed its importance in Greece to the worship of Zeus at Olympia to the south-east of Elis.

North of the Isthmus of Corinth, Thebes was well known for its horses and so was Thessaly, which later was famous for its cavalry. Further north still was Thrace from which Rhesus came to assist Troy, bringing his white horses which Dolon, the captured Trojan spy, declared to be the fairest and tallest that he had ever seen.

On his first night at Troy, however, two Greeks, Odysseus and Diomed, slew Rhesus while he was asleep and rode off on his horses. This is one of the few occasions when riding is mentioned by Homer. The Homeric warriors always fought from chariots drawn by two horses although occasionally three or even four horses were used.

The probable reason for the infrequency of riding is that the Homeric horses were too small to carry an armed man and it is notable that the size of Rhesus' horses is especially stressed. Some authorities maintain that the Greeks used chariots instead of riding because the large Mycenaean shield would have been impossible to manage on horseback. That may well be so, but it seems unlikely that it was the only reason. They could have invented a more suitable shield if they had wished to ride, although it is to be noted

that the Athenian cavalry did not carry shields.

Each chariot carried the charioteer and a fighting man. The warrior would often dismount and fight on foot while the charioteer withdrew a little way to the rear and waited there so that his partner could get back into the chariot if retreat was necessary.

The Homeric horses were mostly fed on barley although especially favoured horses were fed on wheat and even, in the case of Hector's horses, given wine, in the same way as horses now are sometimes given beer after hunting.

Our main knowledge of the Greek horse in classical times is derived from Xenophon the Athenian (c 465 – c 355 BC). He wrote a book on horsemanship and another on the duties of a cavalry commander. He had an earlier contemporary, Simon, who wrote on horsemanship and whose work he quotes. A small portion of Simon's work has survived but the text is in a very corrupt state. Xenophon was a practical man and wrote from experience. His work is, allowing for the difference in country and conditions, as applicable today as it was when it was written.

The great advantages that we have over the Greeks of that period are horseshoes, saddles and stirrups, none of which were invented until long after the Ancient Greek era.

Because of the lack of horseshoes Xenophon lays great emphasis on the need for horses to have good feet, for he says that without good feet all the horse's other good qualities are useless. He also gives instructions for hardening a horse's feet, by making the horse stand on loose stones about the size of a fist.

There was no saddle, only a padded saddlecloth, and for this reason all ancient writers demand a horse with a sunken backbone, as a prominent backbone would have been very uncomfortable for the rider. Since there were no stirrups Xenophon lays a great deal of stress on mounting. He recommends that a horse should be taught to crouch for its rider to mount and also that the groom should be taught how to give the rider a leg up; but he points out that these facilities may not always be available.

The Greek horse appears to have been vicious and inclined to bite, for Xenophon says that a horse should always wear a muzzle when being groomed or being led

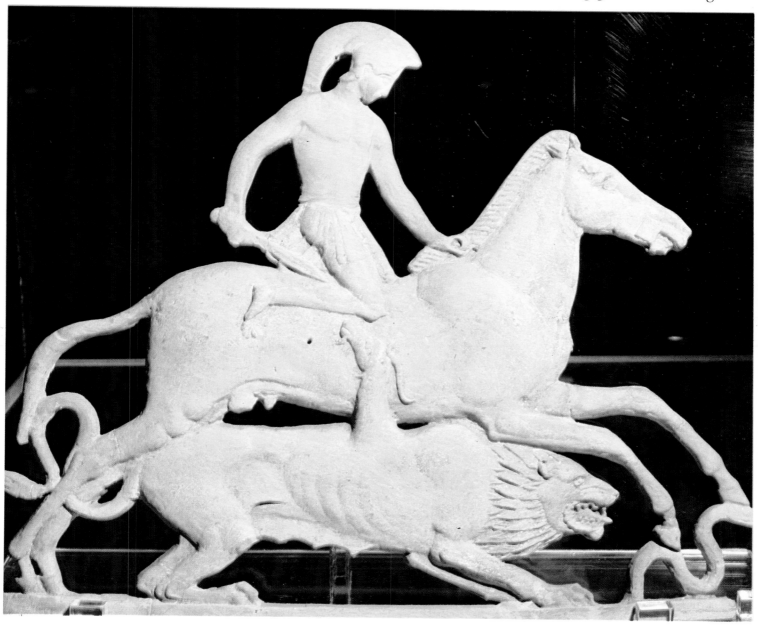

out without a bridle. He also warns against going too close to the front of the horse as well as taking care at the rear. Xenophon has one sentence that should be written up in all stables. He says, 'The one best rule and practice in dealing with horses is never to lose your temper, for an angry man acts without forethought and does things which he afterwards regrets'. In his book he gives instructions on the purchase, training and stable management of horses; but he does not deal with breaking which, he says, is the job of a horsebreaker.

Xenophon's *Cavalry Commander* is a book which could have been studied with advantage by cavalry officers as long as cavalry was in existence. It should be studied again if the military mind ever comes to realise that in the right country, and properly used, horses can still be more useful than machines.

The Athenian cavalry was recruited from the richer classes. They had to provide and maintain their own horses and arms, although they received an initial grant. Both men and horses wore armour, but the cavalrymen did not carry a shield. Their chief weapons of offence were javelins, which they used both for throwing and for spearing at close quarters. In addition, they carried sabres. Xenophon did not like the long lance which he said was both liable to break and difficult to manage, but later the lances of his cavalry gained Alexander (331 BC) his victories. Greek cavalry seldom if ever charged home against infantry. They used to ride up, throw their javelins and wheel away again.

The supreme example of good cavalry tactics at this period was displayed by fifty cavalrymen who had been sent from Sicily to assist the Spartans in 369 BC. Xenophon tells us:

These cavalrymen although few in number dispersed to different points and they would ride along the enemy line or charge towards it and throw their javelins. When the enemy moved against them they retreated and then wheeling round again threw their javelins. While pursuing these tactics they used to dismount and rest their horses and if anyone moved against them while they were dismounted, they easily vaulted onto their horses and withdrew. If on the other hand they were pursued to any great distance from the main body of the enemy, they attacked their pursuers when they retired, and hurling their javelins at them created havoc. Thus they compelled the whole army either to advance or to retire as they wished.

There is no doubt that in classical times the best horses in Greece were in the north, in Thessaly and Thrace. Herodotus says that the Thessalian horses were the best in all Greece but that when the Persian King Xerxes (480 BC) raced them against his Persian horses, the Thessalian horses were soundly beaten. The famous oracle at Delphi in perhaps a less ambiguous than usual utterance testified that Thrace was the place for horses.

Further south Argolis, Arcadia and Aetolia produced good horses, and in Sparta, we are told, from the time of the Persian invasion the people were keener on horse breeding than in all the rest of Greece, and bred many winners of the Olympic and other such games.

The Greek horses, however, being bred especially for chariot-racing, would appear to have sacrificed stamina and stoutness for speed and early maturity, as has happened in many cases with the English racehorse. Grattius of Falisci (AD 1), whose work shows him to have been a practical hunting man, says, 'Speaking of the horses of Thessaly and Argolis they are very large and high-stepping. What better horse ever ran on the racecourse at Elis? [This was where the Olympic Games were held.] But do not attempt to use them for hunting, they are too flashy to stand up to the hard work of hunting the woodlands.' He further says that the horse of Epirus did not compare with the Sicilian horse for hunting and did not deserve its reputation amongst the Greeks, and that the bay horse of Macedon was of no value as a hunter.

The thing that the Greeks most desired for the horses they bred was a victory at the Olympic Games or a similar event. Xenophon attributes the following observation to his compatriot Simonides the poet: 'The breeding of chariot horses is generally considered to be the noblest and grandest business in the world'.

Chariot-racing was the sport *par excellence* of ancient Greece, an enthusiasm which lasted well over 1,500 years. There were ridden races at Olympia and there is an amusing account of a military meeting arranged by Xenophon's Greek mercenaries. Dracontius, who was responsible for laying out the course, sent the horses down a steep slope where they then had to turn on the shore and come back to the starting post (surely the first point-to-point). The slope was so steep that on the way down most of the horses rolled over and over and on the way up the riders had difficulty in making their horses take it even at a walk. 'There was', Xenophon says, 'much shouting, laughing and cheering.'

The earliest Greek account of a chariot-race is in the *Iliad*, the first race at the funeral games of Patroclus, Achilles' charioteer. There were five contestants and a prize for each. The first prize was a slave woman skilled in household duties, and a tripod; the second prize an unbroken six-year-old mare carrying a mule foal; the third prize a large new cauldron; the fourth prize two talents of gold; the fifth an unused bowl with two handles.

The race itself is sufficiently full of incident to satisfy any reader of racing stories; the yoke of the leader breaks, resulting in his

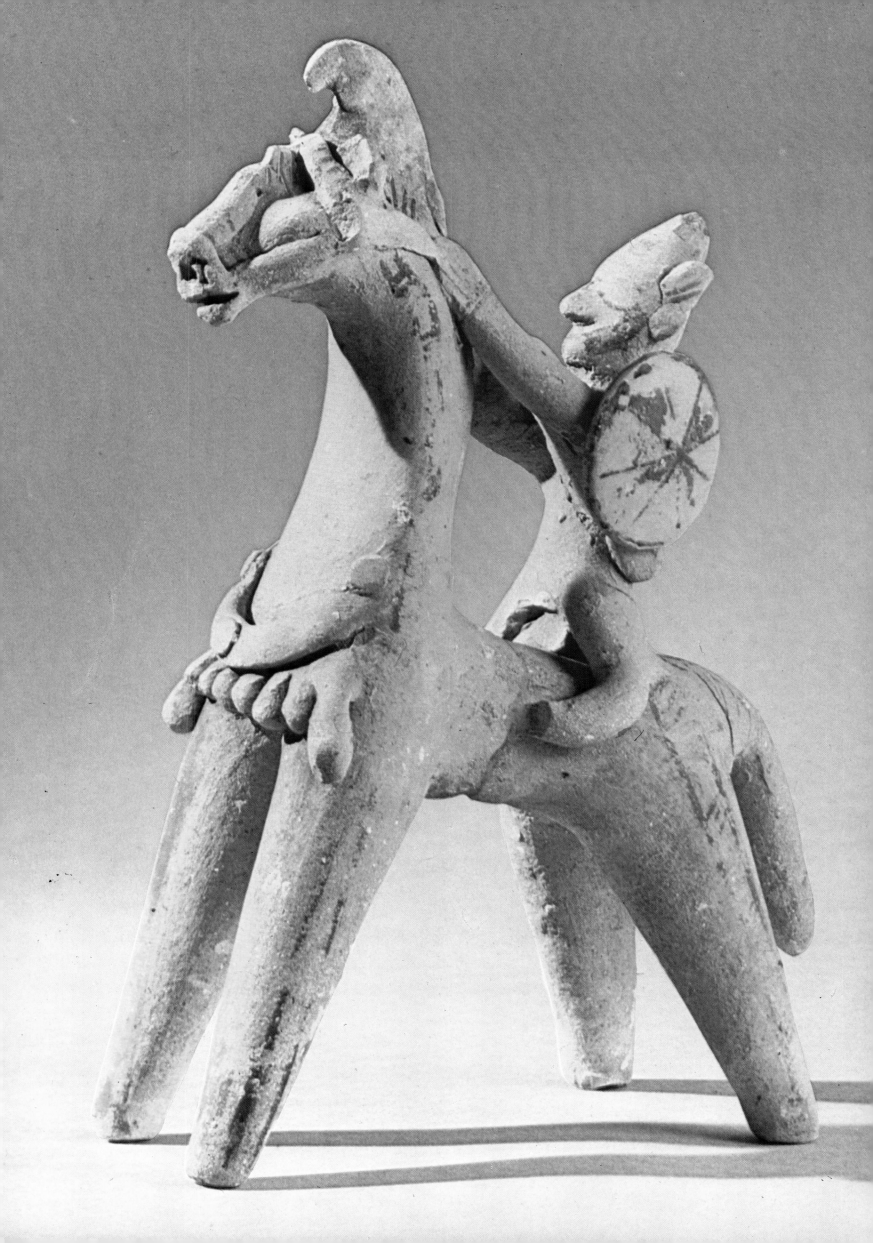

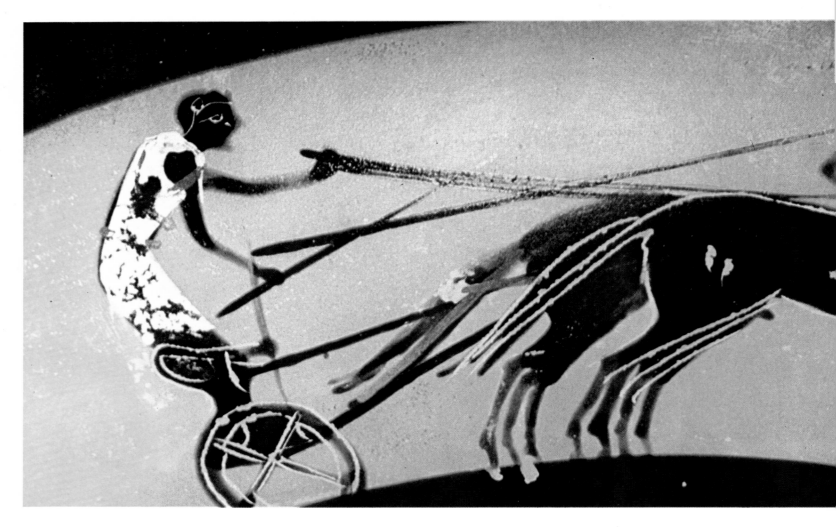

taking a nasty spill, and there is foul driving by the favourite, the youthful Antilochus who has taken too much to heart a lecture by his father, Nestor, about how clever driving could make up for the slower speed of his horses. Spectators in the stand argue so fiercely about who is winning that they almost come to blows, and after the race Antilochus is called upon to take an oath that he has driven fairly, which he cannot do.

The most important chariot-racing event was at the Olympic Games. The four-horse chariot race started in 680 BC, the two-horse chariot race was not introduced until 408 BC. In 384 BC a race was started for chariots drawn by four foals. As we later hear of a race for ridden foals it seems that the Greek word *pôlos*, translated foal, cannot have the same significance as our word foal. As in Greek literature there are several references to foals who have not cast their teeth it seems likely that in Greece a horse counted as a foal until it cast its first milk teeth when rising three. Even so, this seeking after early maturity must

have done great damage to the breed.

The honour of winning a chariot-race at Olympia was as great as, if not greater than, that of winning the Derby in England. Poets were commissioned to write poems in honour of the winners. The poet Pindar (c 522-c 440 BC) made his living by writing such odes. It is extraordinary how he managed to write so many poems in honour of winners of chariot-races without giving any useful information about chariot-racing at all. He gives the impression that he was not really a racing man.

The best sculptors of the period were commissioned to make statues of the winners. Part of the inscribed pediment of the statue to Cynisca, the sister of King Agesilaus of Sparta, has survived, stating that she was the first woman to breed winners at Olympia (c 386 BC).

Chariot-racing remained popular throughout the Roman Empire. When the Empire was divided and the Western Empire fell the sport still held its sway at Byzantium.

Originally there were four

groups of chariot teams which used to compete. They represented the four seasons, green for spring, red for summer, blue for autumn and white for winter, but gradually the reds and whites faded away and there remained a terrific rivalry between the greens and blues, often resulting in riots in the streets. This rivalry was partly political as the blues were supported by the landed gentry, and the greens by merchants and tradesmen.

On one occasion only did the two unite, in the Nike riots (AD 532), and this nearly cost the Emperor Justinian his throne. The situation was saved by the courage of his wife Theodora, the bear-keeper's daughter who, whatever her origins, proved herself worthy to be an Empress. 'Flee if you like,' she said to the Emperor, 'the ports are open but I will not fly, for I think the old saying true, a regal robe makes a good shroud.'

After the sixth century the Greek horse as such must virtually have disappeared, except perhaps in the Peloponnese, carried away by wave after wave of barbarian invasion which swept the country.

There is no further mention of the Greek breeds of horse.

In the nineteenth century we hear of no native breed of Greek horse; instead horses were imported into Greece from various parts of the Turkish Empire. Today there are once more studs and herds of horses on the plains of Thessaly, but they are imported breeds and largely bred for racing in Athens. A number of mares are also kept for mule breeding.

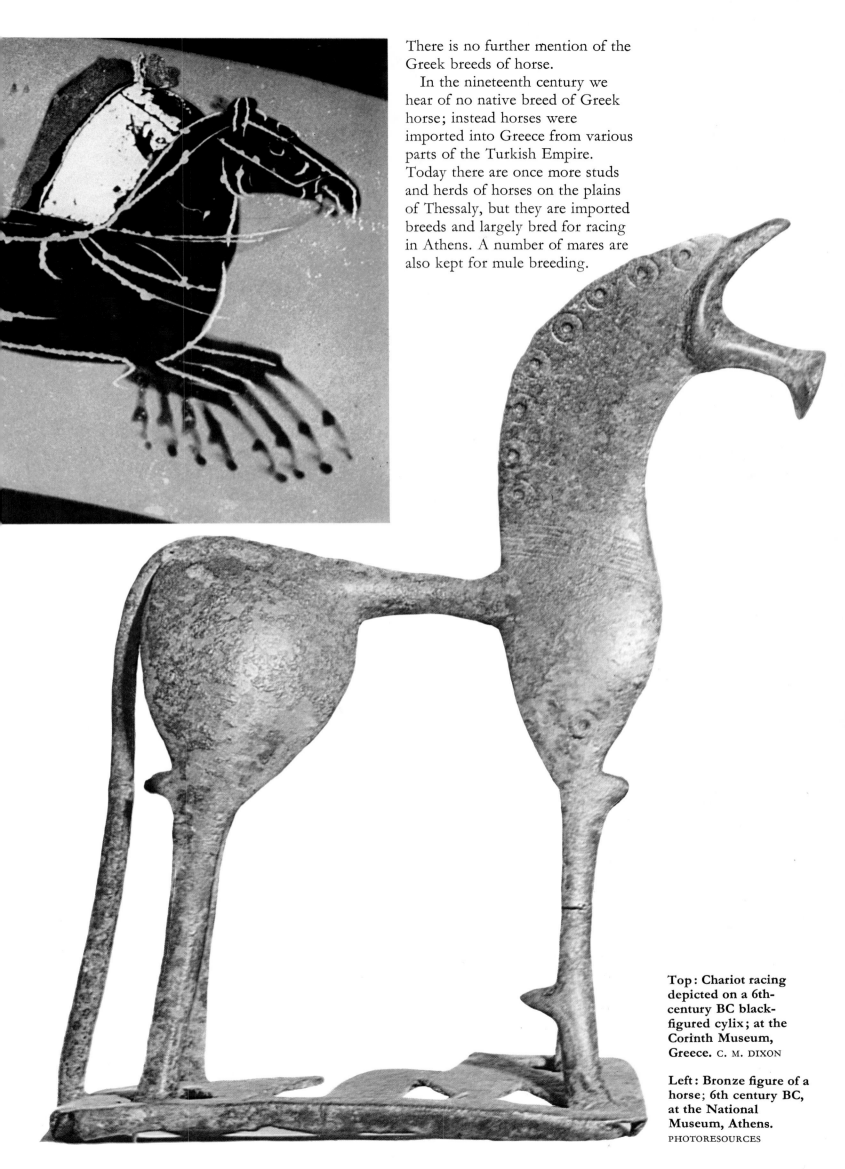

Top: Chariot racing depicted on a 6th-century BC black-figured cylix; at the Corinth Museum, Greece. C. M. DIXON

Left: Bronze figure of a horse; 6th century BC, at the National Museum, Athens. PHOTORESOURCES

**Maharana Jawan Singh
(1828-38) hunting wild
boar; a painting from
Udaipur, India.**
VICTORIA AND ALBERT
MUSEUM, LONDON.
PHOTOGRAPH:
PHOTORESOURCES

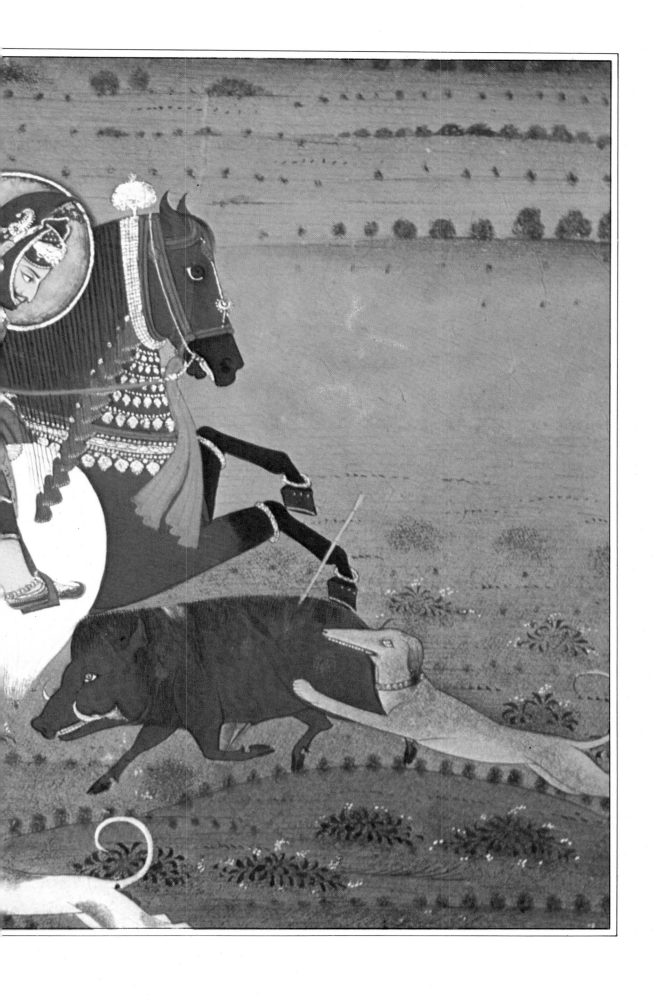

The Wooden Horse of Troy

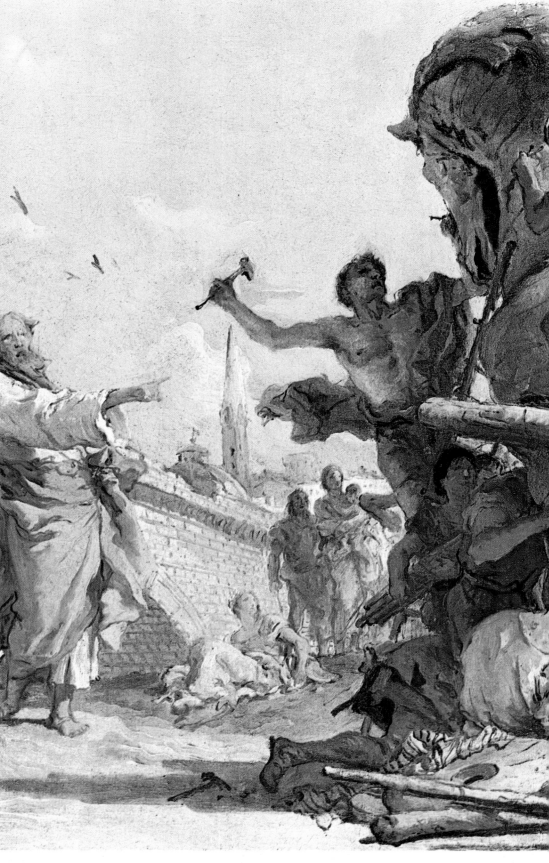

MORE THAN three thousand years ago the Greeks under Agamemnon, King of Mycenae, fought before the city of Troy for ten long years without avail. At last they became weary of their fruitless attacks, and were advised by the Seer Calchas that they should stop attacking the walls and devise some stratagem whereby they could conquer the city.

Eventually the Greek hero Odysseus, always crafty, suggested that they should build a huge hollow wooden horse and leave it filled with men, while the remainder should sail away and hide behind the nearby island of Tenedos. The idea was accepted and the Greeks set to work with such a will that the horse was finished in three days.

The horse's belly was as large as a ship and on its lofty neck they fixed a crested mane of purple splashed with yellow gold. Its eyes were made of sea-green beryl with pupils of blood-red garnet. They put white teeth in its mouth and made an air vent, hidden in its mouth. They gave it pricked ears and a tail which flowed down to its heels, and its feet were made of bronze covered in tortoiseshell. They made a trap-door in the side for men to enter and fitted wheels so that it could be dragged along easily. Its bridle was purple and its bronze bit inlaid with ivory and silver. Upon the horse they put the inscription 'For their safe return home the Greeks dedicate this thank-offering to Athene.' The bravest of the Greeks, believed to have been between twenty-two and thirty-five soldiers, volunteered to enter the horse. Afterwards the Greeks burnt their tents and sailed away.

The Trojans came out from their walls and gathered about the horse. Some said that it should be dragged into the city, others that it should be burnt or thrown over the cliffs. Laocoön, the priest of Apollo, rushed down from the city with a large following of people and furiously urged them to put no trust in the horse, finishing his speech with the famous phrase, 'I

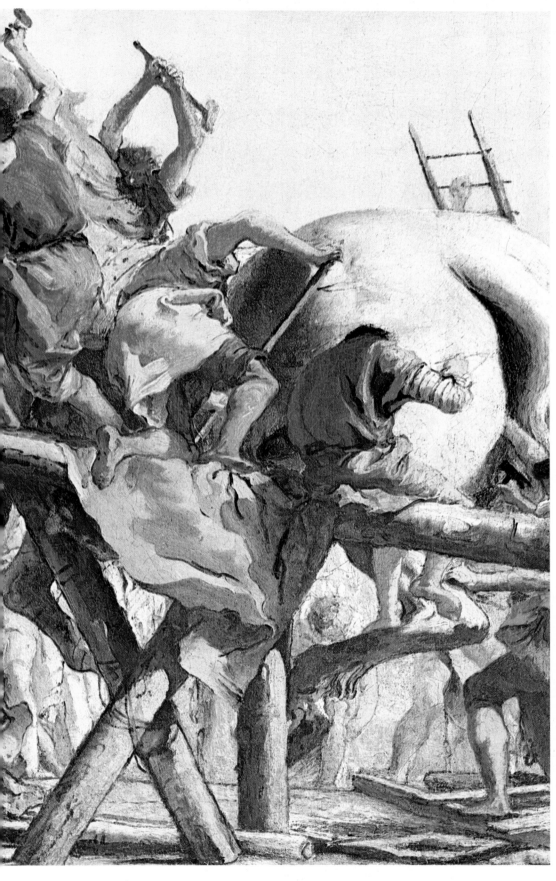

relation of Odysseus, who said that he had incurred the wrath of Odysseus and must be sacrificed to ensure a safe passage home for the Greeks. Sinon also told the Trojans that if the horse were dragged into the temple of Athene in the city to replace the image of the goddess, which Odysseus had stolen some time before, Troy would never be captured and the Trojans would conquer Greece itself. The Trojans then began to drag the horse up into the city, breaking down the walls to do so. They strewed the way with flowers, while youths and maidens accompanied the horse with hymns.

Four times the horse stopped as they tried to drag it over the threshold of the temple, and each time the clash of arms sounded from within, but the Trojans, in their frenzy, took no heed and took the horse into the sanctuary of Athene. The Trojans then devoted the evening to feasting and dancing. When night fell, most of the Trojans slept, overcome by drunkenness and exhaustion. During the night Sinon lighted a fire, which was the agreed signal for the Greeks to return from Tenedos, and then went to the horse and helped the Greeks to descend by ropes and ladders. They fought their way to the gates and opened them to the returning Greeks. Amidst great carnage Troy fell. Only a few Trojans escaped, including Aeneas, the son of Anchises and Aphrodite who, as the founder of Latium, was also the founder of Rome.

Left: The Building of the Wooden Horse by Tiepolo.
NATIONAL GALLERY, LONDON

Overleaf: Tiepolo's painting of the Wooden Horse being dragged into Troy. NATIONAL GALLERY, LONDON

fear the Greeks, especially when they bring gifts.' Whereupon he hurled his spear into the side of the horse and a sound like a groan issued from it.

But at that very moment the Trojans' attention was diverted by a shepherd dragging in Sinon, a

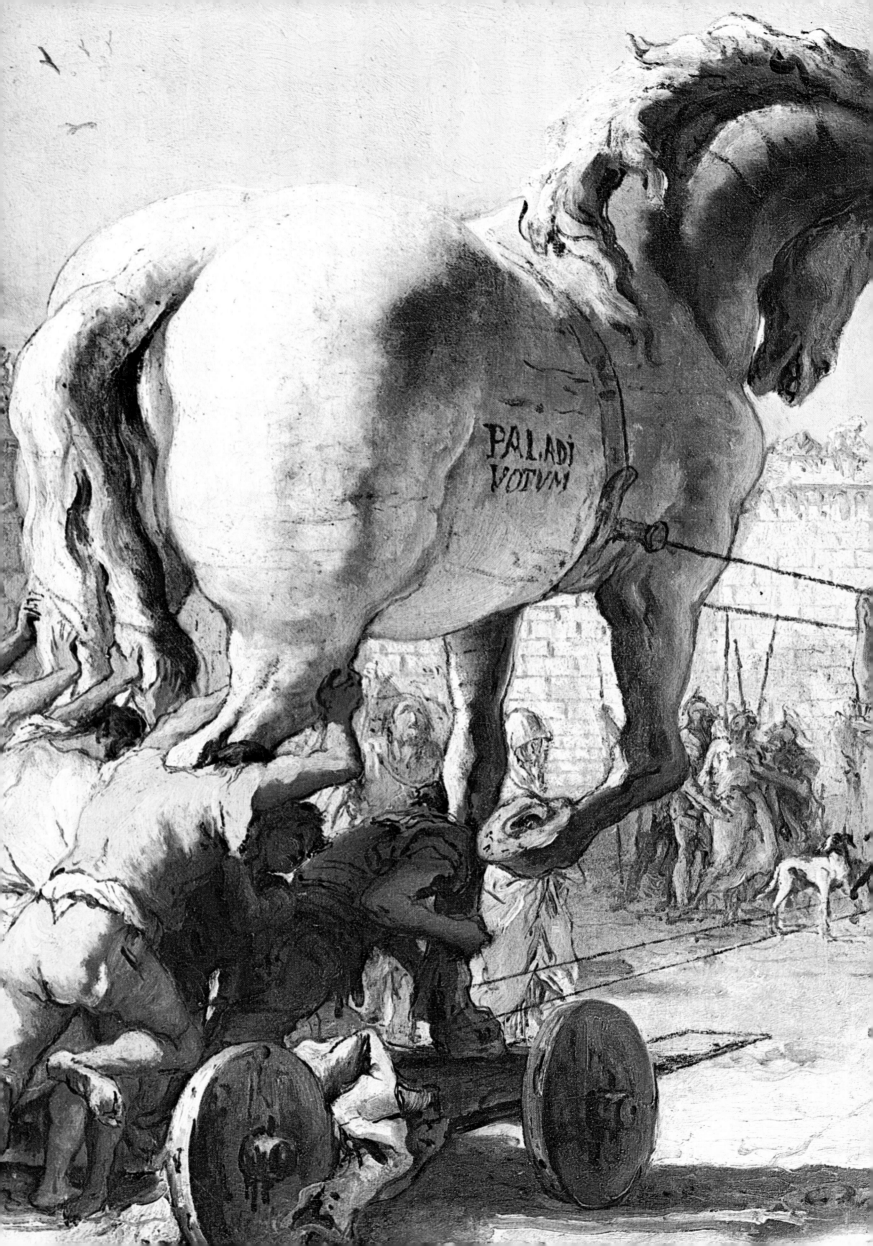

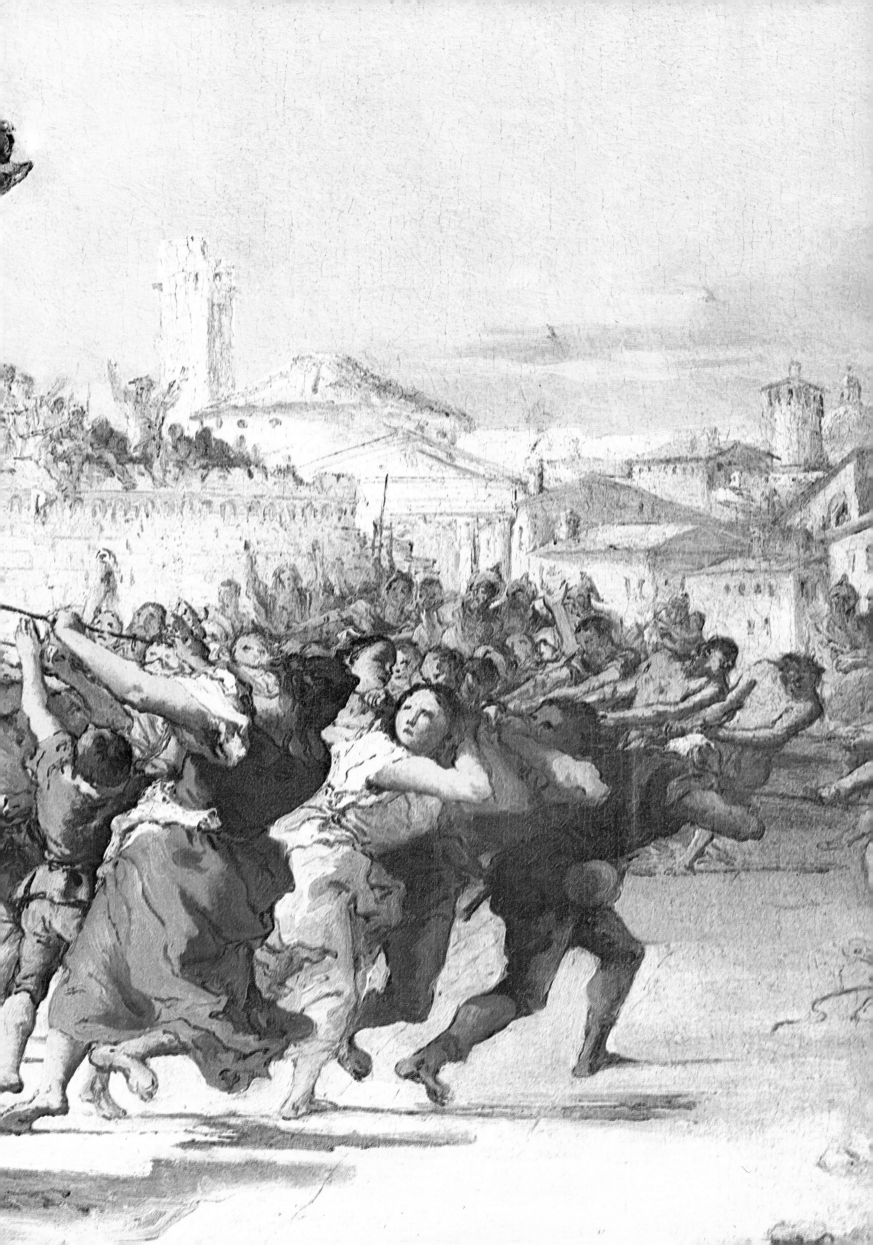

Equine Sculpture

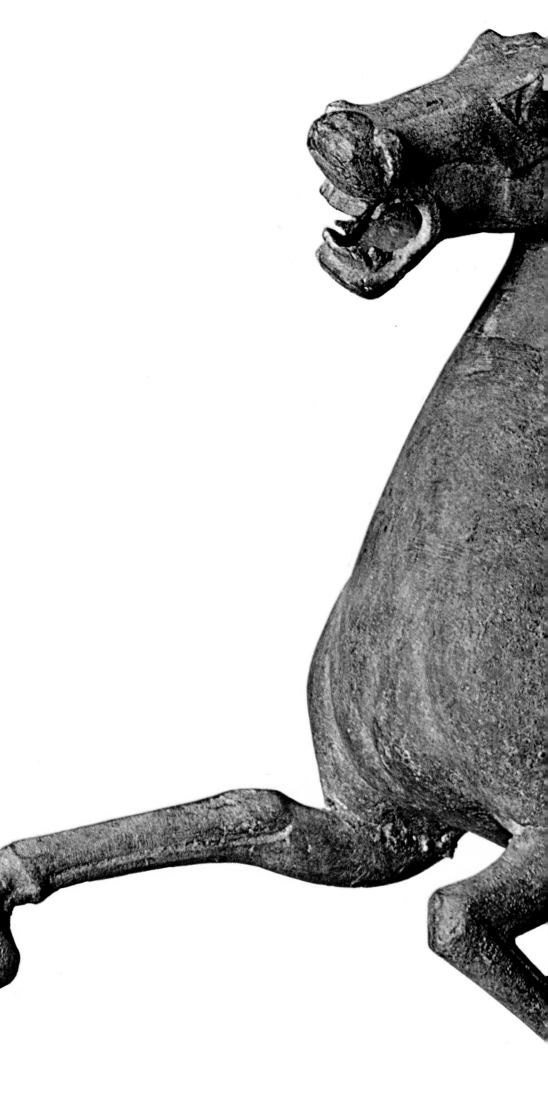

A GREAT EQUESTRIAN statue is an inspiring sight, but the sheer scale of such monuments, involving as they do unusual patience and persistence on the part of the sculptor, great expense for the patron, and – where bronze is concerned – considerable skill in the casting, means that there are not many of them about. Most of the monarchs and bemedalled generals in their plumed hats, whose memorials litter the squares and boulevards of cities round the world, are poor examples of the genre.

Nevertheless, the portrayal of the horse and his rider has always been a challenge to the skill and imagination of the sculptor, and has produced some outstanding works of art. The 'grand-daddy of them all' is to be found in Rome: the Emperor Marcus Aurelius ruling the world with a benign gesture from his proud, mettlesome steed.

This huge bronze effigy, nearly seventeen feet high, dominating the Piazza del Campidoglio, was created in about the year AD 173. It is the classical prototype from which the leading sculptors of the Renaissance – over a thousand years later – gained much of their inspiration.

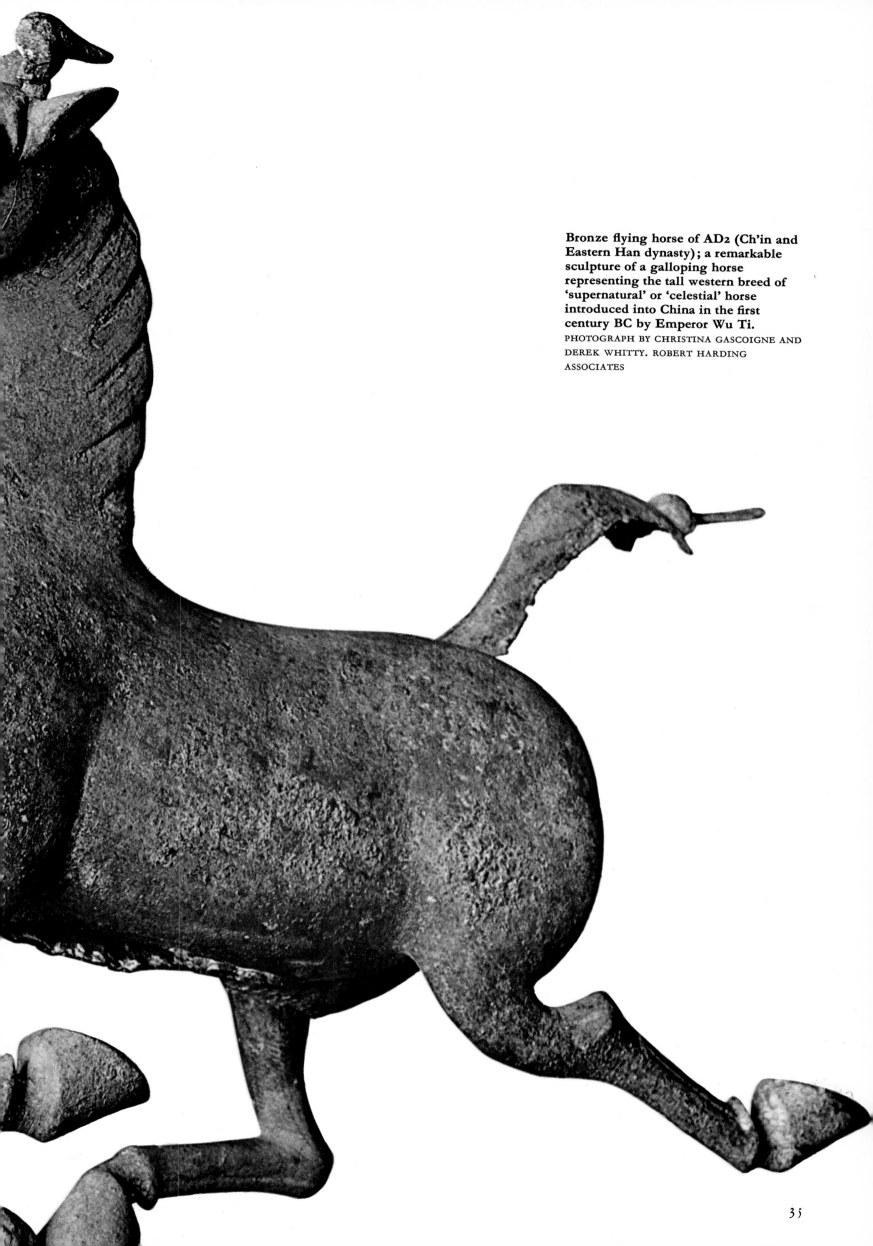

Bronze flying horse of AD2 (Ch'in and
Eastern Han dynasty); a remarkable
sculpture of a galloping horse
representing the tall western breed of
'supernatural' or 'celestial' horse
introduced into China in the first
century BC by Emperor Wu Ti.
PHOTOGRAPH BY CHRISTINA GASCOIGNE AND
DEREK WHITTY. ROBERT HARDING
ASSOCIATES

Viewed from almost any angle, the composition expresses the vigour and power of a great nation – no matter that there are no reins or stirrups, the effect is still the same. That is part of the fascination of free-standing works that cannot be conveyed by a photograph: the spectator can move round them and appreciate the purely artistic qualities of line and mass, fine detail and bold modelling. Although neither the name of the artist nor that of the horse has come down to us, who can doubt that this noble animal was the very *Copenhagen** of his day, an outstanding product of one of the famous Roman studs.

But representations of a horse do not have to be so large, or in bronze. They have been delicately modelled in wood and ivory, and baked in clay.

The head of a horse in the form of a terracotta scent-bottle, although only a few inches high, shows several interesting features of its time. Excavated in the island of Rhodes, it dates from about 600 BC, and reveals Egyptian influence in the elongated eye and the kind of cavesson, a bitless bridle which figures in Assyrian reliefs.

Large or small, these works can tell the student of history a great

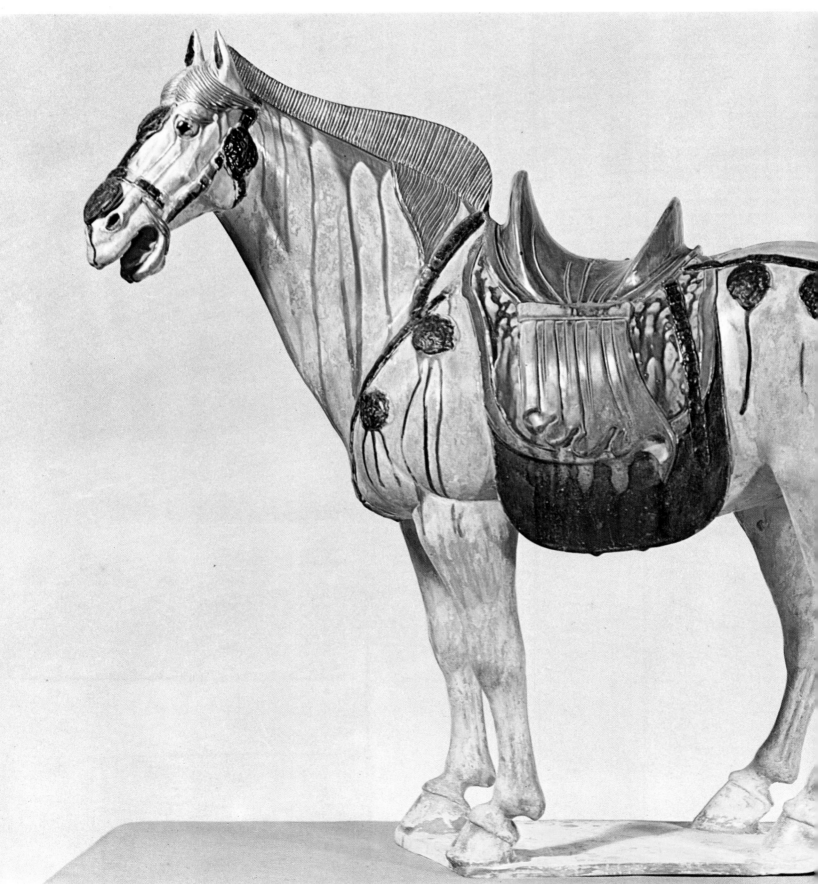

deal. The sculptor is a man of his time reflecting the ideals, the prejudices and indeed the whole lifestyle of his era in a way that experimental painters can, and often do, ignore. A certain understanding of the background can help the enjoyment of the works' special qualities, which may be far removed from any idea of literal 'lifelikeness'.

For instance, the horses'

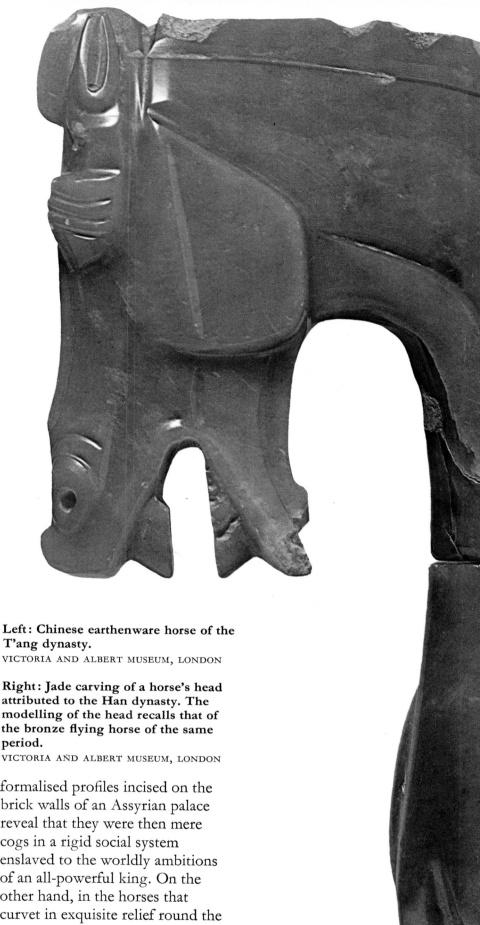

Left: Chinese earthenware horse of the T'ang dynasty.
VICTORIA AND ALBERT MUSEUM, LONDON

Right: Jade carving of a horse's head attributed to the Han dynasty. The modelling of the head recalls that of the bronze flying horse of the same period.
VICTORIA AND ALBERT MUSEUM, LONDON

formalised profiles incised on the brick walls of an Assyrian palace reveal that they were then mere cogs in a rigid social system enslaved to the worldly ambitions of an all-powerful king. On the other hand, in the horses that curvet in exquisite relief round the frieze of the Parthenon now in the British Museum, the flowing lines and natural treatment demonstrate a perfect rapport between horse and rider of a free people.

The Egyptians, who did everything on a vast scale, went in for sheer numbers. It is written in the Book of Exodus that the Pharaoh took 'six hundred chosen charioteers, and all the chariots of

*The Duke of Wellington's charger.

Egypt' to pursue the children of Israel; that means at least a thousand horses . . .

The tradition of Phidias, who was responsible for the design of most of the Parthenon sculpture, did not die with the defeat of the Greeks by the Persians. This is proved by the detail from the sarcophagus from the Royal Necropolis at Sidon, portraying the Macedonian conqueror, Alexander the Great, hunting with his dogs. Such wall decorations were part of the mystique of the ruler of those days, portraying him as a warrior chieftain, killing lions or leading his enemies into captivity. The Parthenon carvings, on the other hand, were in celebration of a pagan but religious event: a time of joy, when the recitation of verse had as important a part to play in the festivities as the relay race.

Differences in style and technique are caused by the working of different materials. The high finish of Egyptian art is largely due to the fact that they liked to use very hard stone which was rubbed and polished. The Greeks used crystalline marble which was more amenable to rasp, chisel and claw. (Only one piece of a bronze horse has survived from that era.) Later masters working with clay or wax were able to exploit the rich, textural possibilities of surface treatment, for casting in bronze.

Reverting then to Marcus Aurelius, it can be seen that Rome took over the culture of Greece, but we have to wait until the fifteenth century before another flowering of artistic genius occurred, and the horse appeared again as an important feature in art.

The Middle Ages, while producing figure sculpture of rare refinement, relegated horses to a very minor role. Probably the only exception is a sparely chiselled statue in Bamberg Cathedral.

By the early fifteenth century the time was ripe for change. There were heroes to commemorate and

there were artificers in bronze, well trained in the artillery foundries of the day, to carry out one-piece and hollow castings with great accuracy.

In 1443, Donatillo, the great Tuscan sculptor, was commissioned by the Venetians to sculpt a monument to the *condottiere* general Gattemalata. This noble statue, which stands at Padua, is a severe conception of enormous power which one can criticise only for the tail being placed far too low in the rump.

Verrocchio's famous statue of another Venetian general, Colleoni, followed some forty years later and showed a more dynamic approach. The rider's body is twisted with scornful arrogance in the massive saddle, and the horse's action has far greater impulsion. Here again there seems to be some fault in the musculature of the hindquarters.

No doubt Leonardo da Vinci would have outstripped both of

these if his sketches for the monument to Francesco Sforza had been translated into bronze form, but after arguments over the cost the model was destroyed during the French occupation of Milan by archers who used it for target practice.

The High Baroque period brought an ever-increasing virtuosity in technique, which sometimes declined and became slick and sentimental.

The outstanding exception to this trend of superficiality was Giovanni Lorenzo Bernini (1598-1680), a protean genius, who was architect, painter, sculptor and musician. Towards the end of his long life he carved two breath-taking equestrian statues: one of Constantine, the first Christian Emperor, and the other of the French king, Louis XIV, as Hercules.

The *Constantine*, in the Vatican, is an extraordinary achievement for any sculptor, let alone one already

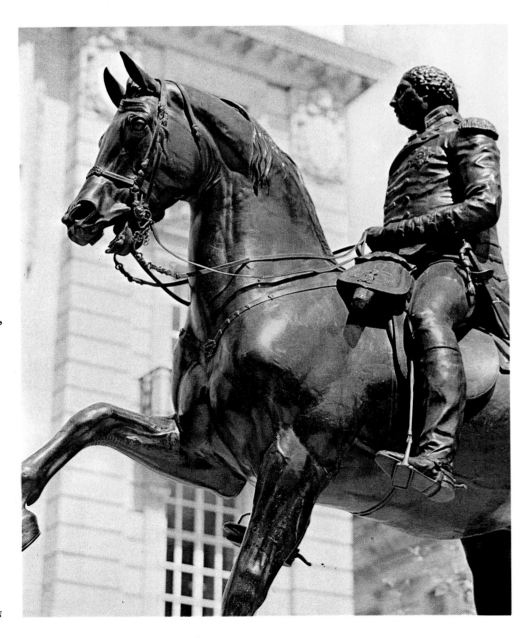

Right: George III by Matthew Cotes Wyatt (1836) in Cockspur Street, near Trafalgar Square, London. C. M. DIXON

in his late sixties. It shows in dramatic form the moment when the Emperor beheld that vision of the Cross in the sky which caused his conversion in AD 312. His horse rears up in alarm, and Constantine's outstretched hands and tense expression convey an overwhelming experience.

Bernini has here created a pictorial unity of a three-dimensional statue combined with a background carved in relief. The horse's body is attached to a curtain, apparently billowing in the wind, which frames the group and adds a contrasting diagonal sweep to the opposite motion of the horse and rider. This overcame the problem of balancing a stone horse on his hind legs. Nobody, before or since, has demonstrated such incredible mastery over his medium in conveying a fairly complex idea.

The *Louis*, by contrast, is somewhat mundane. Louis is portrayed as a commander, with literary antecedents of Hercules, surmounting a rocky pass on the way to the Temple of Glory.

Strangely enough, Prince Eugene of Savoy, who had taken part with Marlborough in the series of victories in the Low Countries that ended Louis XIV's supremacy in Europe, is celebrated by a fine work by Anton Fernkorn in Vienna. Standing on an elaborate plinth in the Heldenplatz, it shows the popular hero – dashing, confident – in full martial fig of immense boots, half-armour, curly wig and tricorne hat, on a noble Lippizaner that rears up in the air. The steep angle of the horse's body is here sustained by a flowing tail secured to the base – a device that Stubbs adopted, even in his paintings.

This work was part of the host of statuary commissioned and carried out to enhance the grandiose rebuilding of the city by Fischer von Erlach, including the superb Riding School. Naples, Madrid, Copenhagen, Paris and Antwerp had all maintained Haute Ecole riding establishments, but only the one in Vienna survived the French Revolution and its aftermath. The English, despite the

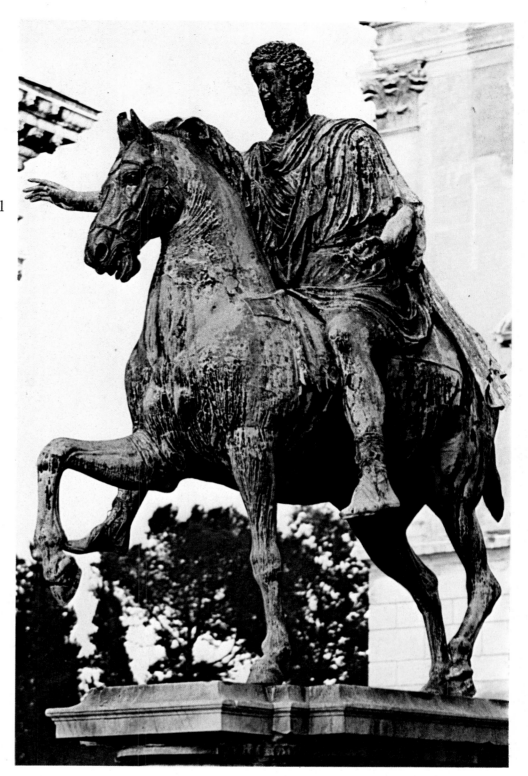

admonitions of the Duke of Newcastle, had never been too keen on the strict disciplinary methods of the Continental schools, developed from the demands of warfare.

It is a pity that Charles I, who was no mean horseman, should be commemorated by such a feeble work as his statue by the Huguenot, Hubert le Sueur, at the southern end of Trafalgar Square. The horse looks more like a sausage than a Lippizaner.

The armour worn by the King was a faithful copy of a suit now in the Tower of London, which shows that although he was only 5ft 4ins tall, he is nevertheless

Above: The Emperor Marcus Aurelius, the Capitol, Rome, AD 173.
C. M. DIXON

portrayed as a full 6ft in height! The statue was supposed to have been melted down during the Protectorate, but it was preserved by the brazier to whom it was sold. He buried it in his garden and triumphantly produced it for re-erection at the Restoration in 1660. He had, incidentally, made a useful profit selling knives and souvenirs supposedly formed from the metal!

By the eighteenth century, when the Hanoverian dynasty became established, interest had shifted more towards sport and

competitive racing. It is not too easy to portray in sculpture a galloping horse and so it came about that equestrian sculpture became merely a way of showing off the rider, of greater or lesser fame.

The first and most attractive of this kind in London is Matthew Cotes Wyatt's bronze of George III on his favourite charger, *Adonis*, near Trafalgar Square. This is full of vitality, and considered Wyatt's best work. It was commissioned by a committee of subscribers to commemorate the first Hanoverian really to identify himself with Great Britain. The statue of his son, George IV, by Sir Francis Chantrey in Trafalgar Square, is not so successful, although he charged £9,000 for it.

Not far away in St James's Square, there is a statue of William III, an altogether delightful rococo conception by John Bacon the younger. This has the interesting detail of a molehill shown under the horse's hoofs, in memory of the fact that William died after a fall he took when his horse stumbled over a molehill – an event which adherents of the Jacobite cause used to celebrate with a toast to 'the little gentleman in black velvet'.

In the last hundred years a number of equestrian statues of varying quality have been erected, among which should be mentioned those of Richard Coeur de Lion in Whitehall, Edward VII in Waterloo Place, and the Duke of Wellington and the *Peace* quadriga at Hyde Park Corner. But perhaps the most strikingly original is G. F. Watts's powerful image of *Physical Energy* in Kensington Gardens. This is a replica of the memorial to Cecil Rhodes at Groote Schuur near Cape Town. The vivid forcefulness of this twelve-feet-high composition is a most remarkable creation by a Victorian artist, chiefly known for his deeply psychological portraits of notabilities such as Tennyson.

To come to the present day, it seems that the age-old fashion for equestrian sculpture has passed. No one has suggested that

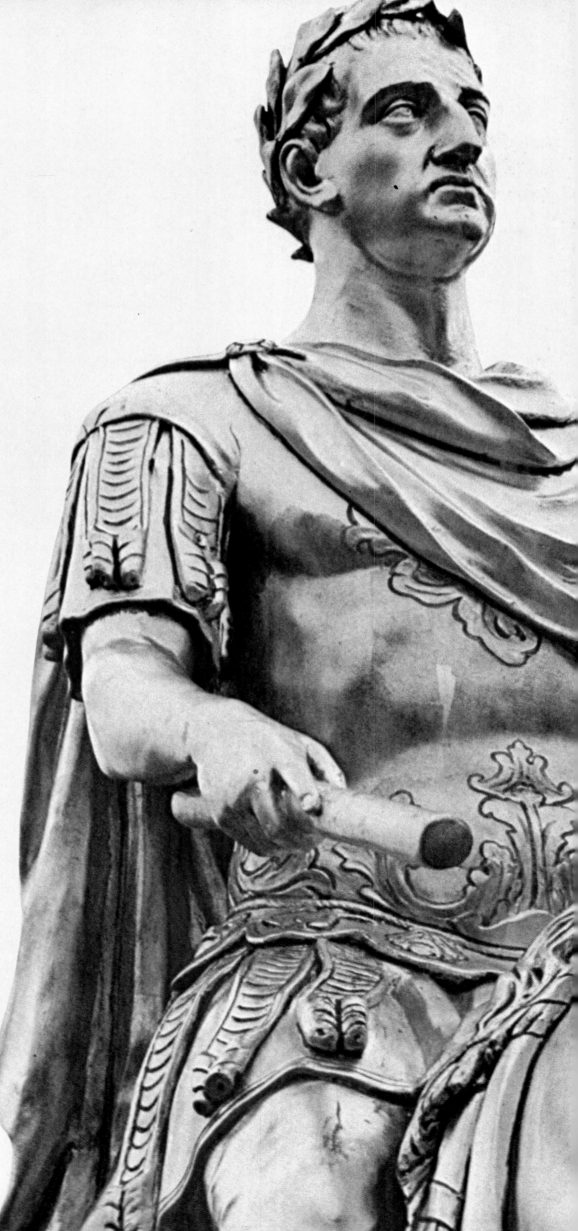

Churchill should be memorialised as a Hussar at the charge of the Battle of Omdurman – a chance that has been missed. Racehorses and showjumpers are now the thing.

John Skeaping, one-time Professor of Sculpture at the Royal Academy, has done a lifelike standing version of the great sire, *Hyperion*, which is at Lord Derby's stables at Newmarket, and also a most attractive one of Derby winner *Mill Reef* and John Hislop's great champion *Brigadier Gerard*. The statue of 'The Brigadier' stands in the garden of the Hislop home near Newbury, overlooking the paddocks in which mares and foals roam – some of them sired by the famous stallion. There is, too, Munnings's statue of *Brown Jack* at Ascot.

Two female sculptors who are doing good work on a small scale, are Jean Walwyn and Pamela du Boulay. One fears, however, that there will never be another artist of genius who will be bothered to master the intricacies of the subject.

Degas dabbled in modelling and there is a nice statuette of his, of a horse jumping an obstacle, at the Tate (marred only by the lack of ears), but neither Rodin nor Epstein nor Henry Moore has been interested in this particular subject: perhaps, as we have seen, it has been too well done by the old masters?

Without the enlightened patronage of Court or Church, or a sense of national pride, such works seem to be out of place in this mechanised age. The *avant garde* sculptors of today who win the prizes offer for our admiration dreary arrangements of bits and pieces of iron girders welded together with drain-pipes.

The times are not likely to encourage the emergence of a new Bernini.

Left: William III as a Roman emperor, erected in 1734 at Hull, Humberside, England. C. M. DIXON

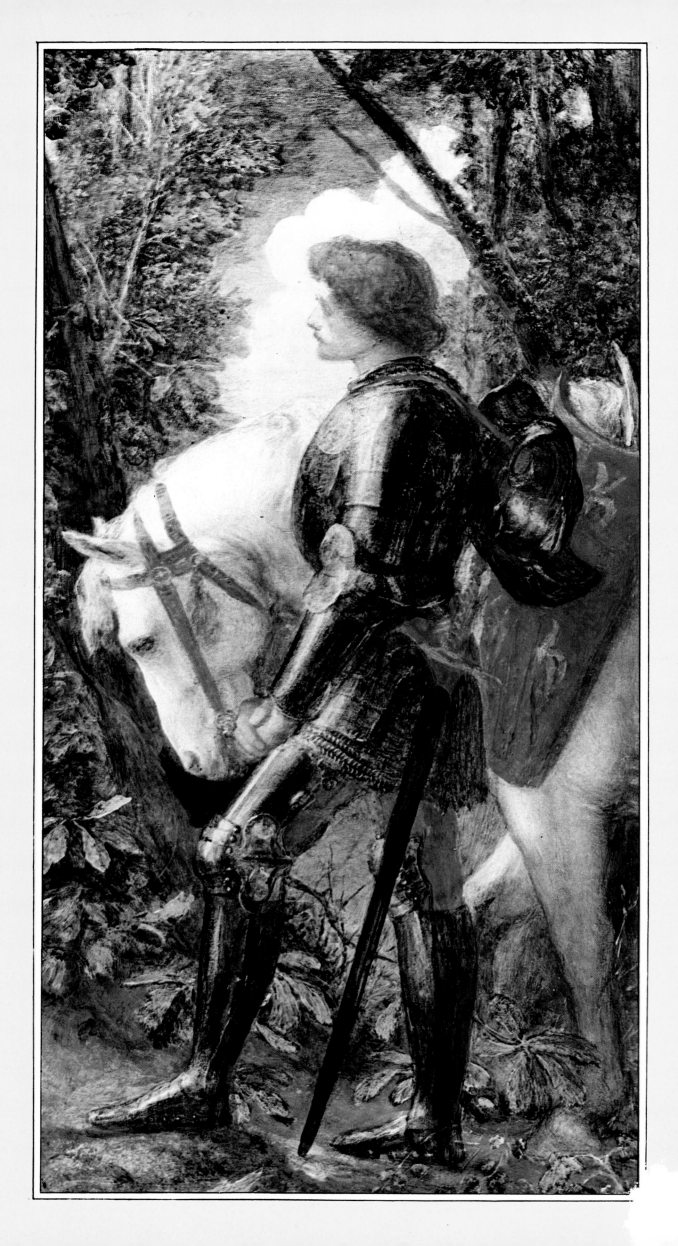

Sir Galahad

MUCH OF THE legendary history of Sir Galahad comes from Sir Thomas Malory's *Le Morte Darthur*, a book in which are retold the beloved stories of King Arthur and his Knights.

Galahad was first introduced to the Round Table of King Arthur by his father, Sir Launcelot, who awarded him the Order of Knighthood. The young Sir Galahad was much admired by Queen Guinevere, who often commented on his handsome countenance and his virtue. Swift in the use of lance and spear, he soon became champion of the tournaments, and gained a great reputation amongst his fellow knights.

One day an apparition of the Holy Grail appeared at the Court while the knights were feasting. The silver chalice seemed to glide along the length of the great banqueting hall before vanishing as quickly as it had appeared. For moments no one dared to speak. Then the knights spontaneously began to praise God for sending such a sign, and agreed that they were so inspired by the vision that they would devote their lives to seeking the Holy Grail. King Arthur and his Queen were

Left: Sir Galahad, painted by
G. F. Watts.
WALKER ART GALLERY, LIVERPOOL.
PHOTOGRAPH: COOPER-BRIDGEMAN
LIBRARY

Overleaf:
'O just and faithful Knight of God!
Ride on! the prize is near.'
'Sir Galahad in Quest of the Holy Grail'
by Arthur Hughes, who was born in
London in 1832 and died in 1915.
WALKER ART GALLERY, LIVERPOOL

overcome with sorrow at the thought of the departure of their knights, but nevertheless wished them Godspeed in their search and a safe return.

Sir Galahad mounted his horse and began his journey from Camelot, travelling for many days through dense forests and valleys in which rivers slowly meandered until he reached a white abbey. There he met another of King Arthur's knights, Sir Bagdemagnus. One of the monks took them behind the altar where he showed them a shield as white as snow, and explained that only the worthiest knight in the world should carry it. Sir Bagdemagnus did not heed the warning of the monk, and rode from the abbey armed with the shield.

Shortly after his departure he met a white knight who threw him from his horse, declaring that the shield could only be carried by Sir Galahad: Joseph, son of Joseph of Arimathea, had proclaimed that it was destined to be his many years previously, and had made a red cross on the shield with his blood. Convinced that the shield could not be for him, Sir Bagdemagnus returned to the abbey and gave the shield to Sir Galahad who continued his journey.

Sir Galahad's adventures took him to a castle owned by seven evil brothers – representing the seven deadly sins – who had imprisoned the maidens who stood for the good souls since the Incarnation of Christ. The brothers advanced towards Sir Galahad determined to kill him,

but the power of the knight was too great and it was he who slew them before releasing the maidens from their imprisonment. With every adventure he encountered Sir Galahad came closer to finding the Holy Grail. Many visions, apparitions and written signs came to guide his path, and God appeared to him in the form of a white hart, accompanied by four massive lions. He travelled across high seas guarded by a 'jantlewoman', went to Scotland, and later voyaged to other lands where he met Sir Bors and Sir Percival, both knights of the most perfect purity, who also sought the Grail.

Alfred, Lord Tennyson, fascinated by the legends of King Arthur and his Knights, wrote an epic poem about Sir Galahad which ended:

The clouds are broken in the sky,
And thro' the mountain walls
A rolling organ-harmony,
Swells up, and shakes and falls,
Then move the trees, the copses
 nod,
Wings flutter, voices hover clear,
'O just and faithful Knight of
 God!
Ride on! the prize is near.'
So pass I hostel, hall and grange;
By bridge and ford, by park and
 pale,
All armed I ride, what'er betide
Until I find the Holy Grail.

Eventually the knights found the Holy Grail, and were blessed by a bishop. As the bishop ended his blessing a host of angels surrounded Sir Galahad and carried his soul to God.

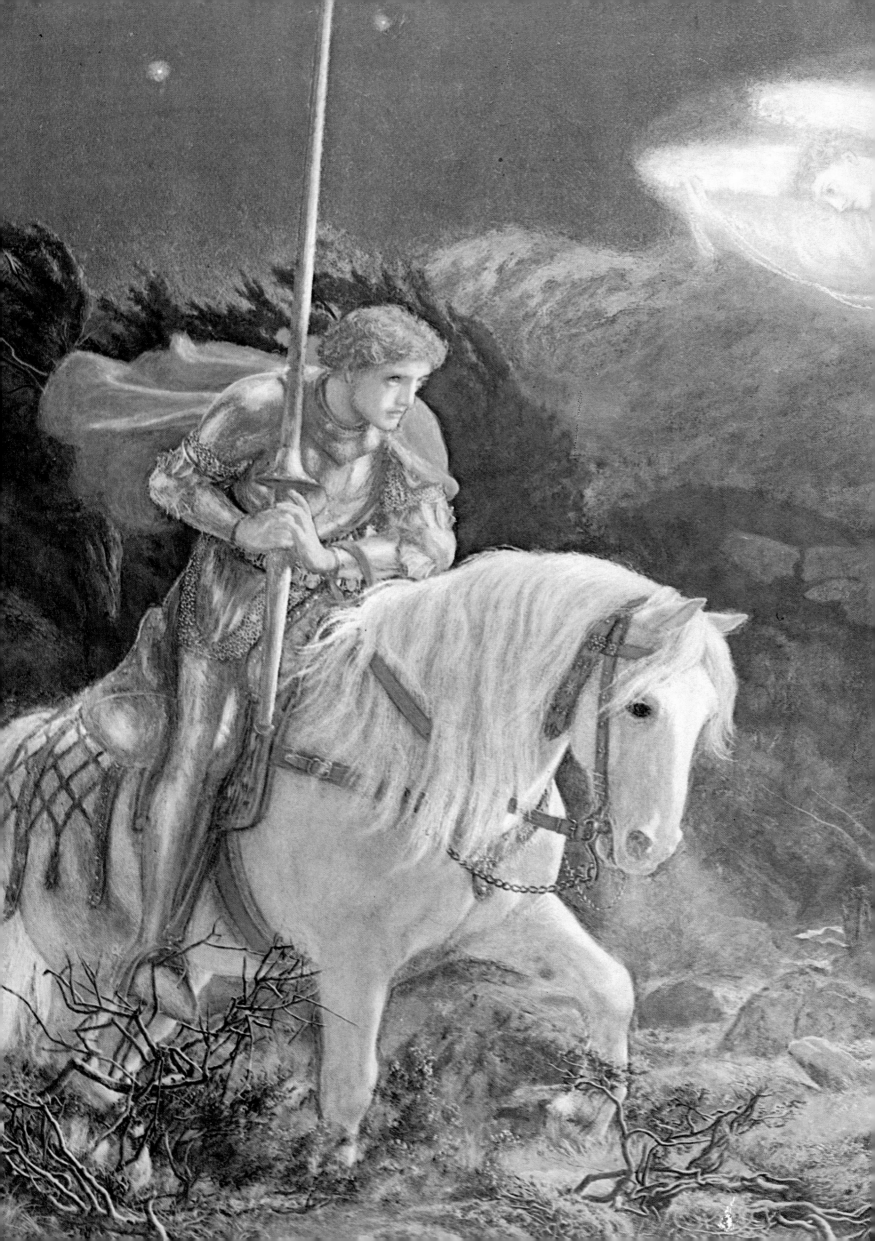

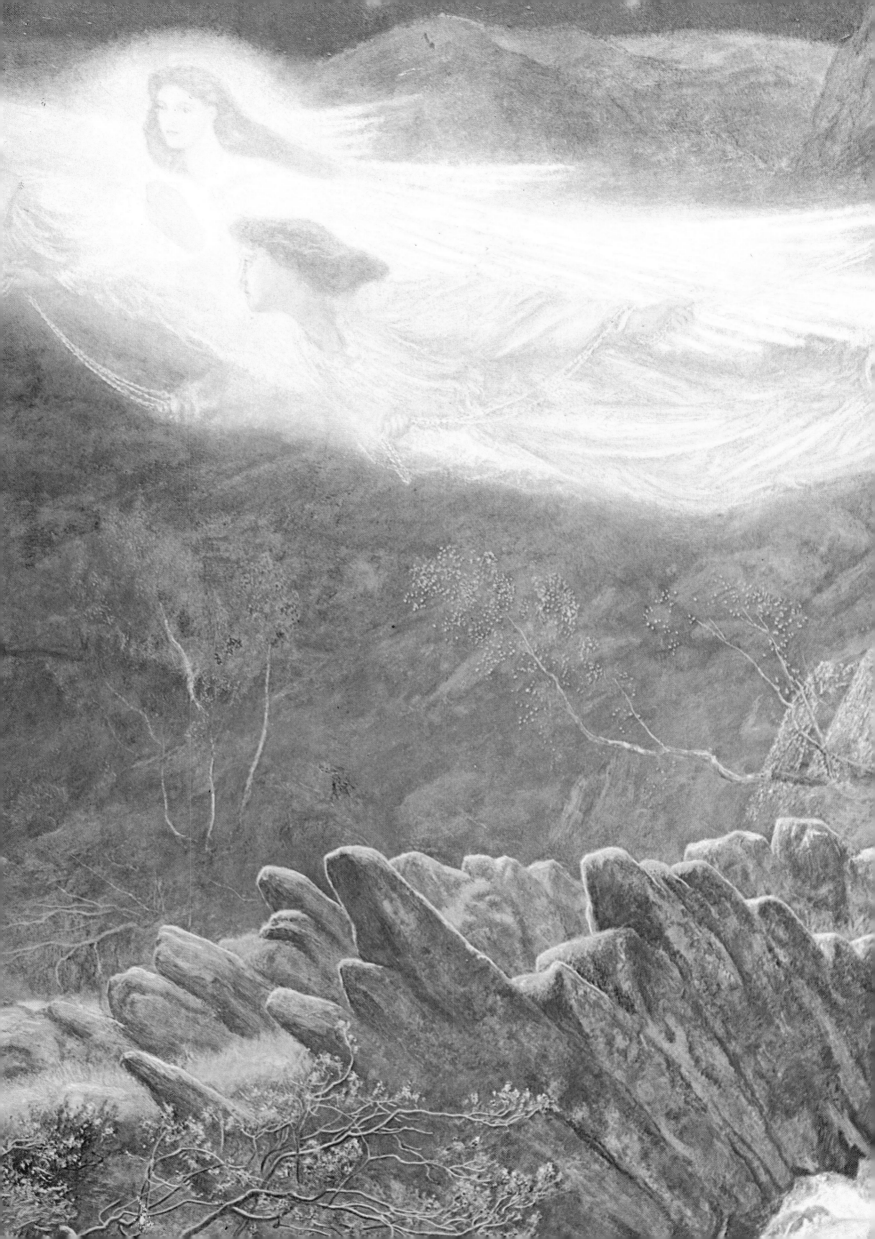

St George and the Dragon

NO ACCURATE historical details exist concerning the life of St George, patron saint of England. Legend suggests that the chivalrous and romantic knight was martyred near Lydda about the year AD 303, but there is little evidence to support this claim.

Some historians insist that he was nobly born, became a gifted soldier of high rank and paid the penalty for daring to criticise the religious persecution of Christians by the Emperor Diocletian. Condemned to death, he died as valiantly as he had lived and was subsequently made a saint.

The eighteenth-century historian, Edward Gibbon, took a different view and asserted that the man venerated as a saint was no more than an unscrupulous soldier of fortune whose eventual death was thoroughly deserved. Sent by Constantius to Alexandria, he so infuriated the people that ultimately they rose up against him and dragged him to prison, where he was murdered and his body was thrown into the sea. Such a death at the hands of pagans made him a Christian martyr with the inevitable canonisation.

Gibbon may have denigrated St George unfairly, for more than a thousand years earlier the exploits of the knight had brought him fame in western Europe. The Crusades added to his reputation when he was said to have appeared in a vision to Richard Coeur de Lion before the Battle of Acre and promised the king victory.

Garbled versions of St George's deeds had reached England before the Norman conquest; he became a venerated and legendary hero, and churches were dedicated to him. At the Council of Oxford in 1222 his feast day, 23 April, was ordered to be kept as a national festival, and before the end of the century his

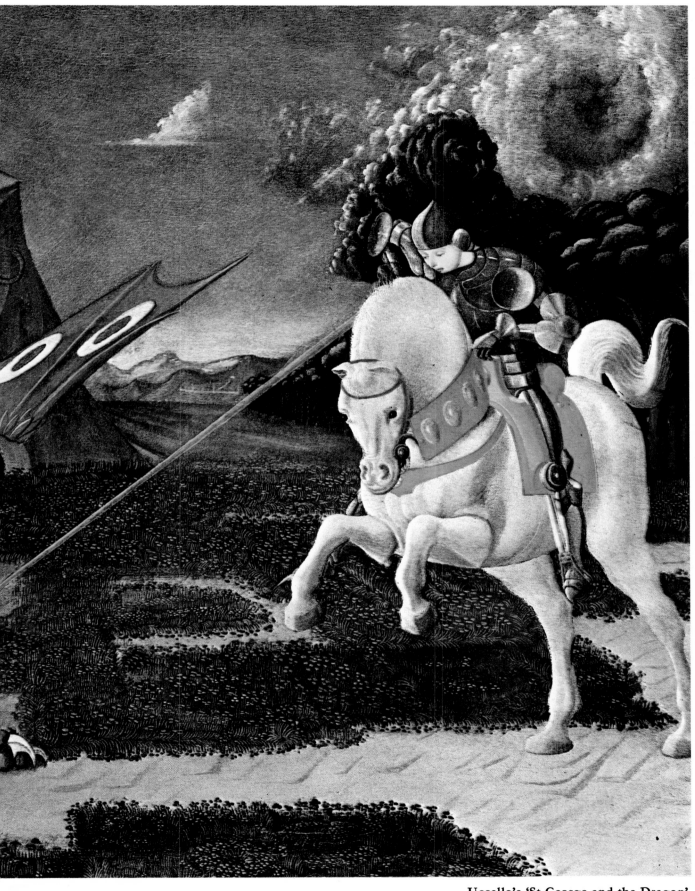

Uccello's 'St George and the Dragon'.
NATIONAL GALLERY, LONDON

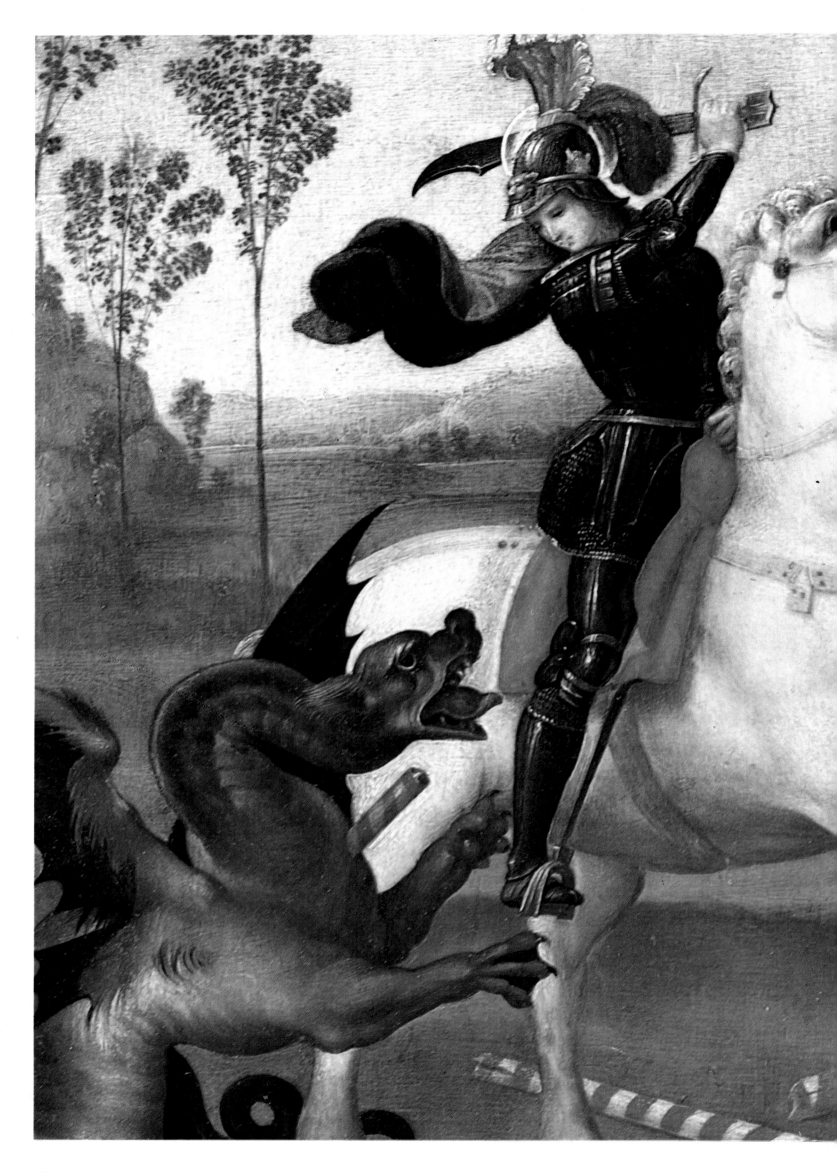

emblem of a red cross on a white ground was recognised throughout the kingdom. King Edward III made St George England's patron saint.

It became customary for the standard of St George to be carried before the English kings into battle and his name was accepted as the rallying cry for English soldiers. In William Shakespeare's *Henry V* the king leads the attack on Harfleur to the cry of 'God for Harry! England! and St George!', whilst the same writer's Richard III rallies his troops with the rousing words:

Advance our standards, set upon
 our foes,
Our ancient word of courage,
 fair St George,
Inspire us with the spleen of
 fiery dragons.

Allegorical tales abounded about St George and the winged dragon, which was considered the emblem of sin in general and paganism in particular. Many of these stories, often embroidered and exaggerated, told how St George came to the city of Sylene in Lybia, where a hideous dragon was terrifying the inhabitants and causing them extreme anguish by demanding that they send him beautiful maidens to devour. One day the king's daughter was to be sacrificed to the dragon, but the chivalrous knight attacked the monster and overcame him so that the princess was able to lead him back to Sylene. There St George agreed to slay him on condition that the inhabitants were baptised.

Such a chivalrous action appealed to painters who depicted the scene upon canvas. Each of them had differing ideas as to the size and monstrosity of the beast, and as to the manner in which it was killed. Raphael's painting in the Louvre is one of the most outstanding of these pictures and shows the saint mounted upon a magnificent cream-coloured charger.

'St George and the Dragon' by Raphael.
LOUVRE, PARIS

49

Knights in Armour

IN ENGLAND the word Knight is derived from the Saxon *kneht*, meaning a man-at-arms or servant to the king, and originally had little association with horses. On the Continent, however, the words *chevalier, cavalliere* and *caballero* prove the close link between Frenchmen, Italians and Spaniards and their horses.

The institution of knighthood gradually evolved throughout Europe and in Britain was first advanced by King Arthur and his Knights of the Round Table.

In Saxon times knighthood was conferred by the priest after solemn confession and a midnight church vigil. The new knight would offer his sword on the altar to acknowledge his devotion to the church and his avowed intention to lead a holy life. He would then give the church a sum of money to redeem his sword, which the priest would gird upon him, after striking him a blow on the cheek or shoulder – implying that this was the last affront that he should ever endure without retaliating. He then took an oath to protect the distressed and to maintain right against might. If he ever failed to honour his oath his sword might be broken, his escutcheon reversed and his spurs smashed . . .

The medieval knight in armour did not become a fighting force with which to be reckoned until the introduction of stirrups. Although some of the Asiatics who invaded Europe in AD 100 had used stirrups it was not until the era of Charlemagne (AD 742-814) that they were adopted by western civilisation. Their adoption was revolutionary, for it enabled a heavily armoured horseman to retain his balance in the saddle whilst using a weighty spear, sword or lance. Previously a chevalier so armed, and wearing mail shirt and helmet weighing some 40 lb, would have fallen from his horse if he had attempted any aggressive action against his enemy.

The shirt of mail, known on the Continent as a hauberk, was a garment made of small rings which were interwoven, and reached to the wearer's knees. Usually the knight wore clothes made of soft leather under his mail. This type of armour offered little protection against experienced and accurate longbowmen, and fell into disuse in the fourteenth century, being replaced by heavier plate armour. Kings and emperors wore elaborate and complicated suits of armour often engraved and inlaid with gold. Knights began to wear breastplates, leg harness, armoured gauntlets and helmets with visors. It became the custom for them to wear above their armour a loose-fitting blouse on which were emblazoned their arms, thus originating the expression 'coat of arms'.

In times of peace the knights enjoyed jousting at tournaments where they could exhibit their courage, chivalry and prowess with their weapons. The earliest tournaments were held in France, where they were probably instituted by the ancestors of the Counts of Anjou. In England many such tournaments and pageants were held in the tiltyard in the part of London that is now Smithfield Market. In France the death of King Henry II in 1559 as a result of the loss of an eye whilst participating in a tournament led to the abandonment of the pastime.

In times of war the knight went to battle with his armourer, his prized war-horses and his lesser valued coursers. Shakespeare's *Henry V* contains the lines:

Steed threatens steed, in high
 and boastful neighs
Piercing the night's dull ear, and
 from the tents
The armourers, accomplishing
 the knights
With busy hammers, closing
 rivets up,
Give dreadful note of preparation.

The end of the use of knights as an effective arm of war came with the greater power of artillery in the middle of the sixteenth century. The range and power of cannons and guns put paid to their role as battle-winning cavalry, but failed to destroy their romantic reputation for chivalry which has lasted until the present day.

Right: The third horseman (Revelations 6:5-6) seen as Titus (AD 39-81) who sacked Jerusalem in AD 70; panel from the altarpiece of the Apocalypse, late 14th-15th century. From the workshop of Master Bertram of Hamburg, now in the Victoria and Albert Museum, London. PHOTORESOURCES

Following spread: Medieval knights with their standards.

ni' angelus i pelagius iemens ansann t a...
po tiisit t haus butens i de mi rupis p...

Herzog Cristof von Bayren

Herzog Friderich von Sachsen

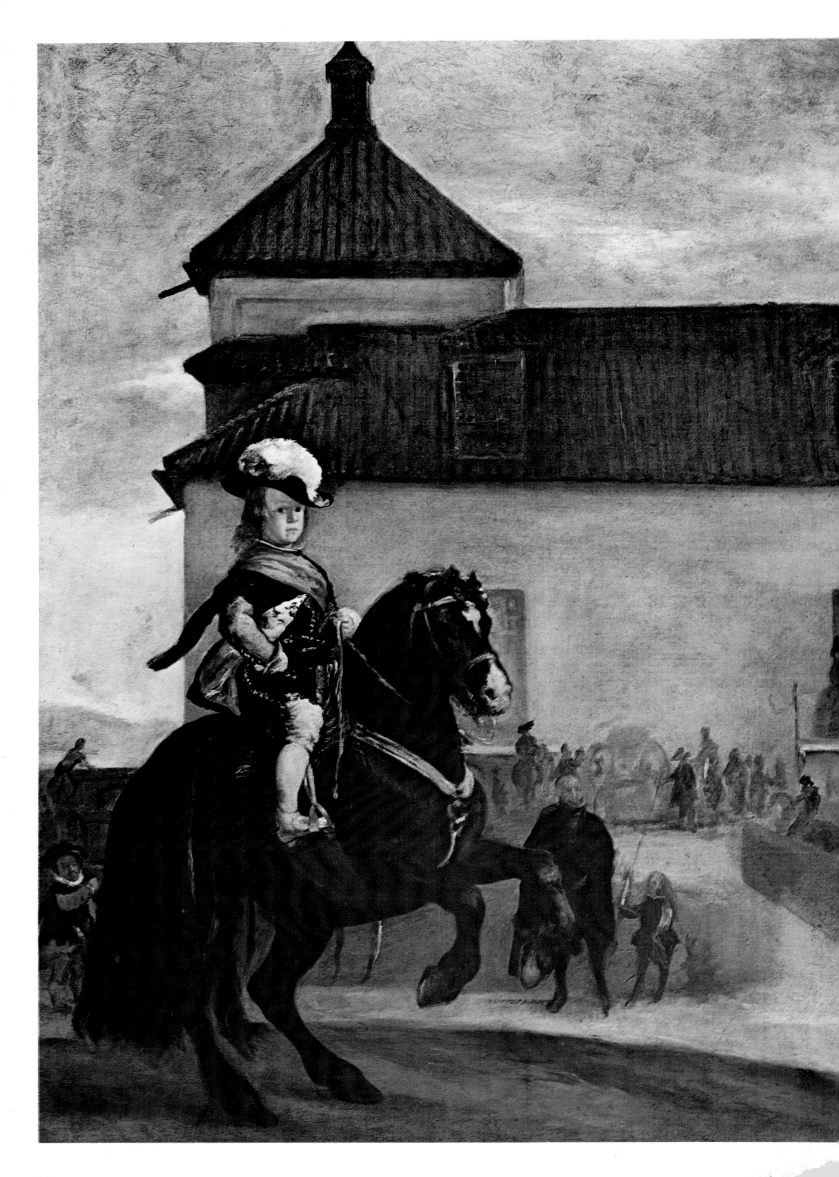

Velazquez

BRITAIN IS FORTUNATE in possessing a number of Velazquez's pictures. Fine examples of his work can be seen in the National Gallery, the Wellington Museum, the Wallace Collection and the Art Gallery at Dulwich, and in Glasgow. The greater number, however, are at the Prado in Madrid, where the magnificently regal portrait of Philip IV on horseback is hung.

Diego Rodriguez de Silva y Velazquez, who was born in Seville in 1599, painted it at the peak of his career in 1635. It formed part of a group of important works, specially designed to hang in the Buen Retiro Palace, which consisted of five pictures of the Royal family, mounted, and also his *chef d'oeuvre*, *The Surrender at Breda*.

It was natural that he should undertake this commission as he had painted the King on horseback some ten years before, and his work had received universal acclaim. But Velazquez is believed to have destroyed the picture because his drawing of the horse had been criticised.

This canvas is naturalistic in that there are no attendant cupids in the sky or floating draperies, but there is still a baroque love of display. The King appears to be wearing some sort of exotic 'Ascot bonnet', and the pink sash of an Order over his armour – and silk stockings – and he grasps a Field Marshal's baton. The resplendent

majesty of golden bridle and accoutrements is rendered with loving care.

The stance of the horse is curious, although reminiscent of Rubens's picture of Prince Ferdinand of Austria. It is presumably a High School movement, as the King is said to have been a first-class horseman, and yet it is neither a *levade*, where the rump would be lower down on the hocks and the fore-legs tucked under the belly, nor a *pesade*, which renders the animal more upright preparatory to a *capriole*.

Such a movement in actuality would be almost impossible to perform without the rider maintaining a much firmer contact with the horse's mouth on a tightened rein. Here the reins are shown lying slack on the horse's neck, as in so many such pictures, and one can only suppose it is meant to convey a negligent, aristocratic mastery of horsemanship.

The painter repositioned the hind legs, as can be seen by the dim outlines of the legs and feet which were overpainted and have now reappeared after a lapse of time.

The diagonal of the horse's body set against an opposite diagonal of the hillside beyond gives it a dynamic quality, enhanced by the beautiful stretch of country leading the eye towards the Guadarrama mountains in the distance.

The horse is not a big animal – or indeed a particularly handsome one; he is not a Lipizzaner but might be a Neapolitan or Andalusian. Whether the magnificent black mane, rippling down past his shoulder and extending below the rider's stirrups, is poetic licence we have no way of knowing. At all events, it was considered lifelike enough to be

taken as the model for the statue by Pietro Tacca that stands outside the Royal Palace.

The King, who loved and admired Velazquez as he did few others in his gloomy entourage at the Escorial, sat for him three hours at a time, which suggests that the tints in the pale, anxious features of the sovereign come from the studio, while the rest of the large canvas, some nine feet high by ten feet wide, has the open air light of an overcast sky.

The painter was exceptionally favoured by Philip, who gave him a studio in the palace – to which the King had a key so that he could go and watch him at work whenever he fancied. This favour, while giving Velazquez unique opportunities of studying the ruling members of an Empire in decline, meant that he was taken up with so many duties at Court that his time for painting was severely curtailed.

There were no more equestrian pictures to come from his brush and later in life he turned his attention to strange but haunting evocations of the Court dwarfs – some of his most mysterious and powerful works. And yet, after his death in 1660, Velazquez suffered a long period of neglect, partly because France became the dominant power in Europe and Madrid was a long way away.

By the turn of the twentieth century, however, he was once again recognised as a unique genius, Manet and the Impressionists having led the way in appreciation. This appreciation was singularly lacking in the half-demented suffragette who slashed the National Gallery's *Rokeby Venus* in seven places. This, Velazquez's only known nude, was saved for posterity by brilliant work of restoration.

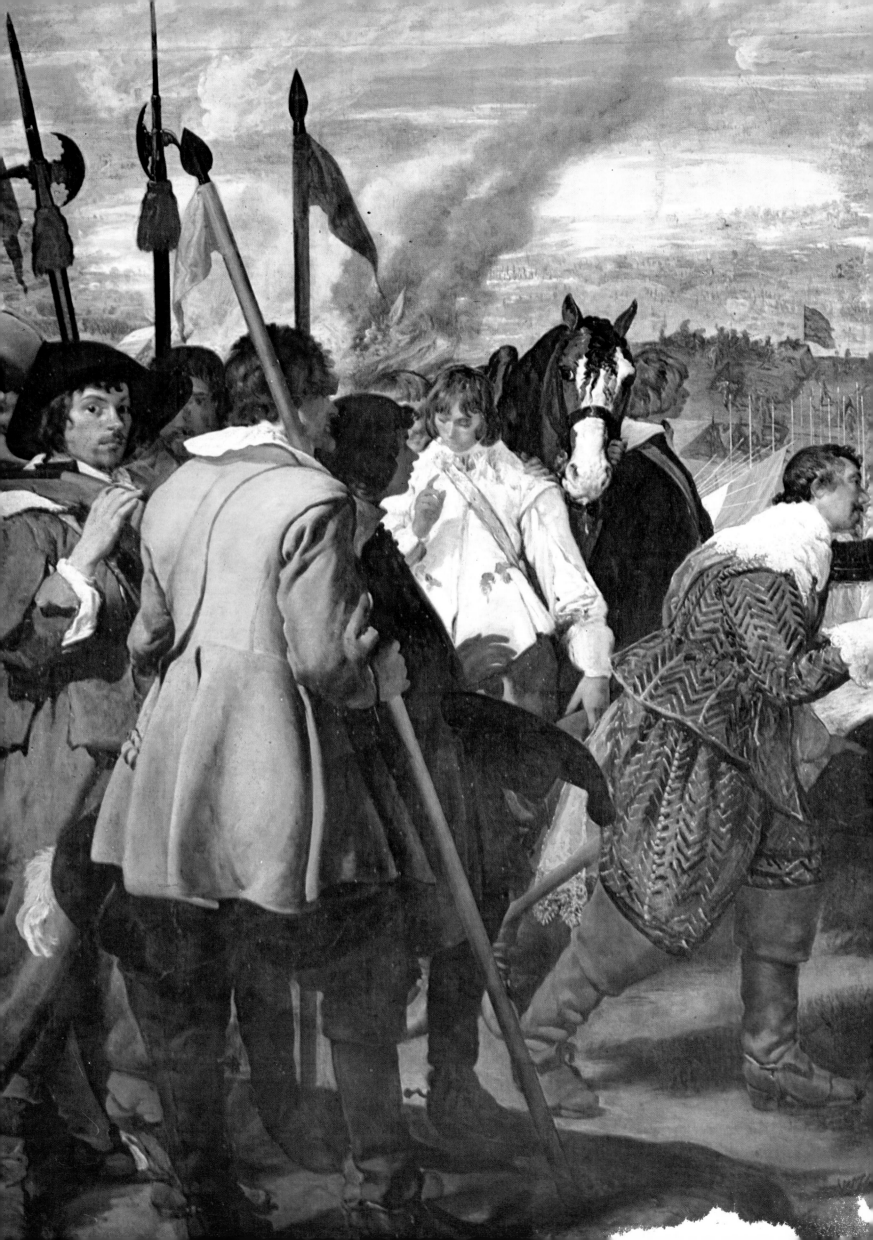

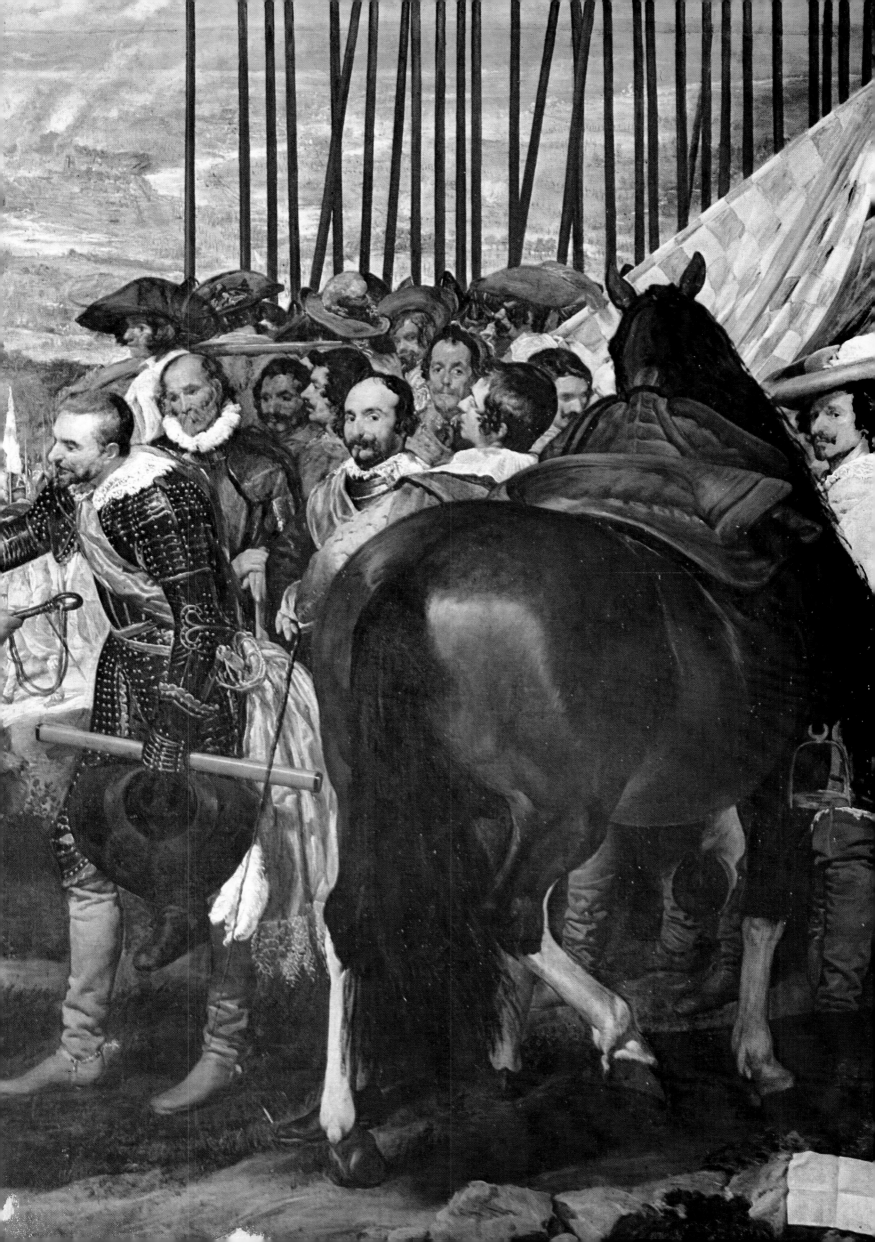

George Stubbs

FOR AN ARTIST who today has such a strong hold on the public imagination, it seems strange that after his death, in 1806, Stubbs and his art should have passed into obscurity. Yet he was ignored by the critics of the nineteenth century and only in the last twenty-five years has been slowly rediscovered.

Even now, his pictures that are on view in public collections are by no means a full representation of his genius, and what evidence remains of his life and character must be gleaned from his surviving work: for he attracted no contemporary biographer. The brief recollections of the artist's conversation set down by the painter Ozias Humphry well after the event, and the correspondence between the potter Josiah Wedgwood and his partner Bentley, when Stubbs was experimenting with enamel colours and ceramic plaques, make up the meagre documentary records. Thus any portrait of the man, and his reaction to contemporary events and the course of his career, must be speculation.

However, his work tells us a great deal about his character which was both straightforward and determined. His integrity and singlemindedness were matched by physical strength and an independence of spirit which he never lost. Although he should not be regarded as a rebellious outsider, he set a course of his own choosing, from which he never strayed despite the temptations of influential opinion or taste.

He was born in Liverpool in 1724, the son of a well-established leather dresser, and apprenticed at fifteen to an undistinguished artist, Hamlet Winstanley, then employed at Knowsley Hall as a copyist, where the boy remained for only a few weeks. It can be assumed therefore that he was self-taught.

After practising as a portrait painter in the north, at the age of twenty-six he went to York where an interest in anatomy, which he taught privately to medical students, encouraged John Burton to commission his illustrations for the *Essay towards a Complete System of Midwifery* (1751), for which Stubbs learnt the technique of etching.

In 1754 he travelled to Rome, probably under the auspices of Lady Nelthorpe of Scawby, Lincolnshire. Both Richard Wilson and Joshua Reynolds were then working in the Italian capital. After his return, and a further period in Liverpool, he began, about 1758, his studies for *The Anatomy of a Horse*.

In order to escape the hostile attention that his dissection had aroused in York, he chose the remote village of Horkstow, near the south shore of the Humber, for the preliminary researches for this book. In this lonely and daunting enterprise he was assisted only by Mary Spencer, his devoted companion until his death and supposedly his common-law wife and the mother of his son, George Townley Stubbs. The carcasses were hoisted into life-like postures by a tackle of his own design, anatomised and drawn with painstaking clarity. Armed with the results, he set off for London in 1759 in the hope of finding an engraver willing to produce the plates for his book. In this he failed, but straightaway established an artistic practice from a studio at 24 Somerset Street where he resided for the next forty-six years.

Stubbs could not have chosen a more auspicious moment to arrive in the city. For an artist with his ability and inclinations, the sporting world and its patrons were to offer him enormous opportunities. Racing and hunting were developing rapidly – the Jockey Club had been formed in 1750 – and they attracted a wealthy and aristocratic patronage, who were impressed by an artist who offered them a new style of animal portraiture that was so realistic and refreshing after the sporting artists of the first half of the century. For the next ten years Stubbs was to progress from one encouraging patron to another: painting family groups, their horses and dogs, their servants and above all their life.

This was the time when the economic and social advantages of landowning, and the creative satisfaction of country-house building and collecting, were all at their height. In the previous two centuries the portrait had provided evidence of rank and ambition, but now this honour could be provided with a far wider range of subject, and Stubbs in the 1760s was to be the most talented interpreter of this new taste for rural life. To this period belong such paintings as *The Grosvenor Hunt*, *A Colt and Two Chestnut Horses*, *Gnawpost and Two Other Bay Horses*, *Colonel Pocklington and his Sisters*, *Gimcrack on Newmarket Heath*, *Racehorses Exercising at Goodwood*, the series of *Mares and Foals*, *Huntsmen Setting out from Southill*, *The Melbourne-Milbanke Group* and *Sir John Nelthorpe out Shooting with Two Pointers*.

By 1766, when he published his enormous work *The Anatomy of a Horse,* George Stubbs had already attracted a number of rich and

Above right: 'Dungannon', 1793.
LORD IRWIN

Right: 'Sweetbriar', 1779. LORD IRWIN

Following spread: 'A Colt and Two Chestnut Horses' by George Stubbs.
WALKER ART GALLERY, LIVERPOOL

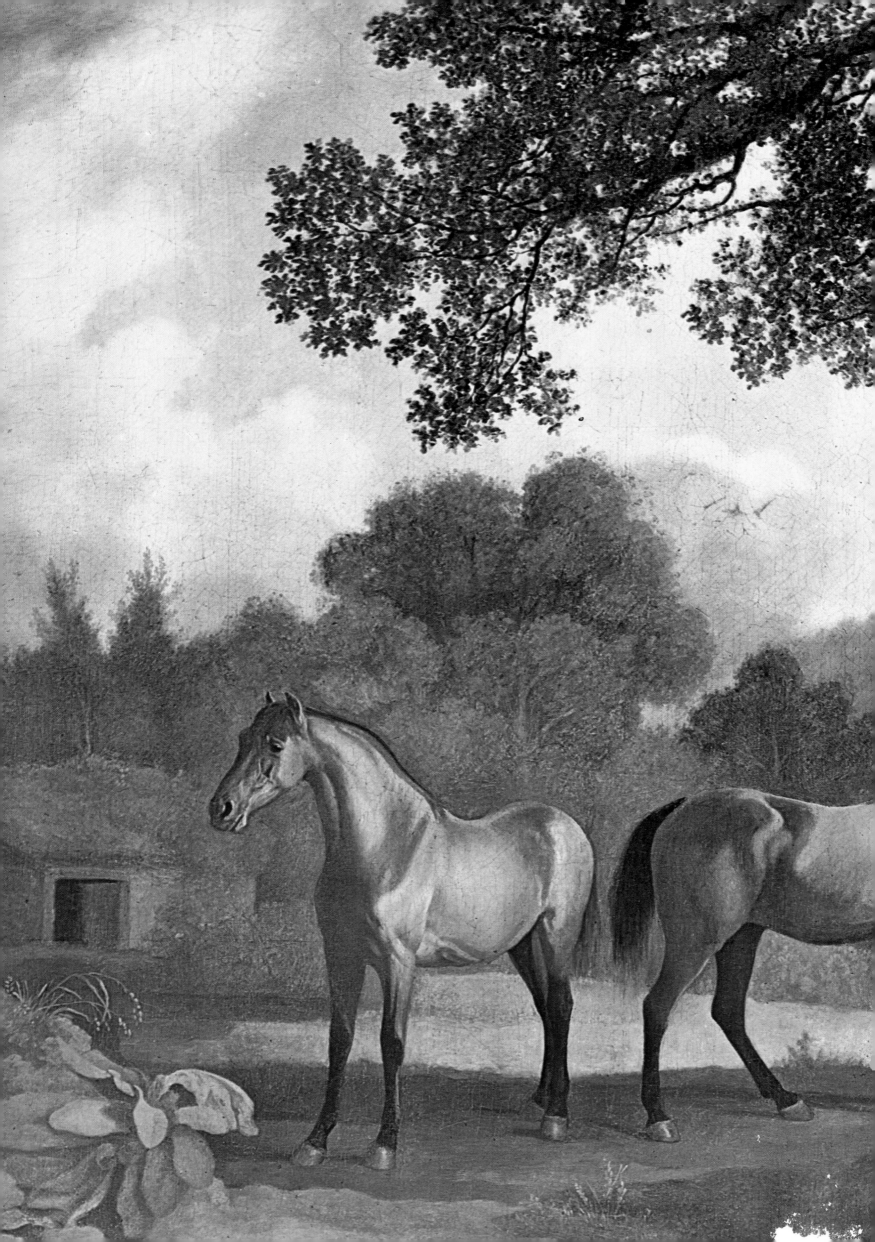

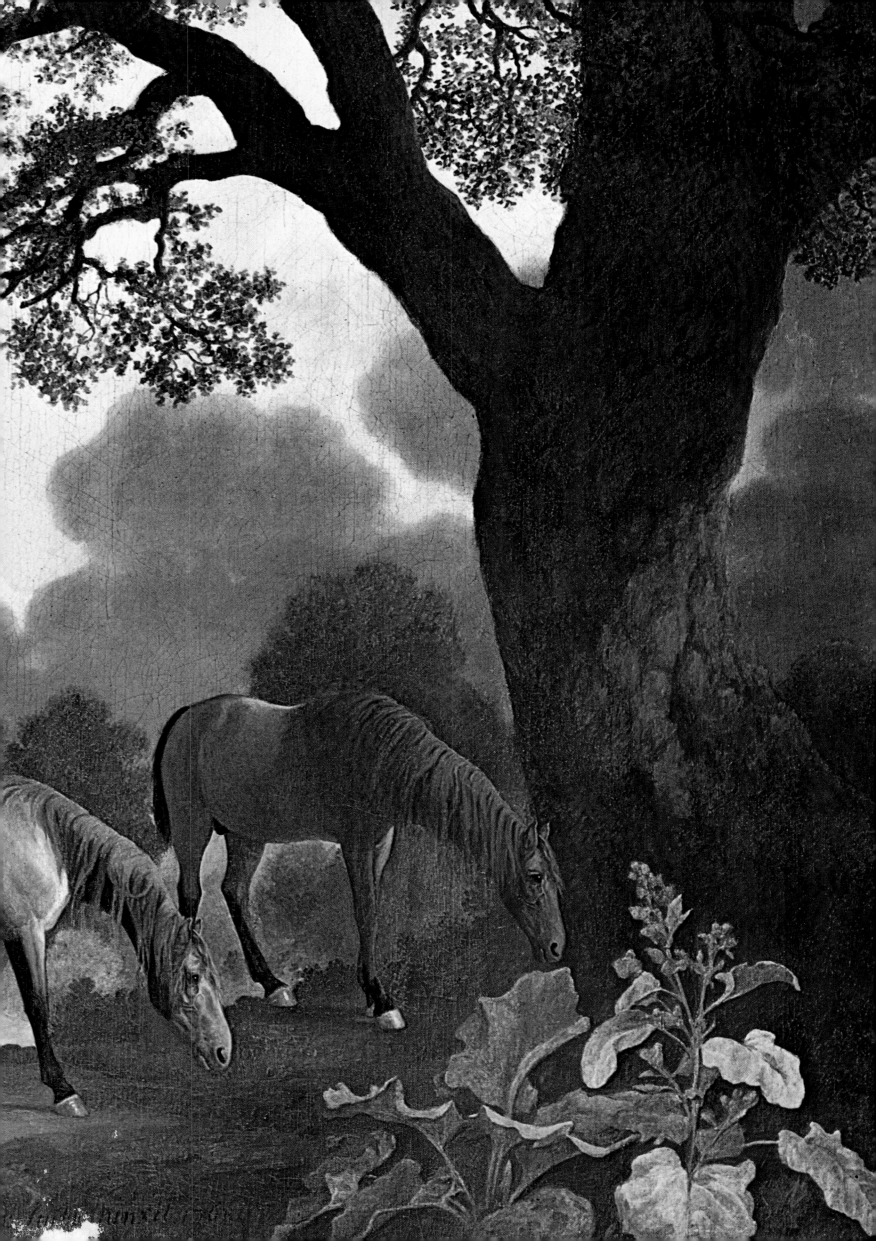

powerful patrons such as the Duke of Richmond, the Earl of Grosvenor and the Marquis of Rockingham. He began exhibiting in London at the Society of Artists in 1761. By the time that he painted *A Colt and Two Chestnut Horses,* his repertoire was not confined to portraits of favourite racehorses and hunters, but extended to romantic confrontations of lions and horses, and to sporting conversation pieces.

A Colt and Two Chestnut Horses is of the same size and of very similar composition to *Gnawpost and Two Other Bay Horses,* a work painted for the third Earl of Macclesfield. The head of the colt on the right is in a slightly different position. A replica of Lord Macclesfield's picture was Lot 93 on the first day of the artist's sale in 1807. That picture was one of those commissioned for *The Turf Review* in 1790 and was exhibited in 1794 as No 15 in the Turf Gallery. But the horses in Lord Macclesfield's picture are described as bays, whereas the Walker Art Gallery's quite definitely represents chestnuts. If the date, 1768, on the Walker picture is correct, the colt, which must be between two and four years old, cannot be *Gnawpost,* which was only foaled in 1767. But it is not unusual for Stubbs to re-use a compositional motif that he had previously employed in a different context.

In the 1760s Stubbs painted a series of pictures of horses and mares grazing in idyllic peaceful landscapes. In *A Colt and Two Chestnut Horses,* as in most of his works, he simplifies the forms in the background, although the lake and the moss-covered hut with the open door may well be part of the estate to which the horses belonged. He employs wide expanses of

Right: The 3rd Duke and Duchess of Richmond, and Lady Louisa Lennox, wearing the blue and gold livery of the Charlton Hunt, watching racehorses exercising. Grooms and stable-boys wear the yellow and scarlet livery of the Duke of Richmond. Painted by George Stubbs, 1759-60.

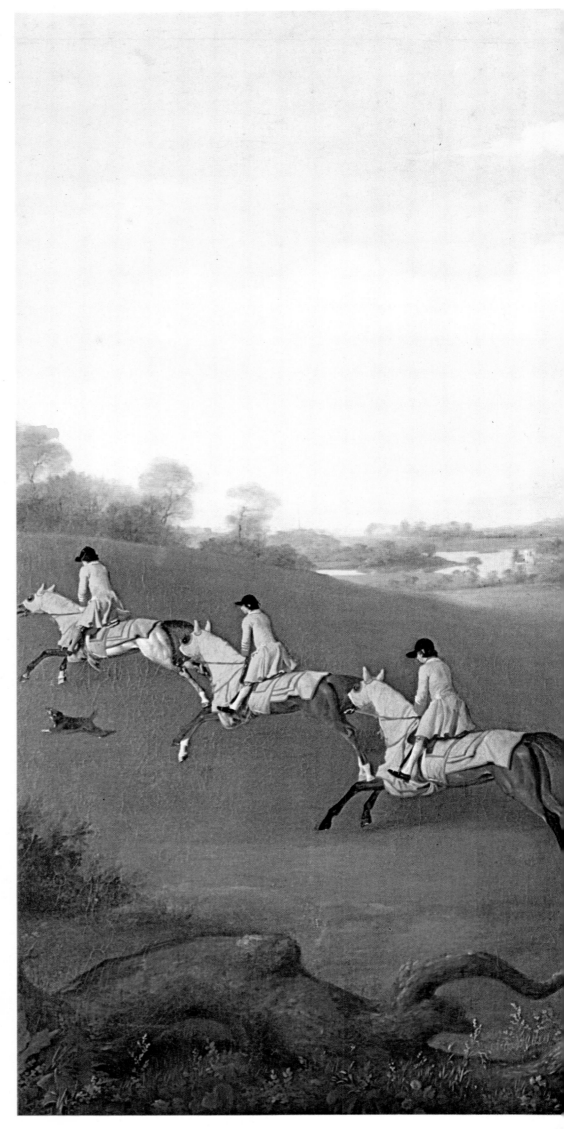

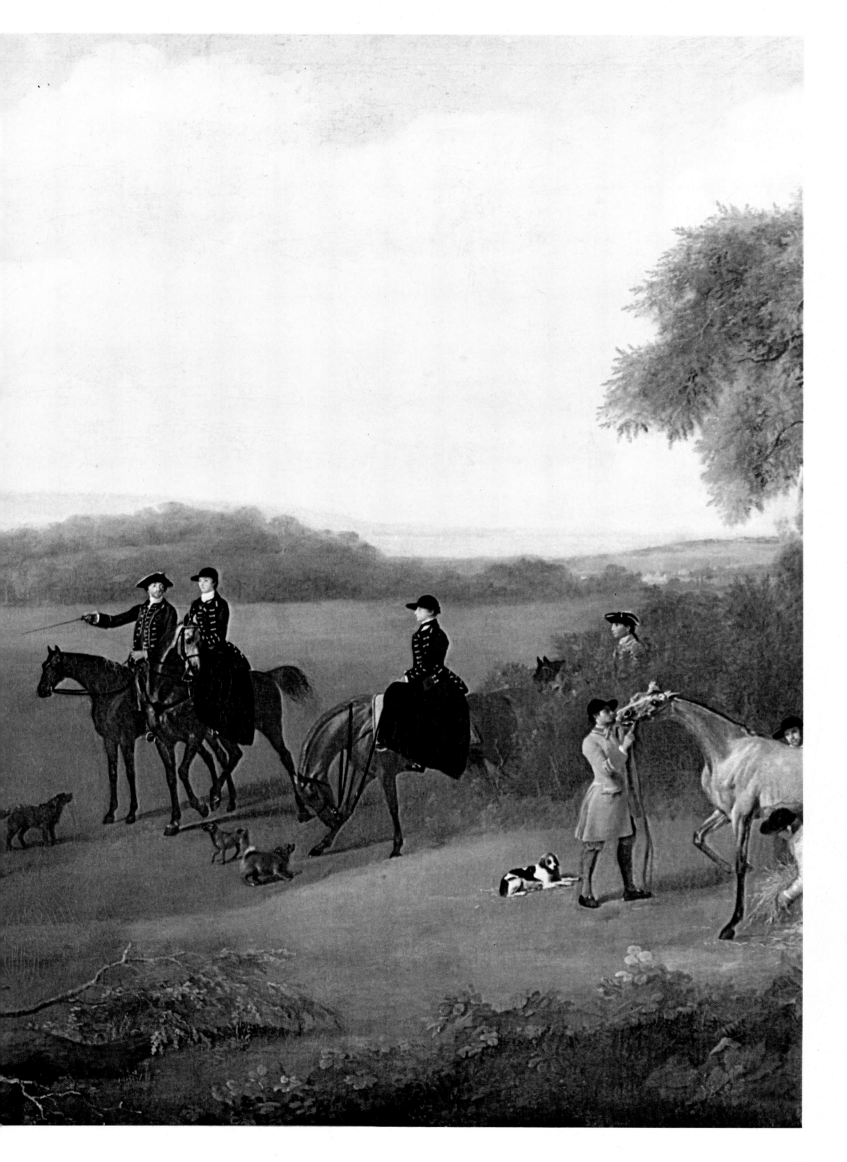

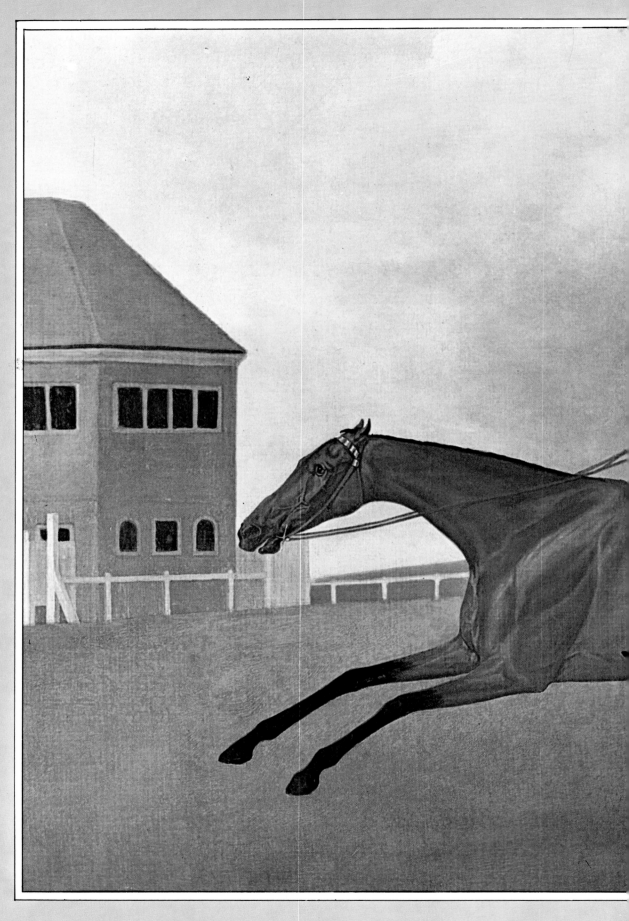

'Baronet' ridden by
Sam Chiffney Snr in the
royal colours.
Painting by George Stubbs.
LORD IRWIN

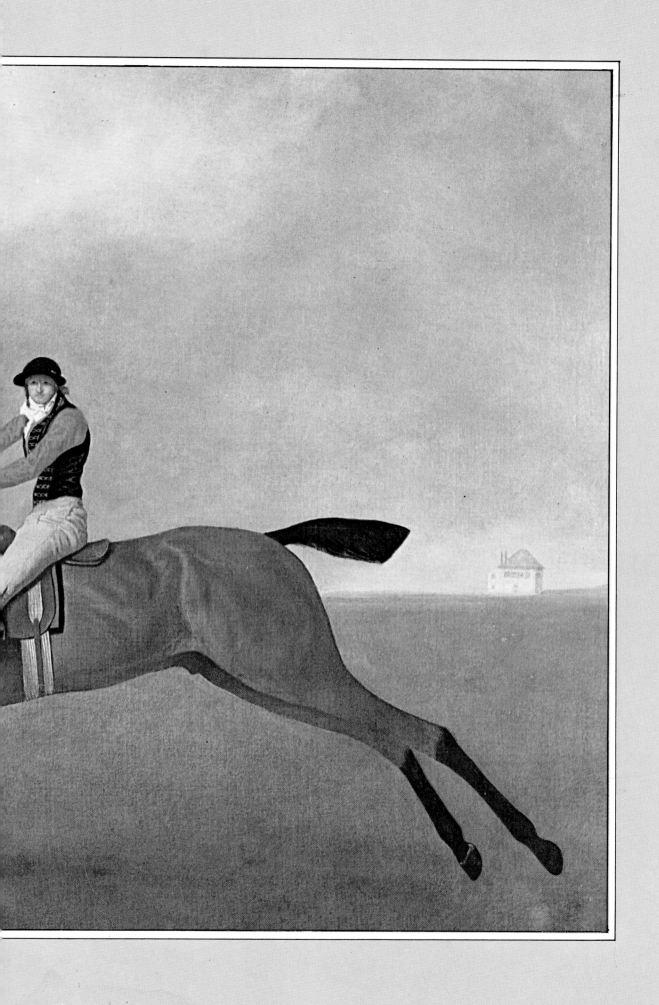

generalised trees and sky so as not to distract attention from the more detailed lines and bolder colours of the horses.

A deep contrast is drawn between the dark grey, towering clouds of a threatening storm and the gentler mood of the three animals grazing unconcerned. Three very definite individuals are framed in varied poses by the trunk and gently curving arms of the giant oak, whilst broad-leafed burdock, a reminder of Stubbs's acute observation of the simple things of life, creates depth. Details such as the shaggy mane falling like bedraggled seaweed from the neck of the colt are striking examples of the way in which Stubbs's scientific accuracy does not clash with his very personal insight and sympathy. Paintings like this rise above those of his contemporaries in their characterisation and reality as well as in their mastery of composition and delicacy of colour.

For some time efforts had been made to create a national school of painting, where artists could exhibit their work publicly and receive constructive criticism. In 1769 the new Academy of Arts was created and immediately Stubbs was to benefit by showing himself to be the animal painter without peer: Sawrey Gilpin (1733-1807) was his only possible rival, and he, like Marshall and Ferneley later, was greatly influenced by his work.

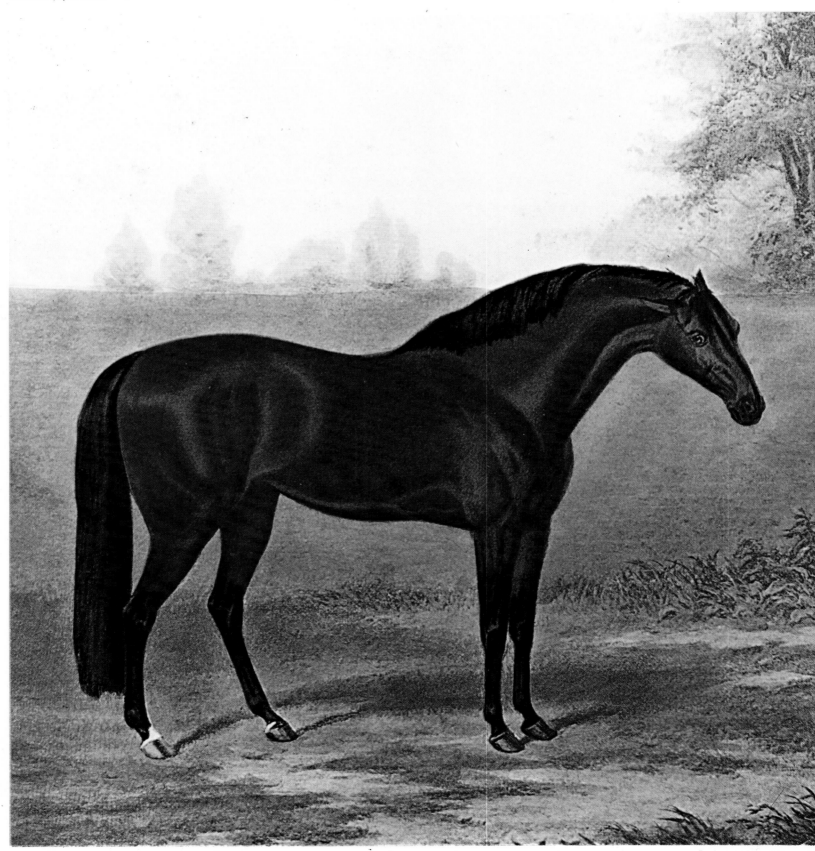

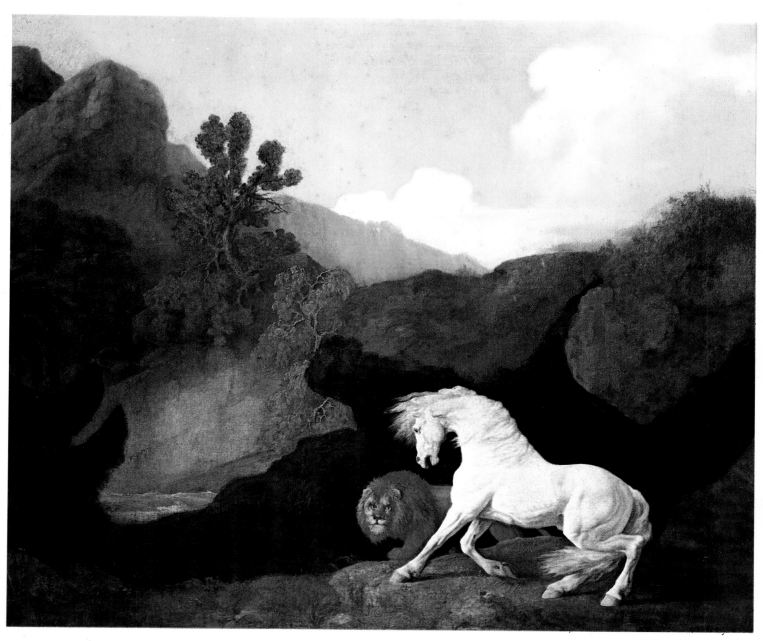

Left: 'The Godolphin Barb'.
FORES LIMITED, LONDON

**Above: 'Horse Frightened by a Lion',
an incident witnessed by Stubbs during
a visit to north Africa.**
WALKER ART GALLERY, LIVERPOOL

During the 1760s his remarkable gifts were given every chance to excel and his output included the etching and publication of the elaborate plates for *The Anatomy of a Horse*, work in oils on canvases of every scale, and experiments with enamel colours to which he was to give his full attention later.

The demands of his rich and influential patrons required him to travel extensively, and they were not to be disappointed. Their paintings fall into two categories: the portraits of horses and dogs, and hunting and racing scenes which were characteristic of the earlier group of sporting artists – Tillemans, Wootton and Seymour. It is not difficult to imagine the impact that his fresh treatment must have brought to these familiar subjects. His predecessors were made to look crude and primitive, for he was able to create a realism that was both immediate and timeless. His other works of this period were the unprecedented subjects of brood mares and foals, painted as a series of symphonic proportions, the wild animals and the various shooting pictures.

Although his style appeared plain beside the fussiness of Wootton and Seymour, Stubbs gave his paintings an individuality and mood of their own. He was above all an intellectual artist for whom every work was a combination of subtle unobtrusive devices. The type of landscape, the colouring, the light and weather conditions, the attitude and movements of his figures and animals were all part of a disciplined and complex whole, which was stage-managed to create the effect he wanted. His paintings are wholly without sentiment, unlike those of his contemporaries Wheatley and Morland, for his men and women are individuals in their own right. His world of animals, noblemen, jockeys, stable-boys, labourers, coachmen and servants is totally convincing and alive, for each attitude or posture has been closely observed and subtly represented.

By 1780 the newly created Academy of Arts under the wilful guidance of Joshua Reynolds was asserting considerable artistic authority over taste and patronage. Stubbs was eager to change his practice as an animal artist and prove his worth and suitability as a history and portrait painter. This was to cause his early generous employers to desert him. In 1780

he was admitted as an Associate of the Academy, but although he was elected Academician the following year he did not submit the customary diploma work and the election was not confirmed. He further exacerbated the situation by complaining of the lack of prominence that his enamel exhibits were given in the annual show. His place was soon taken by another artist, and he was forced to abandon his new ambitions.

The decline in popularity coincided with his renewed experiments with ceramics and enamel colours with the encouragement and support of the potter Josiah Wedgwood. He applied himself to this project until 1795 with the same vigour that he gave to his anatomical studies, almost to the exclusion of all else. However, the paintings that did appear on ceramic plaques, panels and canvas showed a return to the common subjects of the 1770s and the farming and haymaking subjects have a tender and intimate appeal.

Stubbs was now in his sixties, and although he had lost none of his genius, lack of patronage and financial resources obliged him to return to engraving and his technical skill with the mezzotint rocker produced prints of single foxhounds of exceptional beauty and refinement.

The 1790s brought little encouragement. He was commissioned by the publisher of the *Turf Review* to paint a series of portraits depicting famous racehorses, to be exhibited and reproduced in mezzotint by his son George Townley Stubbs. This enterprise was dedicated to the Prince of Wales, for whom Stubbs was then working on a group of subjects representing the Prince himself, members of his household, his friends, some of his horses and dogs, deer in Windsor Park, and soldiers of his own regiment, the 10th Light Dragoons.

Although the *Turf Review* scheme failed to fulfil the publishers' hopes, and Stubbs completed only sixteen pictures, which remained unsold at his death, these and the paintings in the Royal Collection showed he had lost none of his fire. These few years of patronage were short-lived, however, and the scarcity of paintings dated after 1794 showed that he passed his last years in straitened financial circumstances.

In 1795 he began the most ambitious project of his life, his comparative study of the anatomy of a man, a tiger and a chicken. It is indicative of his independent nature that he knew that this would bring him no financial reward or suitable acclaim in artistic circles. His death in 1806 prevented the work's completion, but from this lonely and private enterprise he was able to issue fifteen plates: their strength and beauty are a fitting epitaph to the man's genius and ceaseless curiosity.

On the morning of 10 July 1806, after working on the *Comparative Anatomy*, he sat in his chair and, declaring that he was going to die, soon did so in the same straightforward way that he seems to have lived.

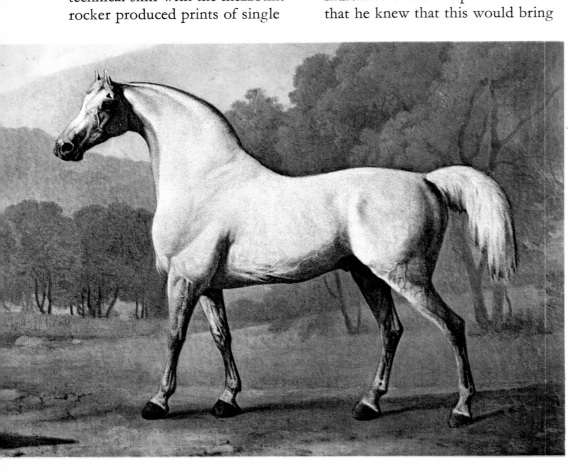

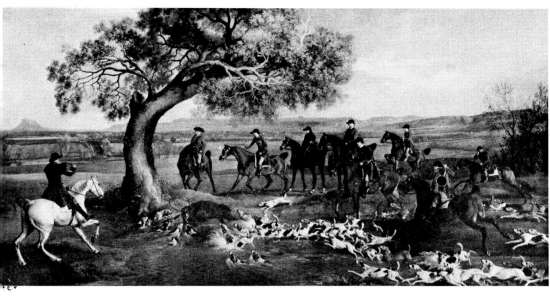

Far left: 'Mambrino', 1779.
TRUSTEES OF THE GROSVENOR ESTATE

Left: The Grosvenor Hunt, 1763.
TRUSTEES OF THE GROSVENOR ESTATE

Below: 'Molly Longlegs'.
WALKER ART GALLERY, LIVERPOOL

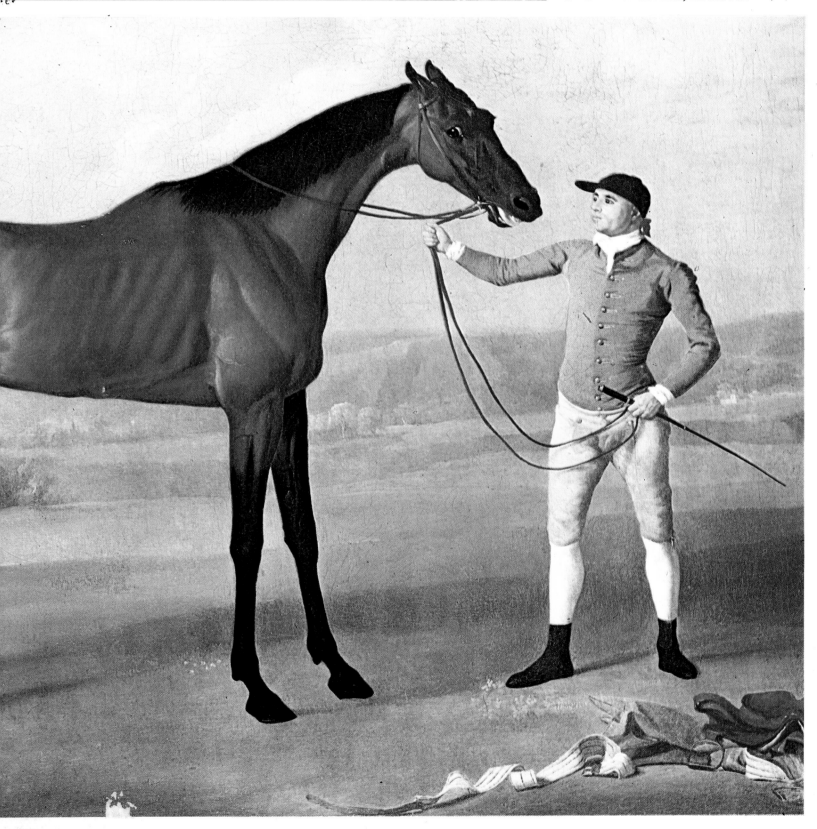

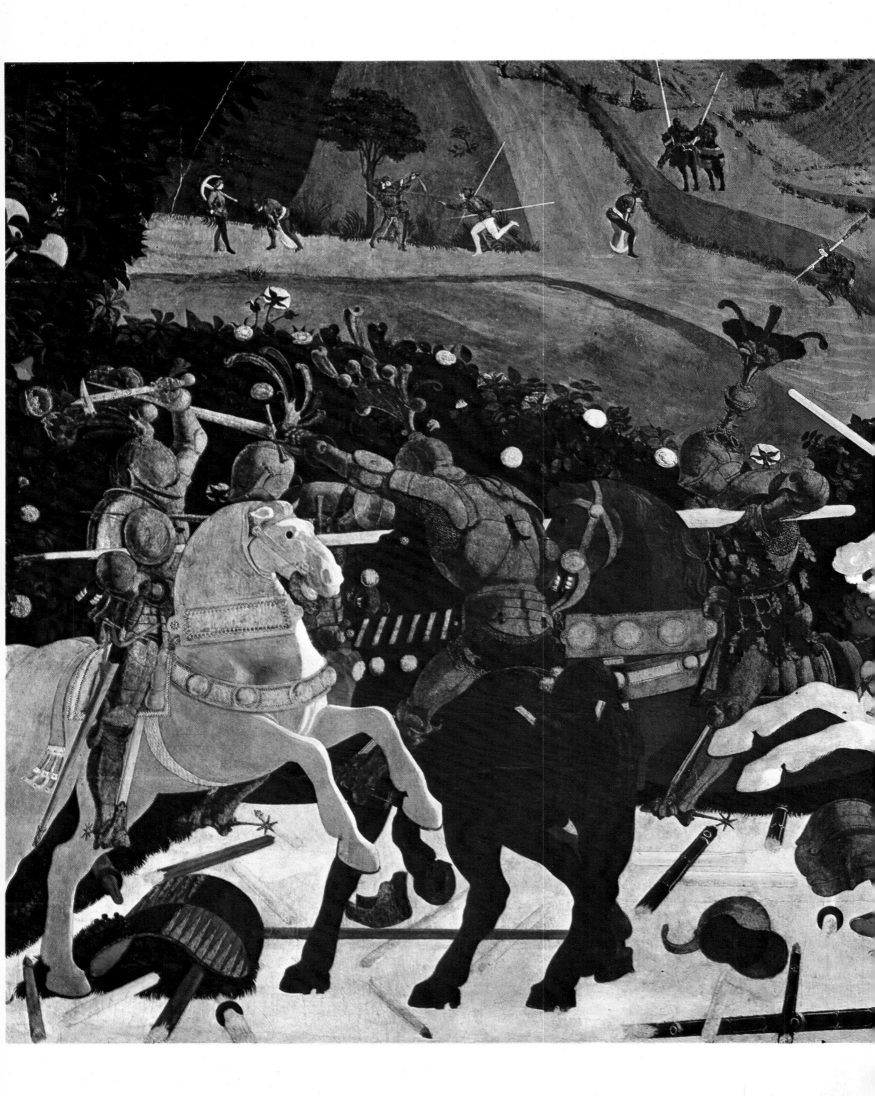

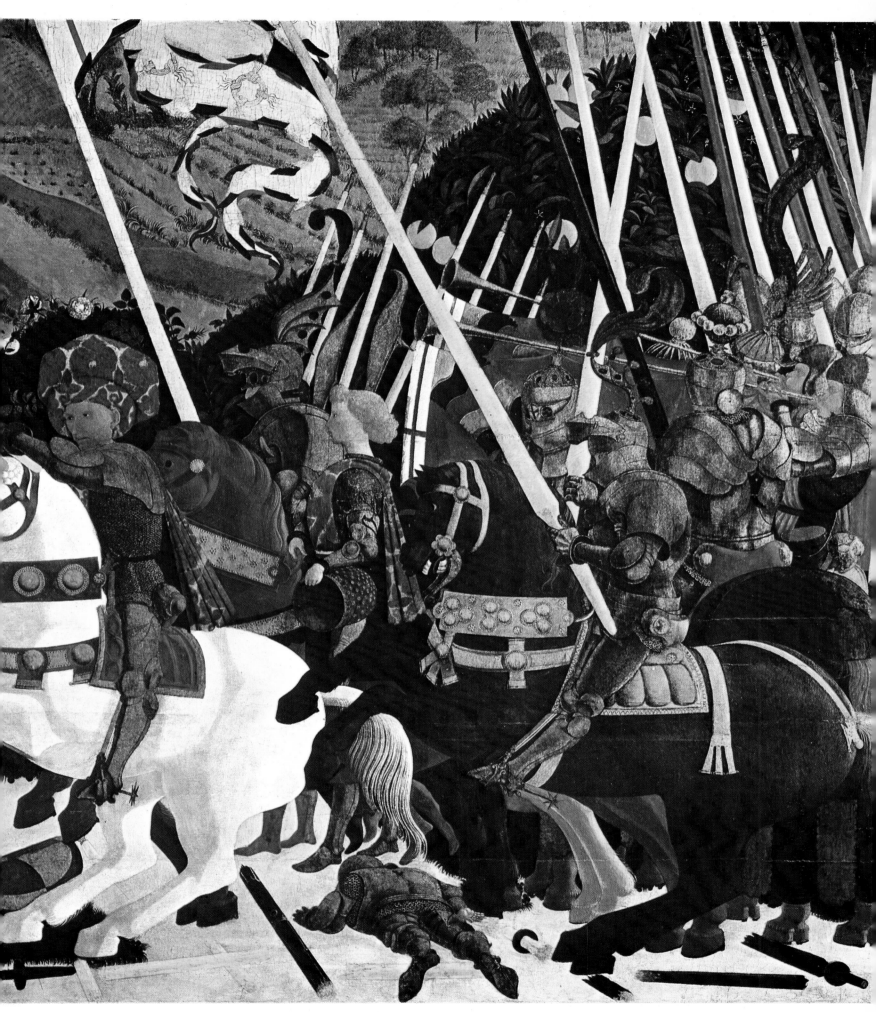

'The Battle of San Romano', by Uccello.
NATIONAL GALLERY, LONDON

George Morland

GEORGE MORLAND'S father lived in London where he successfully carried on a business as an artist, engraver, dealer and picture restorer. He also sold artists' materials. George, his eldest son, was born on 26 June 1763 and was christened in St James's Church, Piccadilly.

As a child of three George Morland showed such aptitude for drawing that his father, recognising his talent, gave him crayons and paints. As a ten-year-old he exhibited at the Royal Academy, and four years later was apprenticed to his father for seven years.

The apprenticeship was unhappy, for his father proved a cruel taskmaster: he compelled the boy to work unnecessarily long hours and sold his paintings without rewarding him for his efforts. George was forced to copy the works of the Dutch and Flemish Masters which his father unscrupulously attempted on several occasions to pass off to unsuspecting clients as genuine.

Rumour claims that young Morland's only way of defeating his father was to lower his drawings on the end of a rope from the garret in which he worked to a friend waiting in the street below. The friend would sell the drawings and he and George would then proceed to dissipate the money on riotous living.

In 1783 Morland received a generous offer from the great English painter George Romney, who suggested that he should sign articles of apprenticeship for three years and receive £300 per annum. Morland, disenchanted with serving under his father, refused the offer. Two years later he set up house on his own.

For the rest of his life his career was a tragic mixture of hard work in which he industriously painted literally thousands of pictures, and sheer debauchery surrounded by picture dealers, moneylenders, pawnbrokers, pugilists and jockeys. In 1786 he married the sister of his great friend William Ward, who was a renowned engraver. Ward married Morland's sister and the two families shared a house in Marylebone High Street for a time.

Often dressed in a green coat with large yellow buttons, leather breeches and top-boots, Morland would sketch, draw and paint local scenes before becoming almost paralytically drunk on the proceeds. During the latter years of his life he spent some time in Margate, went to France, and for a few months lived with the sporting artist Charles Loraine Smith in Leicestershire. Constantly on the move to avoid his creditors, he met every financial demand by painting yet another picture. Dealers, knowing the popularity of his work, would arrive with a purse in one hand and a bottle in the other. One of his finest paintings was *Inside the Stable*, painted when he lived opposite the White Lion in Paddington.

No artist has ever depicted the English rustic scene more accurately than George Morland. Life in the latter half of the eighteenth century is recorded for posterity in his paintings of stables and barns, blacksmiths, village hostelries and farms crowded with horses, pigs, dogs, chickens and cows.

Often he would work on a picture, only to have it claimed by a dealer in lieu of a debt before the paint was dry on the canvas. Not infrequently the dealer would take away an unfinished work which would be completed by another artist. Yet Morland, for all his debauchery, never degraded his

art. His talent was limitless and, as a friend wrote after his death:

> His magic touch could
> animation give
> and make each object on the
> canvas live.

He died at the age of forty-one

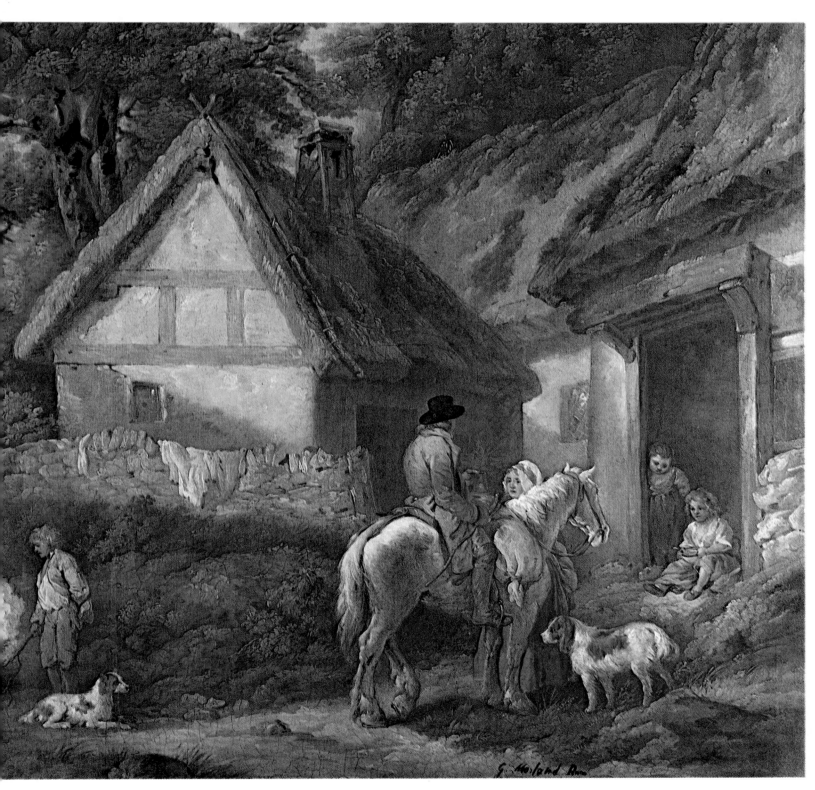

shortly after having been arrested for non-payment of a debt. For the last eight days of his life he was delirious and suffered from brain fever. He and his wife had often discussed death and had always said that should one of them die the other would speedily follow to the grave. Their forecast curiously proved correct, for his wife died four days later and they were buried side by side.

At the end of his life Morland was a pathetic figure of a man 'with bleared and bloodshot eyes, swelled legs, a palsied hand, and a tremulous voice; all bespeaking the ruin of what had once been the soundest of frames, containing the brightest of genius'. It was a genius however, that has remained until the present day.

Above: 'Door of a Village Inn'.
TATE GALLERY, LONDON

Overleaf: 'The Reckoning'.
VICTORIA AND ALBERT MUSEUM, LONDON

73

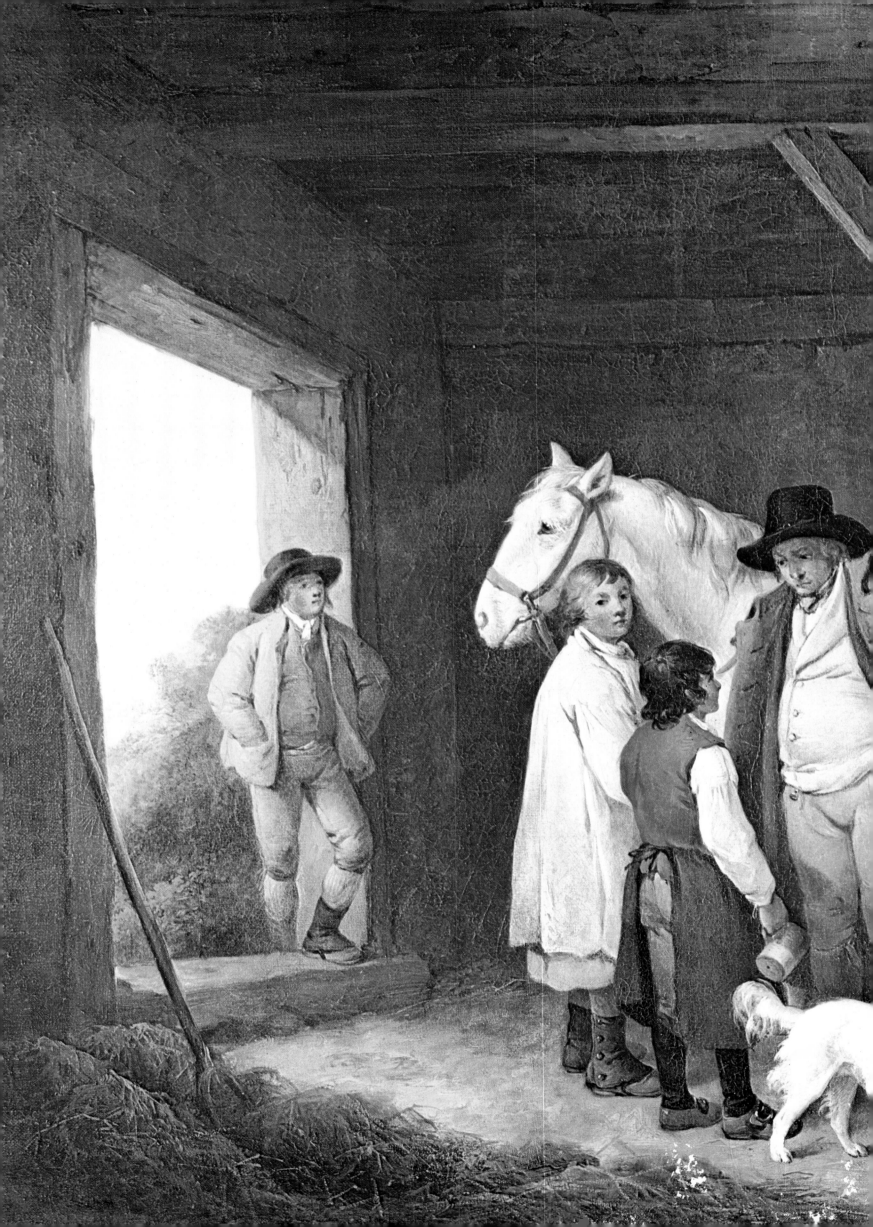

Eugène Delacroix

THE SPLENDID PICTURE, *Horses Emerging from the Sea,* was painted by Eugène Delacroix in 1860, only three years before his death at the age of sixty-five. It epitomises the romantic ideal of which the horse is so often the symbol.

The rider, intertwined in the rhythm of the curving necks of the two magnificent steeds rearing up out of the waves, echoes Delacroix's experiences in Morocco some thirty years before. The houses, too, on the distant shore, although apparently adapted from a view of Dieppe, have a Moorish look about them.

Delacroix despised the empty rhetorical gestures of romanticism with a capital 'R'. He was deeply versed in classical antiquity, and admired the restraint and moderation of Virgil and Homer.

The horse was a recurring image throughout his career. He produced at least eleven major works on this subject between 1822 and 1860. Greatly influenced in his youth by the pre-eminent equestrian painters, Baron Gros and his friend, Théodore Géricault, he wrote that it was 'absolutely imperative to study horses' – even to the extent of practically living in the stables from dawn till night.

He did some delightful water-colours of draught horses and Arabs, but the typical Delacroix horse is something different from either. He saw in them always the heroic, whether massed in battle array or involved in knightly combat, prancing on their strong hocks, manes and tails flying, their masters' sabres flashing in the sun. He could also render the pathos and horror of a wounded cuirassier lying between the bodies of two dead chargers. Even here, the daring colourist takes over from the humanitarian

and the essentially sad scene is enlivened with bold strokes of blue, red and yellow in the bodies of the animals. In another famous canvas, the horse is shown almost pink in colour.

Although he claimed – far in advance of his time – that 'painting does not always need a subject', this giant of the nineteenth century who detested 'realism' nevertheless ransacked the pages of history for dramatic subjects. 'We need to be very bold,' he wrote in his revealing Journal, 'without extreme audacity there is no beauty.' His *oeuvre* covers a wide variety of themes.

He was widely read in English literature and was inspired by the heroes and heroines of Shakespeare (Hamlet, Ophelia and Desdemona), Byron (the Giaour and the Pasha, Mazeppa), Walter Scott (Ivanhoe), and Robert Burns (Tam O'Shanter). The Greeks' war of liberation in 1822 and the Paris uprising in July 1830 provided him with contemporary historical motifs.

His religious works were numerous and in his great decorative schemes at the Louvre, the Palais Bourbon and elsewhere, the gods and goddesses of pagan times live again in an Elysian atmosphere of the Golden Age: the three horses pulling Apollo's chariot across the heavens are painted with incomparable bravura.

His visit to Morocco and Spain in the 1830s influenced him perhaps most of all and resulted in some of his best-known works. He made numerous sketches on the spot, and pictures of Algerian life were painted at intervals over the next thirty years, such was the impression made on him at the time. He well expressed the dignity of the sultans and kaids mounted on their fine horse , either surrounded by their loyal subjects

or traversing wild and barren deserts. The savagery of the lion hunt appeared, too, in several canvases that show horses suffering the onslaught of the wild beasts.

It is interesting to note, by the way, that he knew and admired the vigorous handling of James Ward's pictures and the impressionistic touch of Constable, and was an intimate of the precocious genius Thomas Parkes Bonington.

Latterly, in the picture he painted in 1859, now in the National Gallery, London, of *Ovid in Exile Amongst the Scythians,* we see a new *douceur* in the warm tones of the landscape, an unusual feature of which is the woman depicted milking a mare in the foreground. The underlying theme, with which Delacroix would have felt very much in sympathy, of the ingratitude of authority towards genius, is left implicit – his urge to overstatement being curbed by a more beatific vision of an idyllic existence.

His own life had been a strange mixture of public acclaim and acid criticism, but his long struggle against incomprehension and ill health was finally crowned with belated recognition in France. Since his death in 1863, he has been universally recognised as the true inheritor of the laurels of Michelangelo, Tintoretto and Veronese.

Above right: 'Ovid in Exile amongst the Scythians'.
NATIONAL GALLERY, LONDON

Right: 'The Moroccan Kaid'.
MUSEE DES BEAUX ARTS, NANTES.
PHOTOGRAPH: PHOTOGRAPHIE GIRAUDON

Following spread: 'Horses Emerging from the Sea'.
PHILLIPS COLLECTION, WASHINGTON DC.
PHOTOGRAPH: HAMLY N GROUP PICTURE
LIBRARY

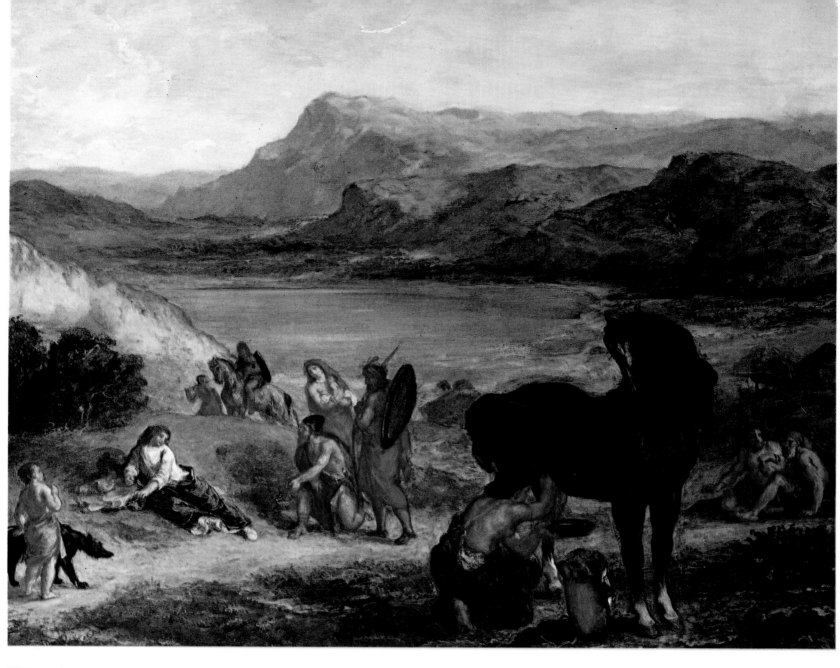

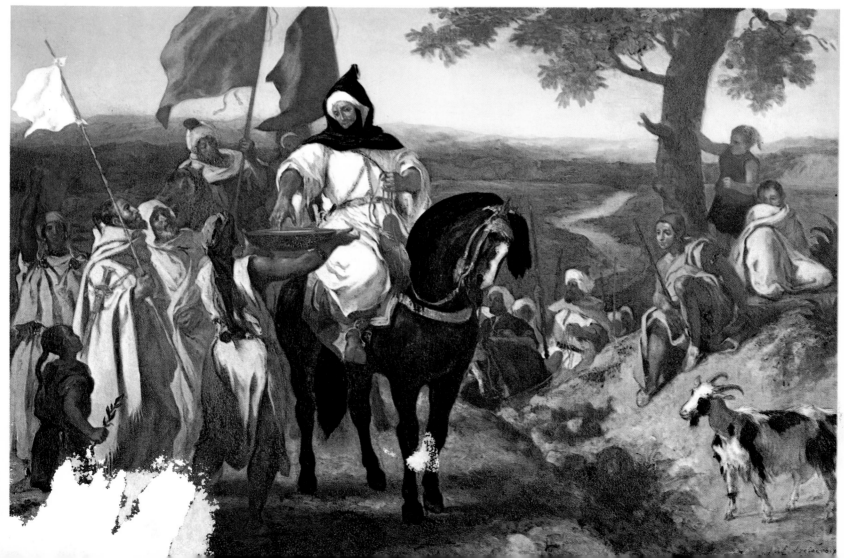

James Pollard

RACING ENGLAND in 1833 was beset by doped horses, dishonest trainers and jockeys susceptible to bribery and corruption, owners of dubious morality where their horses were concerned, and bookmakers whose information service from the training grounds of Newmarket, Epsom and Malton frequently gave them an advantage over the aristocrats who wagered against them. The age of a horse was often open to suspicion, and many considered that the 1833 Derby winner, *Dangerous,* was in reality a four-year-old.

In the painting by James Pollard, which was engraved by H. Pyall and first published in November 1833, *Dangerous* is seen to be winning by a length in Mr Sadler's colours of white, red sleeves, black cap. There had been several false starts before the starter signified 'go' and in the early stages of the race *Dangerous* was nearly last of the twenty-five runners.

Despite such accusations Derby Day was a festive occasion and a reporter in the *New Sporting Magazine* wrote:

There must be something exquisitely delightful in the word 'Derby'; at its sound all evils appear to vanish into thin air – all cares forgotten and all duties suspended. The harassed premier quits the toils of office, the members of both Houses vacate their seats, the rentless country gentlemen forget their arrears, the ruined merchants their embarrassments, the suffering shopkeepers the 'house and window tax', the needy gambler his misfortunes. Epsom! Epsom! is the universal cry, and all rush down to breathe the emb*racing* air . . .

Dangerous never ran again after his victory at Epsom. For a time he stood as a stallion at Cheltenham but in 1835 he was sold, exported to France and used as a Government sire. The painting of his Derby triumph eventually became a part of the Jack R. Dick collection and was sold at Sotheby's in June 1974. Sold at the same sale was Pollard's fine painting the *Finish of the 1833 Goodwood Cup*.

The *New Sporting Magazine* correspondent commented:

. . . Goodwood House, as usual, was filled with the high and titled turfites from all parts of the kingdom, while the course, particularly on Cup Day, was thronged with visitors of every rank and denomination . . .

Ante-post favourite for the Goodwood Cup was the renowned mare *Camarine*, but she broke down a few days before the race and was scratched. In her place *Beiram*, owned by the eccentric Lord Exeter, was installed as favourite, but he could only finish third to *Rubini*, ostensibly owned by Mr Kent who trained at Goodwood. In fact *Rubini* was owned by the Earl of Uxbridge, whilst the runner-up *Whale*, which ran in the colours of Mr Charles Greville, was the property of his cousin Lord George Bentinck. The reason for this charade was partly to allay parental suspicions that too much money was being squandered on the Turf by supposedly impoverished younger sons!

In the first two furlongs of the Goodwood Cup two of the lightweights made the running, but the bridle broke on one of them and the horse bolted, giving his unfortunate jockey a heavy fall. *Rubini* was not an outstanding horse, and his success was a financial set-back to Lord George

Bentinck who had supported *Whale* to win many thousands of pounds.

Lord Exeter, a small man invariably dressed in black, maintained a string of racehorses at Newmarket where he lived Foley House

From his training establishment at Exeter House to Foley House there was a long covered ride in which his horses were exercised in wet and frosty weather. This had two ⬚⬚⬚⬚⬚ for it kept his horses ⬚⬚⬚⬚⬚ were unable to work their horses on the Heath, and prevented the touts from watching their progress.

Above: 'The Race for the Derby Stakes, 1833', painted by James Pollard and engraved by H. Pyall.

Overleaf: 'The Finish of the Goodwood Cup, 1833', by James Pollard, engraved by H. Pyall.

Following spread: 'The Arrival', by James Pollard.

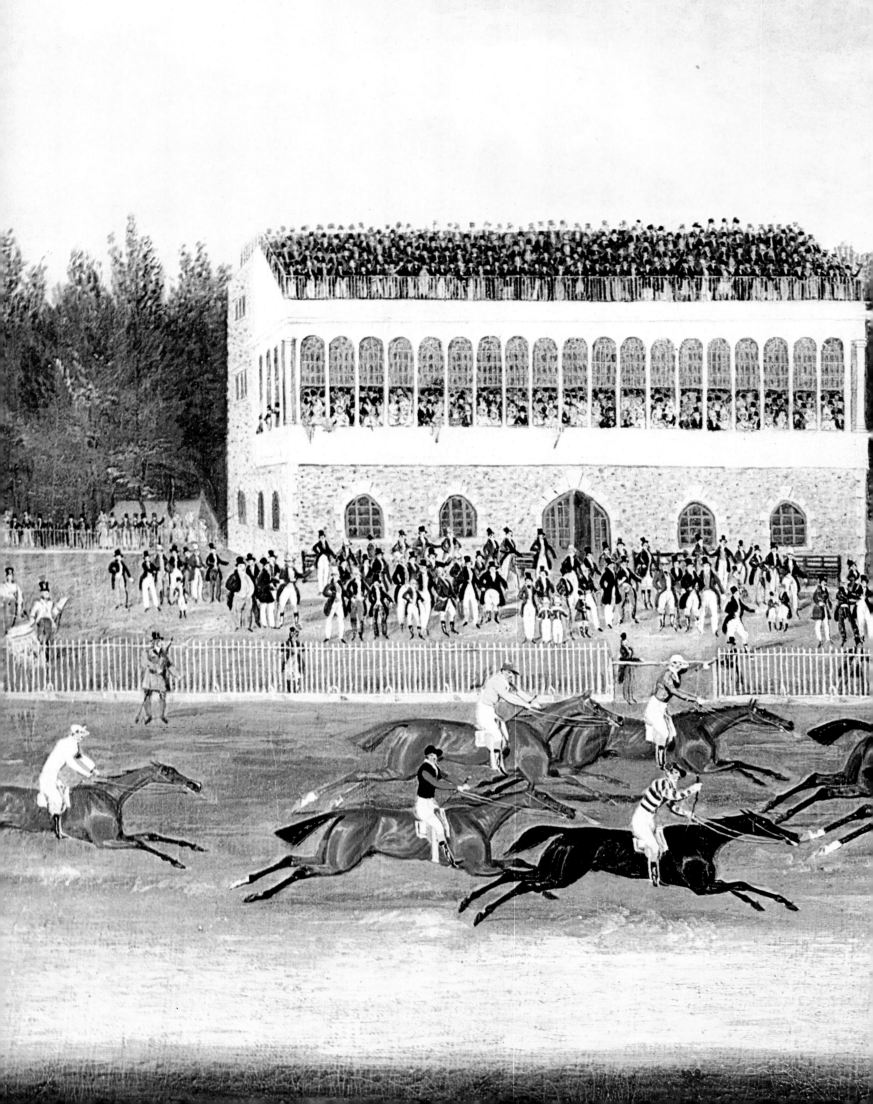

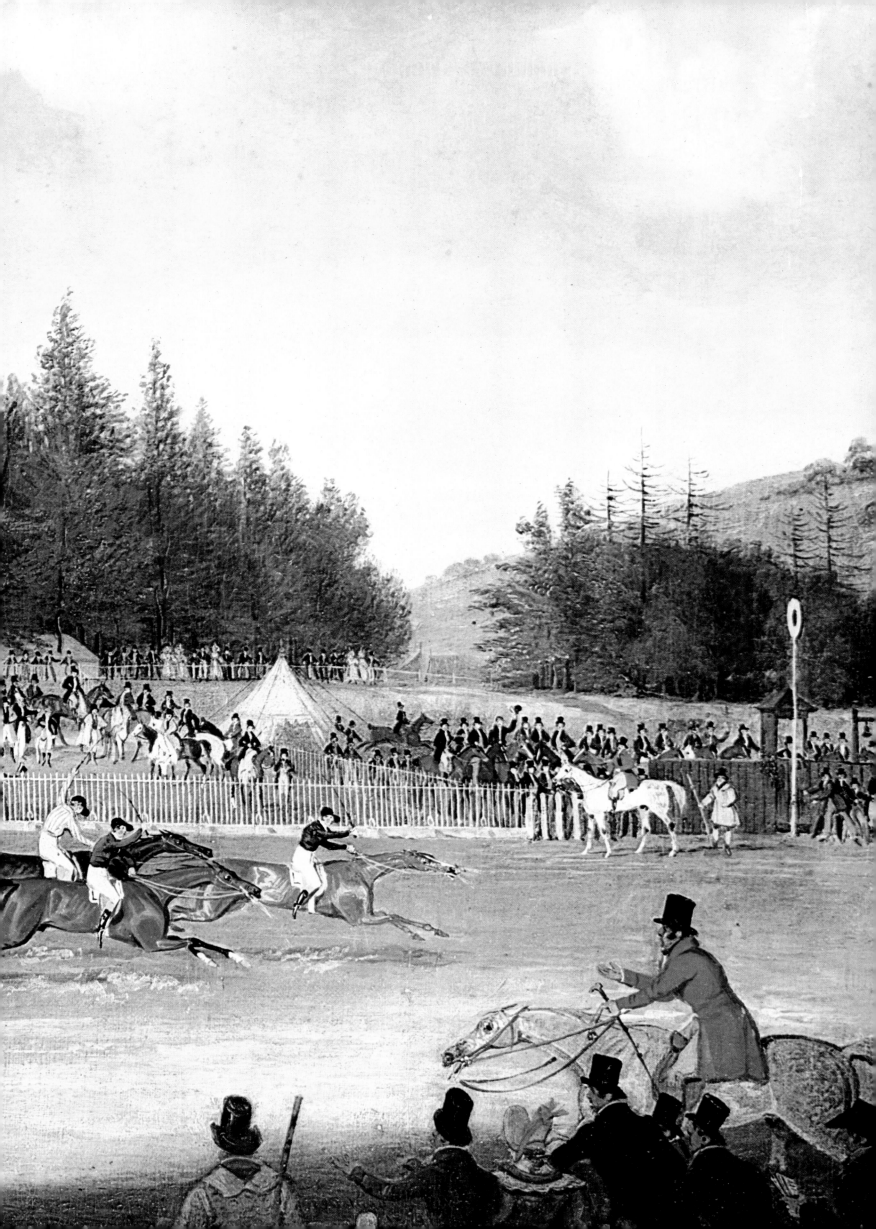

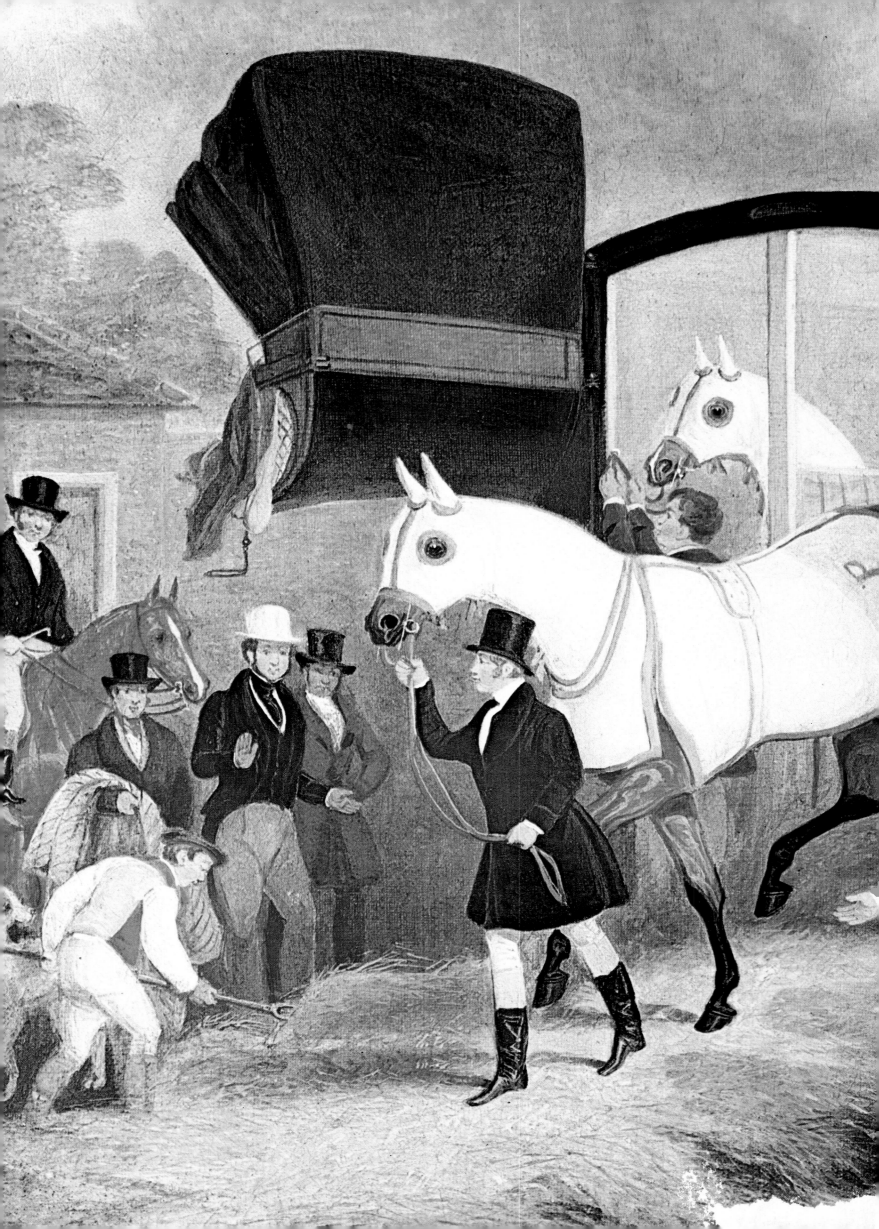

James Ward

AS A PAINTER of horses, James Ward stands supreme. He not only made an accurate physical likeness in bone, muscle and sinew, he also portrayed the *character* of his subjects. His innate sympathy with the animal world enabled him to express the fiery eye and proud carriage of the Thoroughbred stallion no less than the forlorn sadness of an old, worn out work-horse, due for the knacker's yard.

The majesty of the charger, the strength of the brewer's team of Shires, the alertness of ponies, the charm of mare and foal, the humble donkey – he rendered them all in his long life. The fact that these pictures were only a part of his vast output is all the more remarkable. For he made a great reputation, too, as a painter of cattle and dogs, and his portraits, landscapes and battle scenes are far from negligible. The castles he saw on his travels appealed to his romantic nature, and he often introduced them into his pictures.

The brilliant composition *Captain John Levett Hunting in the Park at Wychnor,* reproduced overleaf, which was done in 1817 and exhibited at the Royal Academy in the following year, has only recently been rediscovered and brought to auction, after cleaning, in all its pristine clarity of colour.

For a city-bred urchin, whose first memories were of the slums around Blackfriars Bridge, James's emergence as an incomparable delineator of such scenes was something of a triumph. He had been through a hard school of tuition in the art of engraving but under the influence of his brother-in-law, George Morland, he took to painting in oils, and had so far outdistanced his early illustrative works that by 1811 he

was elected to the Royal Academy.

When he was introduced to George III by Lord Somerville, it is said that the monarch taxed him with his versatility as an engraver turned portraitist, and now landscapist. 'An't please Your Majesty,' replied Ward, 'I engrave to live and paint for the love of the art.'

He was appointed Engraver in Mezzotinto to the Prince of Wales in 1794, and when the Regent succeeded to the throne he commissioned Ward to paint three of his horses, *Monitor, Soothsayer,* and *Nonpareil.* Their portraits still hang in the Royal collection at Buckingham Palace. Ward recorded that he disputed with the King about the correct action of a horse in one of his pictures, but he was nevertheless granted permission to study Napoleon's charger *Marengo* at Windsor Castle. The Emperor's white Barb lives for ever in the painting James did of him, which is now in the possession of the Duke of Northumberland. He also did a vivid portrayal of the Duke of Wellington's famous charger, *Copenhagen,* which he afterwards drew for a set of lithographs of outstanding animals.

His fantastic allegorical picture to commemorate the Duke's triumph at Waterloo, also reproduced here, won him a prize of 1,000 guineas. When finished, however, it was so huge, 21ft x 35ft, and, in the event, so out of tune with popular sentiment, that it was consigned to the cellars and has vanished from sight.

After he had spent six years labouring over what he hoped would be his epic masterpiece, and had sunk his savings and the grant into it, it was a shattering experience for one of his

highly-strung temperament to have it treated so insultingly. The shock, coming as it did at a time when his wife and a favourite daughter had just died, prostrated him.

In 1834 he retired to a little cottage in Hertfordshire. With

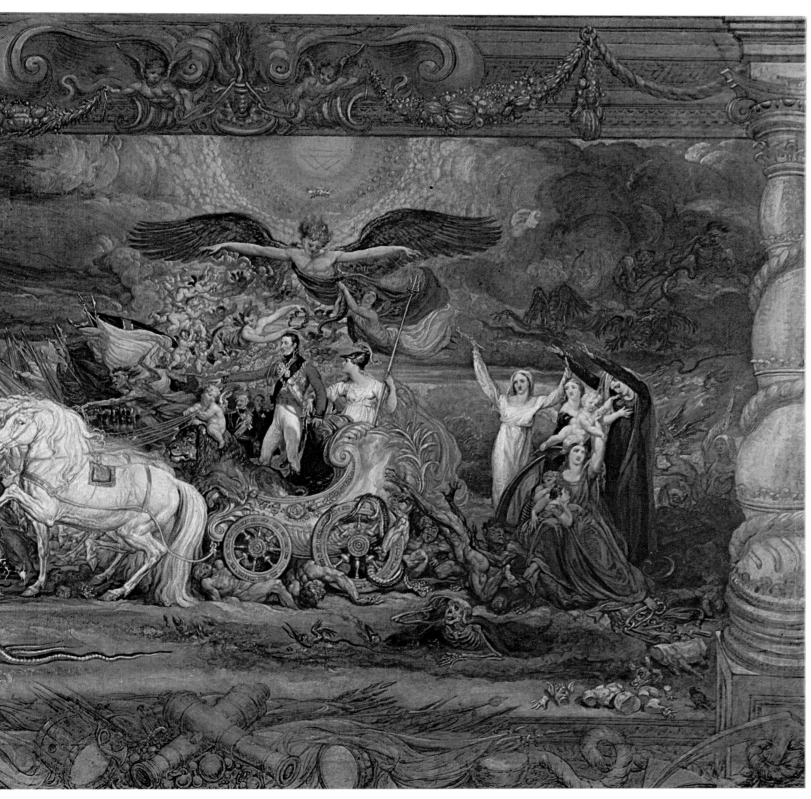

increasing age his thoughts turned more and more to religion, and the works he sent to the Academy exhibitions on such themes never attained the popularity of his animal pictures. He had a stroke in 1857, but lived on to survive his ninetieth birthday in full command of his faculties. The world of art had moved in new directions by then, but the obituary in the *Art Journal* of the time showed with what affection he was held by those who knew and remembered him as a grand old man.

Above: 'The Triumph of Arthur, Duke of Wellington, at Waterloo'.
ROYAL CHELSEA HOSPITAL MUSEUM, LONDON

Overleaf: 'Captain John Levett Hunting in the Park at Wychnor'.
P. & D. COLNAGHI & CO LIMITED

Edgar Degas

THE FRENCH Jockey Club was established in November 1833. The intention was that the Club should administer racing and also be exclusive socially, but it soon became apparent that the members were more interested in wearing their uniform of olive-green coats with gold buttons and being hailed as leaders of the smartest Paris set than in organising race meetings. Consequently the following year the Duc d'Orléans and Lord Henry Seymour instituted the 'Société d'encouragement pour l'amélioration des races de chevaux en France'.

Under the auspices of the Société racing flourished with meetings at Chantilly and Maisons Laffitte, but not until 1857, when the first meeting was held at Longchamp in the heart of the Bois de Boulogne, did the sport attract the attention of Parisians. From that moment it became the habit of all Paris to attend the Sunday afternoon meetings.

In the cheapest enclosures would be bakers, wine-sellers, clerks and students with their womenfolk, whilst in the most expensive enclosures gentlemen would wear top hats and immaculate formal attire and escort elegant women dressed *à la mode* in silk and satin crinolines. To stroll nonchalantly towards the paddock, an attractive girl on one's arm, became the delight of racegoers; the race results were of secondary consideration.

The triumph of *Gladiateur,* owned by the son of one of Napoleon's generals, in the 1865 Derby at Epsom gave French racing a much needed boost, but in 1870 the Franco-Prussian war broke up the Second Empire and virtually brought racing to a standstill. Not for another decade did French racing flourish, but its glamour and its glory had already been immortalised through the paintings of Edgar Degas. Manet and Toulouse-Lautrec also depicted the racing scene, but it was Degas with his ability; bordering on genius, to impart an almost incredible sense of movement to his horses and jockeys which made him supreme in the opinion of many critics.

Edgar Germain Hilaire de Gas was born in Paris on 19 July 1834. His grandfather had fled from Paris during the Revolution, stunned by the shock of learning that his fiancée had been guillotined as a royalist. He started life anew as a banker in Naples, where he married a Neapolitan girl and made a success in the complicated world of high finance. As he prospered, so he expanded his banking activities and eventually sent his son Pierre-Auguste to Paris to manage a branch office. Pierre-Auguste married a Creole girl from New Orleans who had been brought to Paris to complete her education. Two years after their wedding their son Edgar was born.

Edgar's father, cultured and fascinated by contemporary art, frequently took his children to see exhibitions of paintings. There were also visits to the Louvre to admire the work of the great masters. Edgar enjoyed these visits, which contributed to his initial interest in painting. After leaving school he studied in the art school directed by Barrias each morning, and spent his afternoons

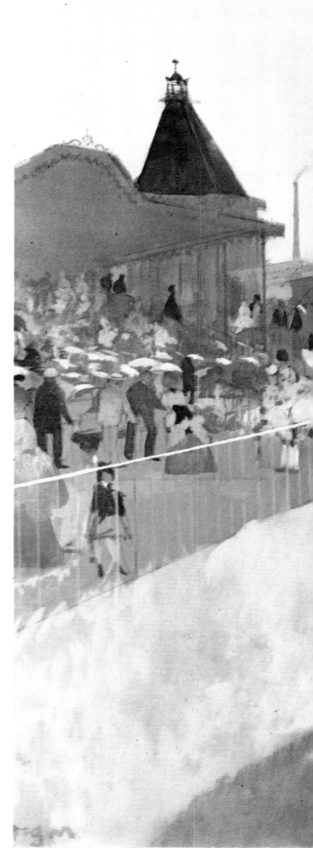

Right: 'Racehorses in front of the Stands'. LOUVRE, PARIS

Following spread: 'Amateur Jockeys near a Carriage'. LOUVRE, PARIS

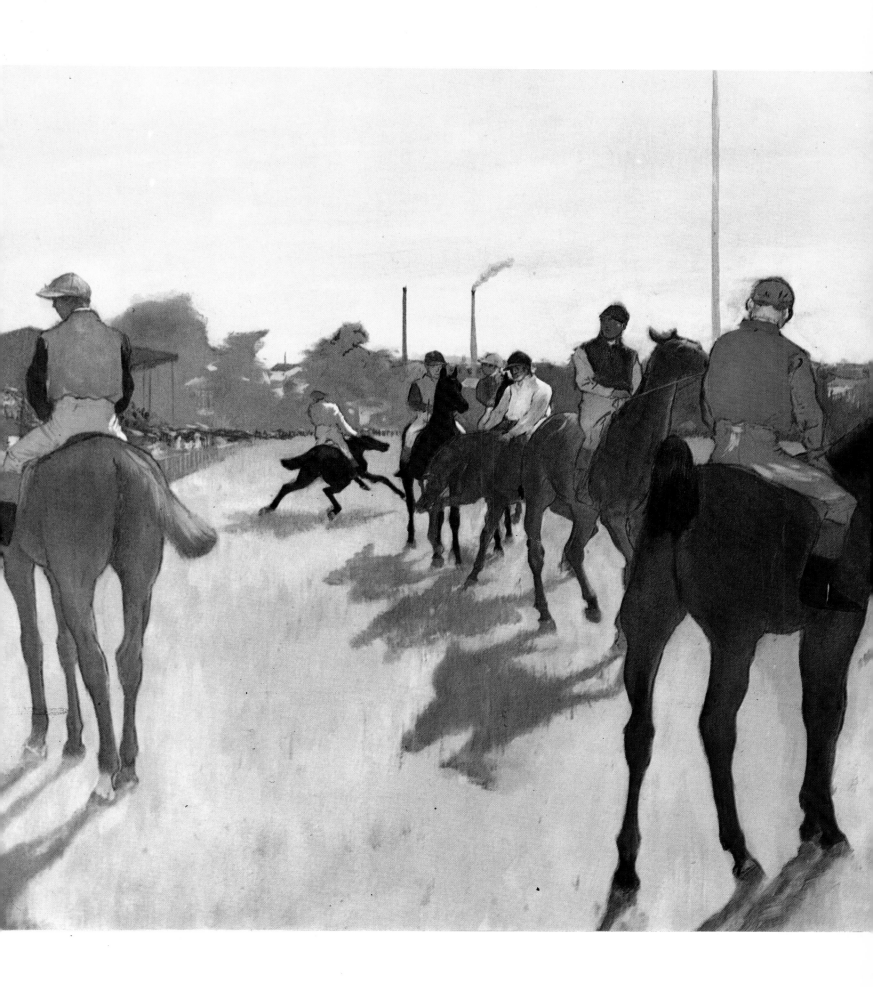

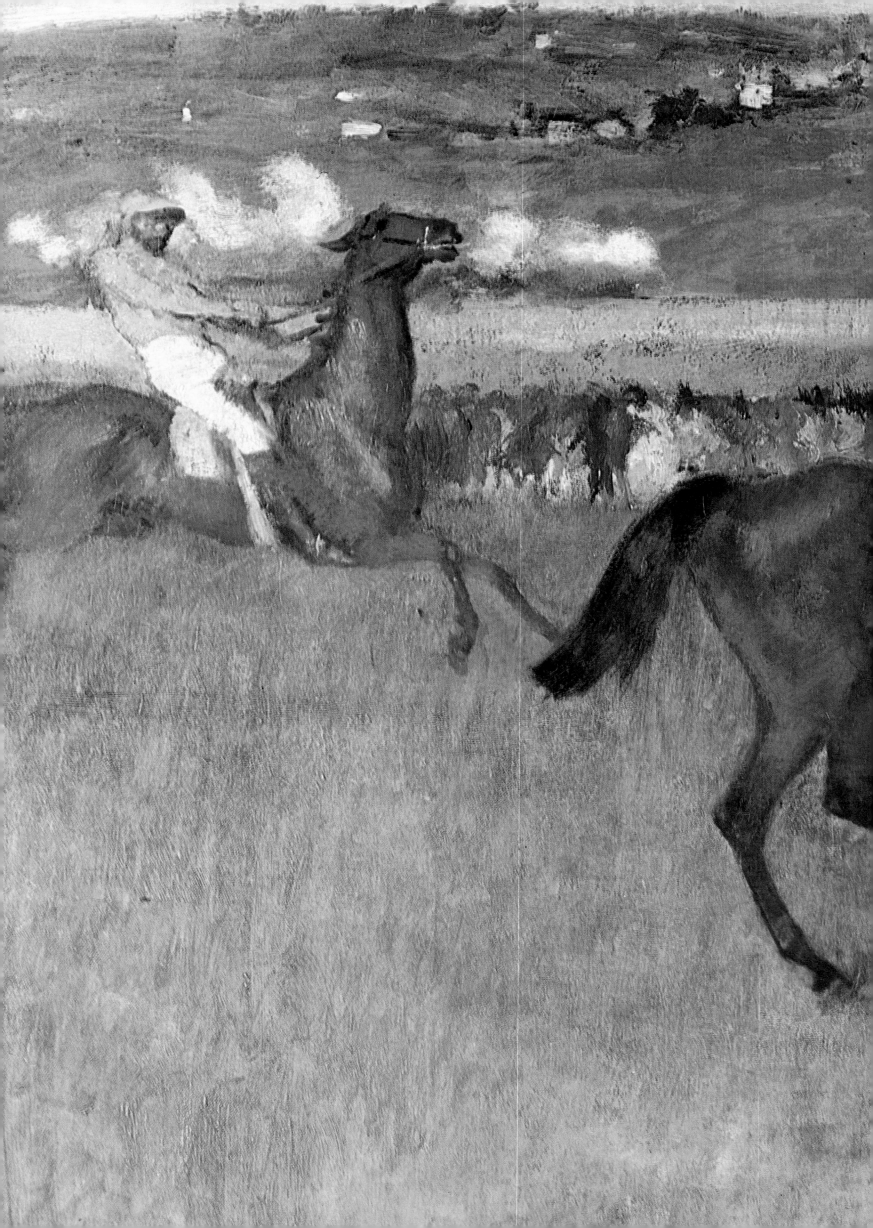

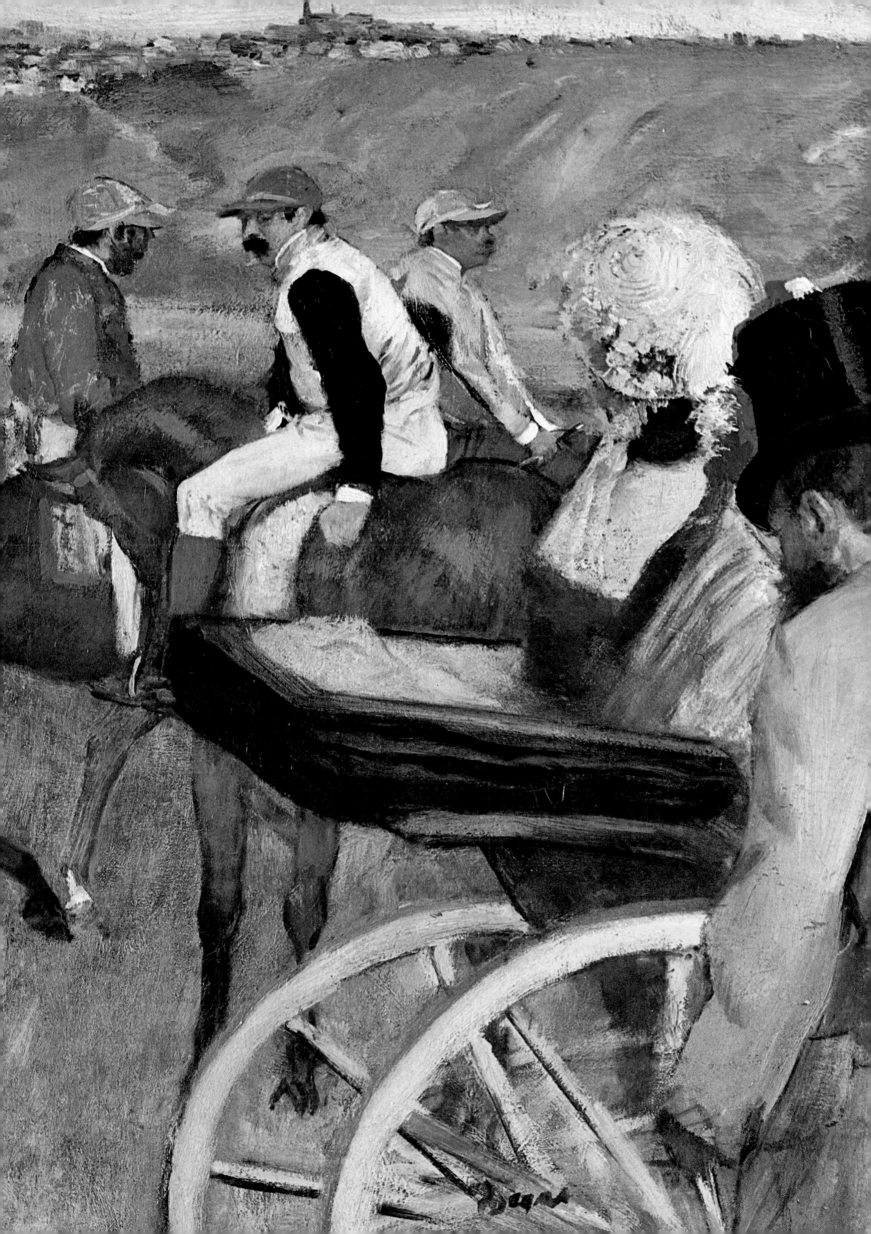

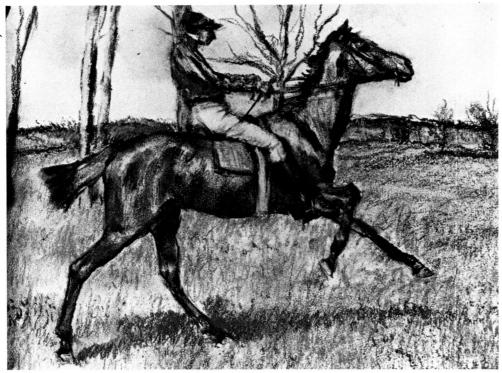

Above: 'The Jockey'.
PENNSYLVANIA MUSEUM, PHILADELPHIA.
(COURTAULD INSTITUTE)

Below: 'The Carriage at the Races'.
BOSTON MUSEUM OF FINE ART, BOSTON,
MASSACHUSETTS. (COURTAULD INSTITUTE)

at the Louvre copying the paintings and drawings of famous sixteenth- and seventeenth-century artists. As a young man he made annual trips to Italy to see his grandfather, and spent much of each day sketching scenes in and around Naples. He had few financial worries.

He worked slowly, in a classical style, and was almost unknown in the art world of Paris. The breakthrough came in the early 1860s, by which time his father was reconciled to the fact that he was determined not to become a lawyer and wanted to devote his life to painting. The de Gas family, being intelligent and intellectual, endlessly discussed Edgar's future as an artist but whenever the subject was debated found it hard to condemn his chosen career.

In the autumn of 1861 Edgar Degas (who only began signing his work Degas instead of de Gas in about 1870) spent two months in Normandy. Here he first made sketches and notes of horses and jockeys. Attracted by scenes of everyday life, particularly on the racecourse and at the theatre, he began to develop his uncanny ability for seizing upon the most crucial moment in an action. Yet his paintings had a deceptive casualness about them, belying the scrupulous trouble he took when completing his paintings back in his studio.

During 1862 his friendship with Manet resulted in his meeting Renoir, Cézanne, Pissarro and Sisley but all of them found him 'bourgeois', and to some extent were sceptical of him. At this time, when he was about thirty, he was described as 'having a high, broad, bulging forehead crowned by silky brown hair, with bright, sharp, questioning eyes . . . and delicate lips half hidden behind a light beard'. He still had doubts as to whether he should have been a sculptor rather than a painter, and often modelled statuettes of horses and ballet dancers.

By 1873, six months after a trip to New Orleans, his eyes began to give him trouble and for the rest of his life he worked less and less out of doors. He often assembled his characters for a painting by blocking them onto squared-off paper, and found that this method appealed to his precise nature. In the last of his 'great years' he tended more and more to work in pastel rather than oils. As his

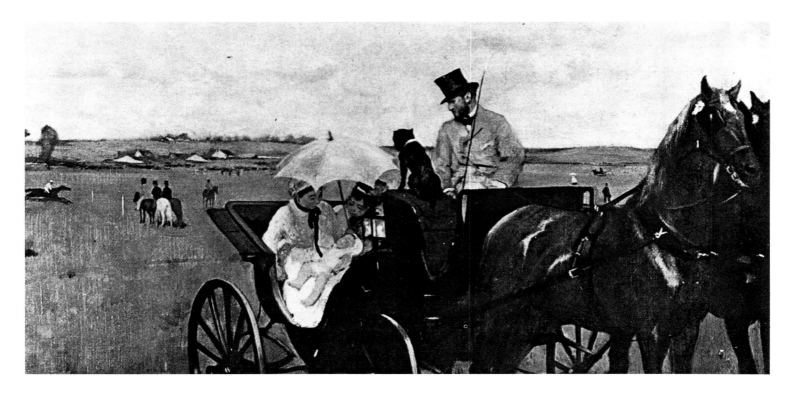

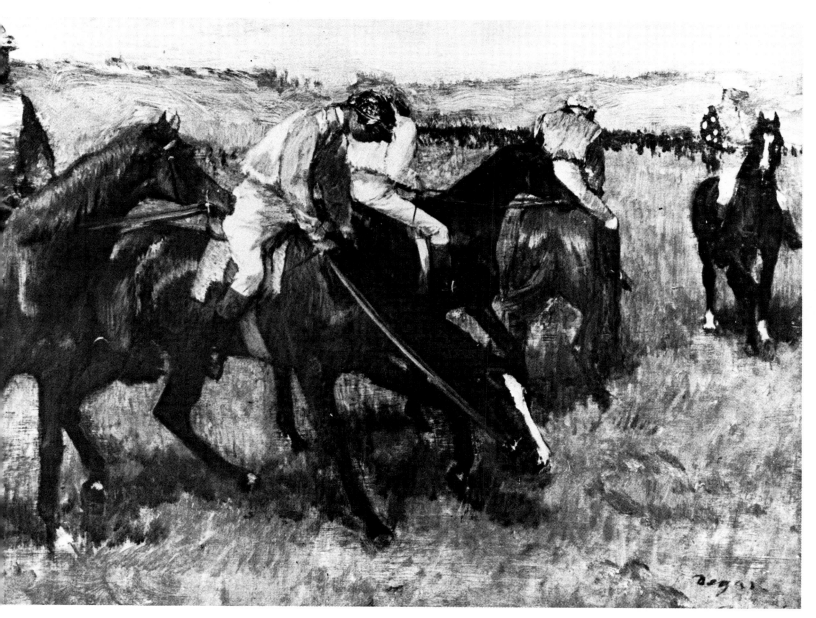

health declined he became something of a recluse, living in Montmartre where he died in 1917 at the age of eighty-three. Almost blind, he had outlived the majority of his contemporaries, the Impressionists, with whom he had been so closely associated.

Throughout his life Degas remained a bachelor. Exceptionally observant, highly intelligent with a sharp and ready wit, utterly loyal to members of his family and at times uncompromising, he could be both churlish and prudish. He enjoyed holding forth at dinner parties as he criticised young artists, poets and authors, but if asked for his help and advice would give it willingly. He only held one show devoted exclusively to his own work – in 1892 – but today his work is coveted throughout the world, and his paintings of ballet dancers and racehorses adorn the walls of the most famous art galleries of Europe and America.

Above: 'Before the Race'.
CLARK INSTITUTE, WILLIAMSTOWN, MASSACHUSETTS. (COURTAULD INSTITUTE)

Below: 'Horse clearing an Obstacle', an unfinished statuette.
TATE GALLERY, LONDON

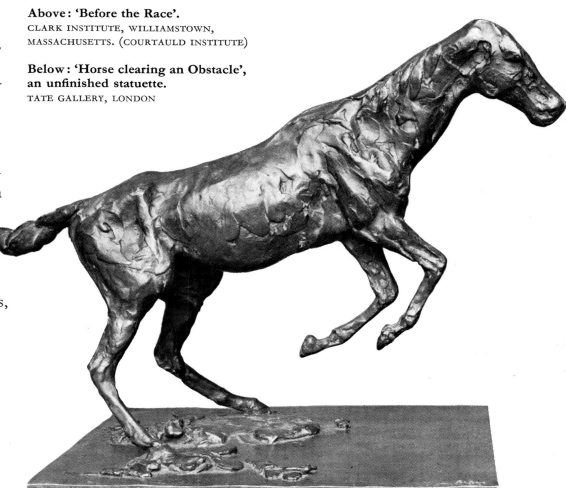

Frederick George Cotman

FREDERICK GEORGE COTMAN (1850-1920) is perhaps best known today for his landscapes. They are very much in the tradition of the Norwich School, of which his uncle, John Sell Cotman (1782-1842) was a leading figure. But one of the most popular pictures in the Walker Art Gallery, Liverpool, is representative of the other principal strand of his work, an interior scene of family life.

One of the Family for many years hung, appropriately enough, in the Coffee Bar at the Walker Art Gallery. It has been used to illustrate countless calendars and periodicals, and is familiar to many older people from its appearance in publications such as *The Hundred Best Pictures* and *The Nation's Pictures*. It has been employed to illustrate an ideal happy marriage by a writer as well known as Evelyn Home, and to illustrate a world without poverty in an article by a leading politician during the Depression.

Surprisingly, however, it was not particularly well received by the Liverpool press when Cotman showed it at the Autumn Exhibition of 1880. One reviewer

prophetically noted it as 'very suitable for the illustrated papers at Christmas time. Sentiment and treatment are alike suited for this end', and the announcement of its purchase by the Walker Art Gallery provoked the following somewhat caustic lines: 'As for Mr Cotman's *One of the Family*, it certainly possesses qualities to commend it to the public taste, and it conveys a lesson of kindliness to the lower animals – a circumstance that may have weighed with the Arts Committee in choosing a somewhat commonplace and illustrated periodical sort of picture.'

Cotman had exhibited the picture at the Royal Academy before the Liverpool exhibition, and it was barely noticed by the leading art critics there. Nevertheless its subsequent popularity is not totally unjustified.

Cotman took an immense amount of trouble over the creation of a realistic picture of a happy family scene, as his grandson Alec Cotman informed the Walker Art Gallery in a letter. The setting is the interior of the Black Boys Inn at Hurley on Thames, a little Berkshire village not far from Maidenhead. The innkeeper, a Mr Street, combined the running of a country pub with the trade of a miller. He can be seen in the extreme right background, hanging up the horse's harness.

His wife is the handsome young woman leaning back to feed the horse, which was a regular visitor at the doorway. Her mother, the old lady, is cutting a large loaf of bread 'in the continental way' in her arms, rather than on the table. This habit was explained by her nationality, for she was German. The little boy in front of her is Cotman's own son, whilst the other two children are Mrs Street's.

Painting a picture of this size (3ft 4in by 5ft 7in) takes considerable time, and Cotman was faced with the problem of how to preserve the large pie on the table. So he thought up the unusual expedient of stuffing it with coke, turning the cut portion away from the spectator.

Two main factors contribute to the immediacy of the picture: the skilfully organised composition and the meticulous eye for detail. Cotman cuts off the table short at the bottom of the canvas so that the viewer becomes a participant at the meal. He arranges the figures to create diagonals from corner to corner. The little girl reaches out offering a tasty morsel, her arm pointing to the open doorway, a line eventually continued to her father occupied with the harness. Another diagonal runs from the old lady's knife via her daughter's outstretched hand to the horse, and parallel to this runs the window-sill. In each case an upper arm of the little boy at the centre acts as a bridge.

Noteworthy too is the flow of light from the window, catching parts of the faces and hands of the diners and leaving other areas in deep shadow, whilst the figures crowd towards the other main source of light, the doorway, which frames the member of the family who gives the picture its name.

It is an ordinary meal enjoyed in natural disorder by an ordinary family. Grandmother has abandoned her knitting on the window-sill, the tablecloth is rumpled and creased, and crumbs, cutlery and plates are far from neatly arranged. Only mother and daughter have a thought for the carthorse. Grandmother remains intent on her breadcutting, whilst son digs into the meat which he is

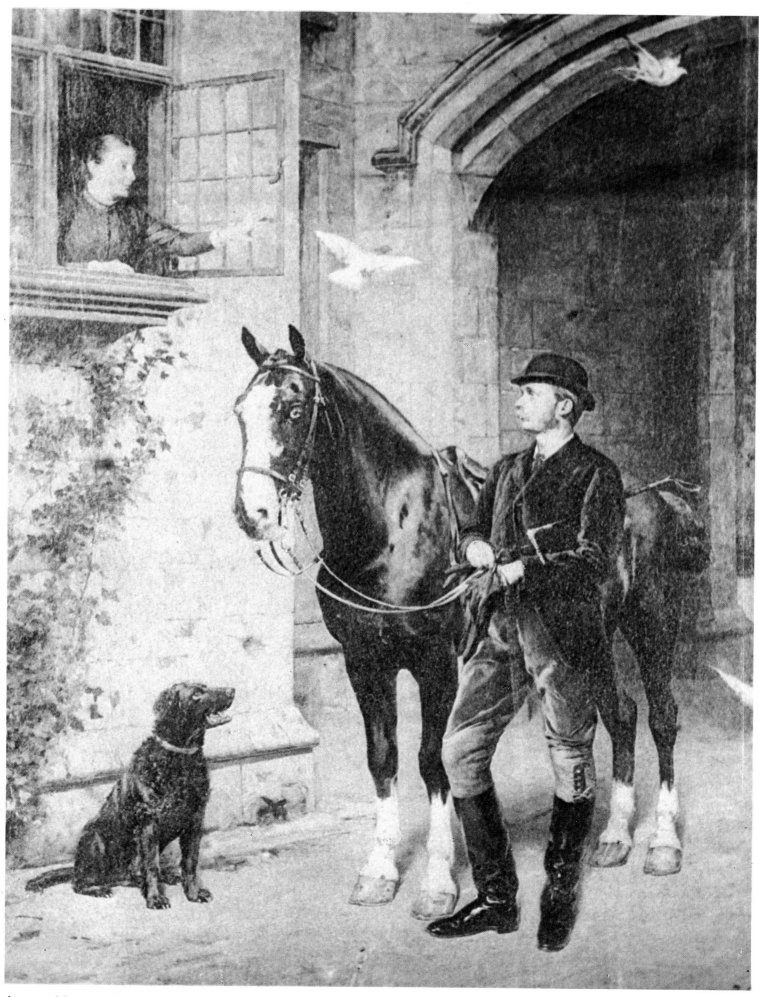

thoroughly enjoying. A paw and a head appear from beneath the table as the dog begs for its share. It is the naturalism of details such as these that makes this picture so attractive.

Above: 'Mr Evelyn Heseltine's Favourites'. ALEC M. COTMAN

Overleaf: 'One of the Family'. WALKER ART GALLERY, LIVERPOOL

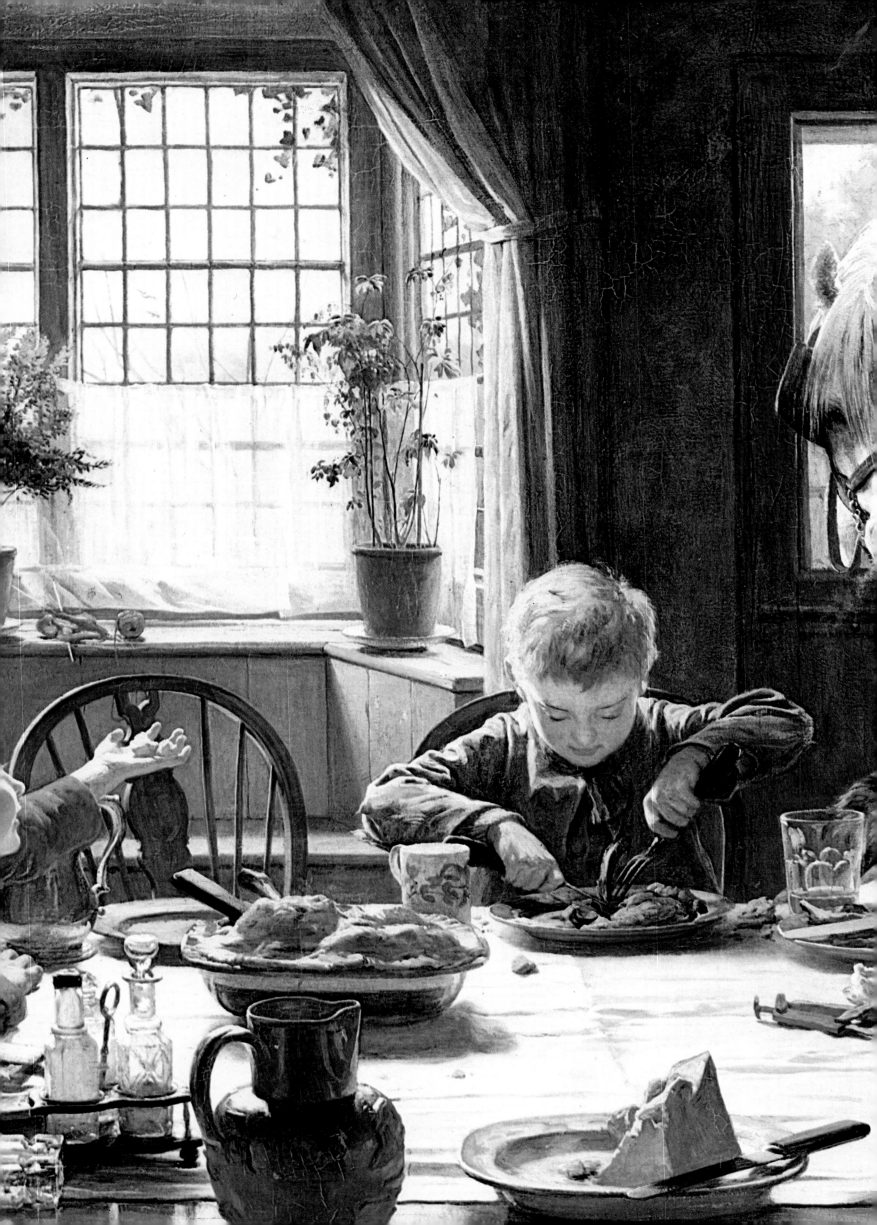

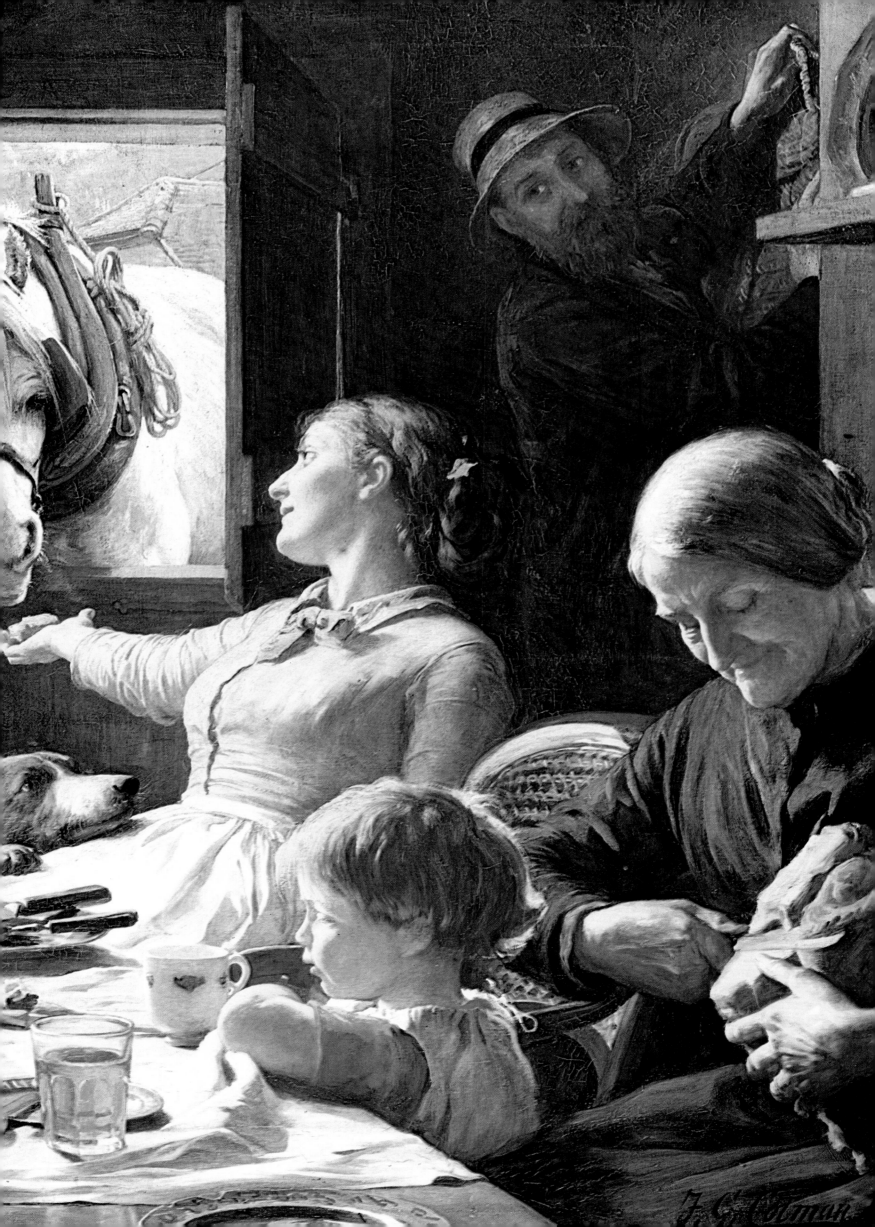

Sir-Alfred Munnings

THE DEDICATION of a memorial tablet to Sir Alfred Munnings in the crypt of St Paul's Cathedral, London, alongside that of John Constable, has more significance than might be imagined. Although both artists were sons of Suffolk millers, with their roots deep in the Waveney valley, they will probably both be remembered for their contribution to the long tradition of English landscape painting.

In Constable's case this is an established fact, but for the time being Munnings stands chiefly in the public imagination as a horse painter. In the fullness of time, his gifts as a landscape artist may well eclipse his present reputation. This is something he would have wished for, if we are to believe his ramshackle autobiography, he found his real artistic fulfilment in painting

As a young man he had lost an eye which left no obvious mark, and even improved his looks. A London editor, meeting him a long time after, described him as having 'the knowing jockey look' – quoting a reference made to the artist Hogarth. He was warm-hearted, outspoken, emotional, prejudiced and impulsive, and his overwhelming sincerity had an endearing quality. His impish sense of fun and schoolboyish exuberance never left him. An extrovert who loved to be the centre of attraction, he was capable of holding his audience spellbound by a prodigious repertoire of home-made ballads and anecdotes. To the end he retained his remarkable memory and Suffolk accent. Above all he was a fighter, whether he was struggling against the fading light to capture

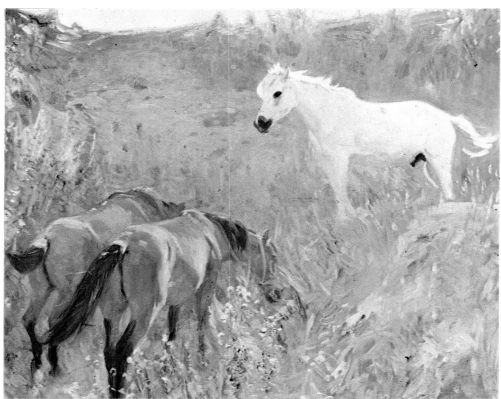

the Suffolk landscape of his childhood.

In appearance he was short and upright, with movements that suggested an extraordinary vitality.

some fleeting impression on his canvas, or battling against the painful gout that was to torment him for most of his life.

Munnings was born at Mendham

Mill in 1878, the second son of John and Ellen Munnings, and his formal education began at the school. After a short unhappy village period at Framlingham College, his

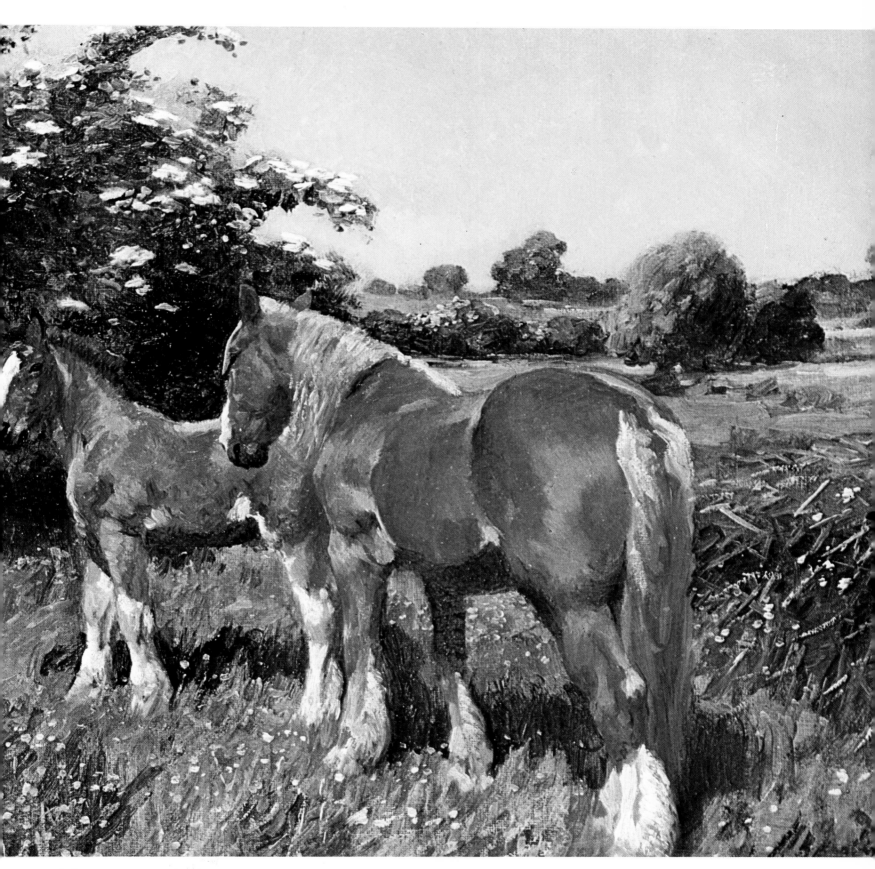

father was persuaded by his talent for drawing to apprentice the fourteen-year-old boy to the Norwich lithographers, Page Brothers. The training he received was to give Munnings a firmness of line that enabled him to handle his brush as a painter with a confidence that was to be the envy of his fellow artists. He acquired a

Far left: 'Ponies in a Sandpit'.
Above: 'Mare and Foal'.
Overleaf: ' "Augereau" and Shrimp'.
SIR ALFRED MUNNINGS ART MUSEUM, DEDHAM

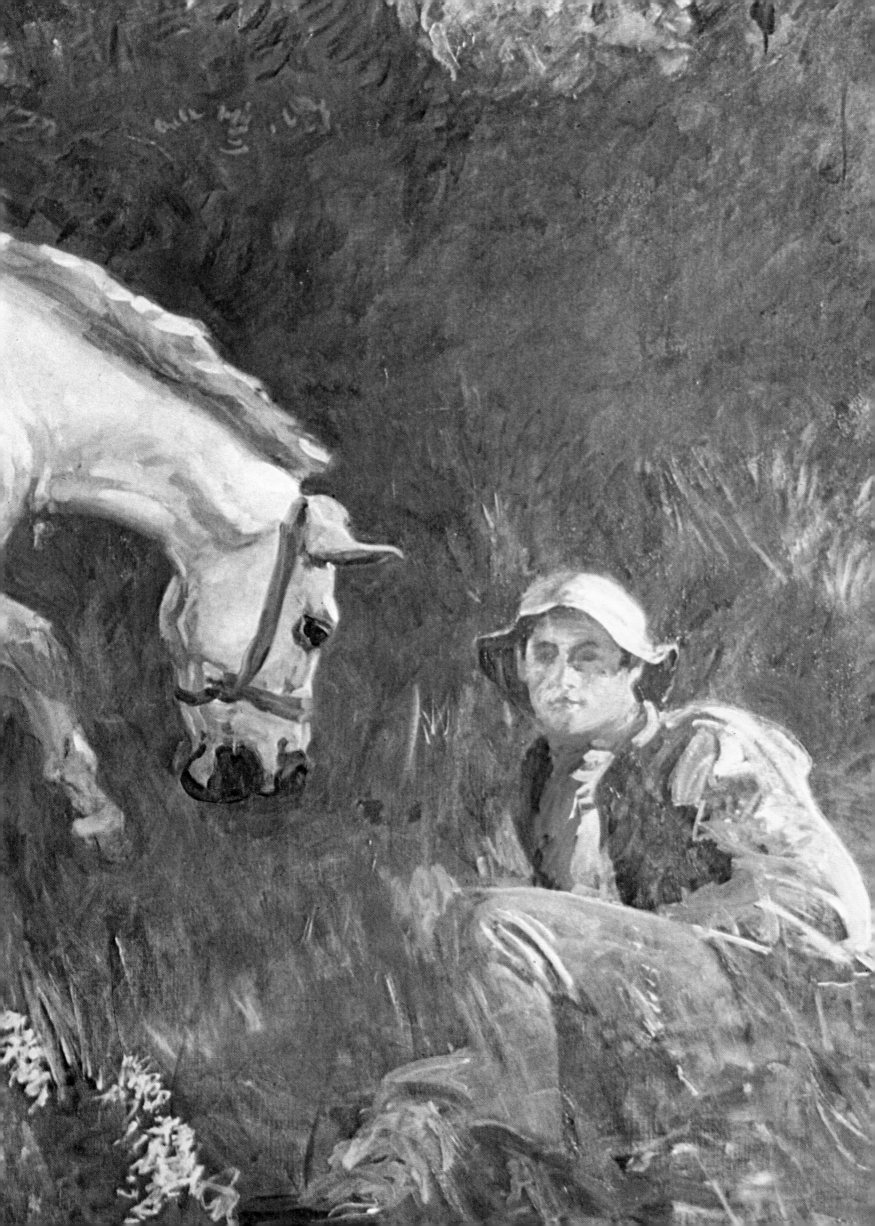

directness and certainty as part of the lithographer's irrevocable craft, in which a faltering hand is not to be tolerated.

In addition to the long hours at Page Brothers, his evenings were spent studying at the Norwich School of Art, where his work was soon to attract favourable attention. During the six years of apprenticeship he travelled on the Continent and studied in Paris. By the age of eighteen, he had exhibited at the Royal Institute of Painters in Watercolours, and at twenty, two of his pictures had already been hung at the Royal Academy, the first of three hundred or more he was to exhibit there in the years to come. The Norwich dealers were soon ready with cash and encouragement.

The sale of his works enabled the young artist to set up his own studio in Swainsthorpe and embark on a period when he was probably at his happiest and found his richest fulfilment as a painter. He lived a nomadic existence, travelling extensively through Suffolk and

Norfolk accompanied by a local boy named Shrimp, a band of ponies and a cartload of canvases. He worked incessantly, using his companions as subjects, and revelling in his new independence and the sheer joy of painting the East Anglian landscape and its people.

From these wanderings come such outstanding works as *The Timber Gill,* about which Munnings said 'I shall never paint anything like it again', and *The Coming Storm,* a painting of great drama and atmosphere. 'I had gone on painting, aware of a portent in the air – hearing the far-off boom of thunder; watching the ominous, dark storm clouds gather and slowly advance. Shrimp riding the white mare was the principal mass of light, showing against a dark and threatening sky'. In his pursuit of light he seems to have provided the link between the traditions of Crome and Constable and the Impressionist mood of his own time.

The bustle and atmosphere of

the horse fairs fascinated him, and almost by a stroke of genius he found a wealth of primitive colour in their gipsy life. The hop-pickers of Alton, Hampshire, to whom he was known as 'Mr Money', were his memorable models for pictures like *Departure of the Hop Pickers* (National Art Gallery, Melbourne), and *Gipsy Life* (Aberdeen Art Gallery). After the First World War he was to paint them again, this time at the Epsom Spring Meeting, producing some of his best-known gipsy studies: *Arrival on Epsom Downs* and *City and Suburban Day.*

In these pre-war years he paid long visits to Cornwall, attending Stanhope Forbes's painting classes at Newlyn. The company included Augustus John and Dame Laura Knight. He found the companionship rewarding, and painted happily amongst the surrounding hills. It was here that he met his first wife. The marriage was short-lived, and ended tragically when she took her own life. *The Grey Horse, The April Fox*

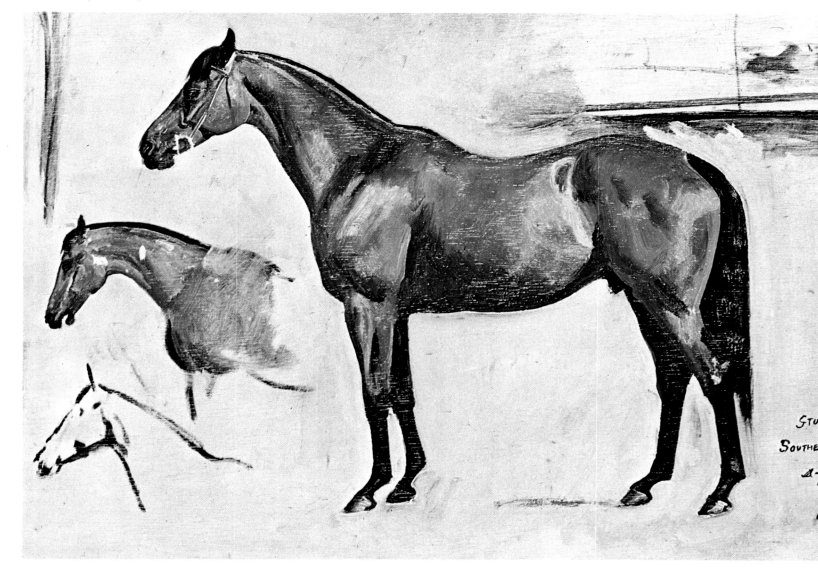

and *Zennor Hill* are paintings that spring to mind from these Cornish days.

The lack of an eye precluded any war service until 1917, when with the help of the artist Cecil Aldin he was found a job at the remount depot at Calcot Park. After twelve months, he was posted to the Canadian Cavalry Brigade in France as an official war artist. He was an immediate success, and responded energetically to a new variety of subjects. His first wartime commission was a portrait of General Seely mounted on his horse *Warrior*. It helped to fix him in the public-eye as an exceptionally skilful painter of formal equestrian subjects. So followed a long series of commissions, which he never regarded as his life's work, but which brought him fame and money.

He was forty, and on his return to England received the distinction of associateship of the Royal Academy. The same year, 1919, he acquired his Castle House property at Dedham, near Colchester, and married Mrs Violet McBride, a young widow, who first caught his attention by her immaculate appearance in the Richmond show ring. Although the marriage was childless, it was a complete success. Violet Munnings soon realised that her husband needed not only a wife, but a comptroller of his household, and a manager of his business affairs. His success was due partly to to her level-headedness, tact and understanding, and his letters to her over the years show that this did not go unregarded by Munnings. She had the good sense to allow him the freedom so essential to artistic creation and, although she was often lonely, she accepted her position as inevitable and necessary.

With the security of wife and home, he started upon a host of commissions which took him to America, France and Ireland and to all the great English houses. He was a familiar figure at Blenheim Palace, Eaton, Cliveden, Cottesbrooke, Belvoir and Berkeley Castle. He was commissioned by *The Field* to portray the Prince of Wales on his hunter *Forest Witch*. His subjects included hunting portraits, stallions, American polo players and sportsmen, Masters of Foxhounds, racehorses, formal portraits and mares and foals.

In 1938 he was favoured with royal patronage and painted a series of studies which culminated in an enormous canvas of *Their Majesties Returning from Ascot*. All his life he was capable of working productively at two levels, and this type of patronage meant working for money. He now had expenses to meet, and seldom found time to paint themes of his own choosing. As a sculptor he had as great a mastery of form

Facing page: Study of 'Southern Hero'.
SIR ALFRED MUNNINGS ART MUSEUM, DEDHAM

Below: 'The 9th Duke of Marlborough on a Grey Hunter'.
BY COURTESY OF THE DUKE OF MARLBOROUGH

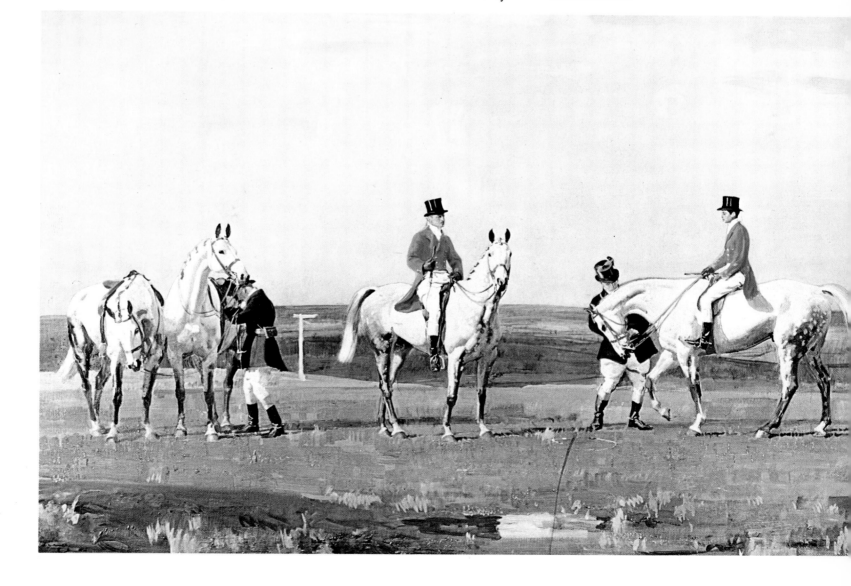

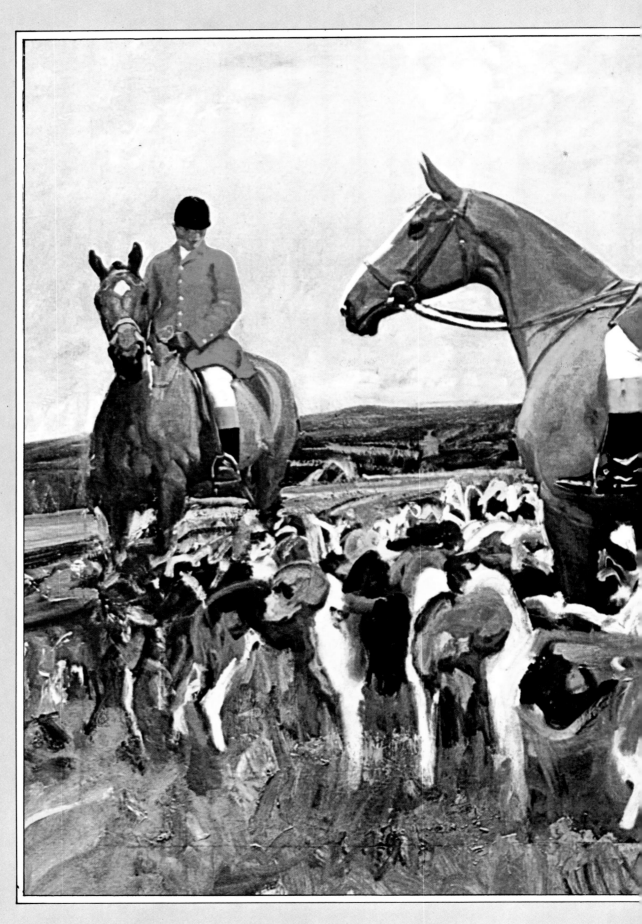

'Nobby Gray'.
SIR ALFRED MUNNINGS
ART MUSEUM, DEDHAM

in this unfamiliar medium as he had in his painting. His bronze statue of *Brown Jack* for the Jockey Club, which now stands on Ascot racecourse, is an example of his tactile skill.

Munnings was elected a Royal Academician on Derby Day 1926, and the flood of commissions ran on unabated. The outbreak of war in 1939 coincided with his sixty-first year and, as there was no call on his services, he shut up his Dedham house and took up residence on Exmoor. The war years produced paintings of the pony herds that roamed the heather, and the landscapes that once again provoked the excitement that he had felt in his early Suffolk days.

In March 1944 Munnings was elected President of the Royal Academy in which capacity he served until 1949. He was knighted the same March and was made a Knight Commander of the Royal Victorian Order in 1947. He possessed no administrative gift, and his presidency might have been a disaster but for the loyalty and support of the secretary, Sir Walter Lamb.

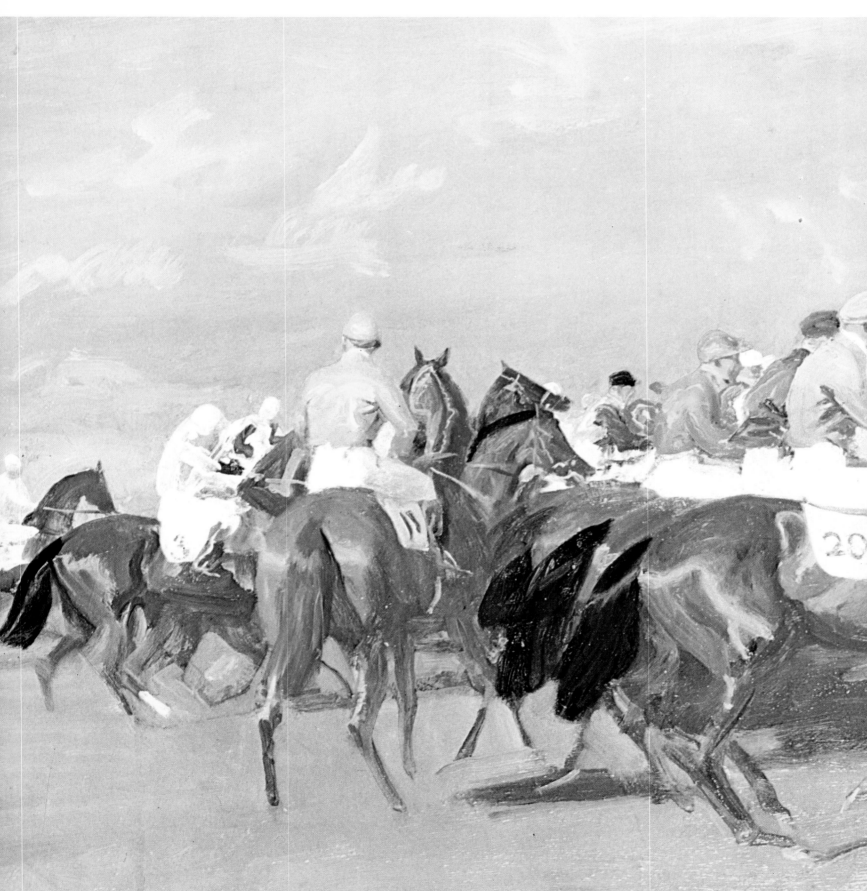

His term will certainly be remembered for his controversial speech at the Royal Academy banquet in 1949. Relayed by radio, his attack on 'modern art', when he referred to Matisse and Cézanne as 'foolish daubers', created a storm. He brought art controversy into the homes of millions, where the names of Picasso and Henry Moore had never been heard. It was not

so much the new manifestations of art of which he was intolerant, but the falsities and shams associated with some of them, and the pretensions of artists whom he considered had never 'served their time'. The rumpus finally decided him to resign his post, and he returned thankfully to his beloved Suffolk.

The crowds that thronged an exhibition of his life's work at the Burlington House Diploma Gallery in 1956 were a clear sign that he had lost none of his old magnetism. The paintings on show acknowledged the duality of his life as an artist. The sensitive, poetic themes hung alongside the contrived works which he had

Left: 'Start at Newmarket'.
SIR ALFRED MUNNINGS ART MUSEUM, DEDHAM

Above: 'Jockey in Yellow Silks'.
SIR ALFRED MUNNINGS ART MUSEUM, DEDHAM

never wanted to paint. In some cases the styles were blended in one painting, but maybe here was the proof that his early works demonstrated his best powers, and for these it is hoped he will be remembered.

On 17 July 1959 he died at Dedham and was survived for some years by Lady Munnings. After her death, Castle House was left to the nation as a perpetual memorial to a truly English artist and an unforgettable personality.

Lionel Edwards

FOR ALMOST half a century Lionel Edwards was our greatest friend and most welcome visitor.* He made our house his headquarters whenever he painted in the Shires, and would arrive with happy face and bear-like hug, flinging his big leather portfolio and his easel on the hall floor as if jettisoning a load of rubbish, though we knew the contents of the portfolio were probably worth thousands of pounds, and the easel was his most precious possession. He often talked about his family, and as he was a brilliant and witty raconteur we never tired of listening to his recollections.

Lionel's father, James Edwards, was born in 1810, five years before the battle of Waterloo. The immense and almost incredible span of years was explained by Lionel being the fifth and youngest son of his father's third marriage. His grandmother, Mary Ann Robertson, who married Thomas Edwards, Vicar of Aldford and chaplain to the Marquess of Westminster, was a friend and pupil of George Romney, so it was always supposed that Lionel inherited his painting ability from her.

He came of a long line of parsons and soldiers, one of whom, Sir Francis Gamul, was a Cavalier in attendance on Charles I at the battle

of Rowton Heath, which he watched with the King from the Phoenix Tower in Chester. The family had in their possession Sir Francis's black ebony stick with jewelled handle and tassel which the King gave him.

James Edwards, Lionel's father, was a doctor of medicine, practising in Chester and specialising in stomach troubles. All his visiting, often long lonely rides in bad weather, was done on horseback – but he was also a keen sportsman and seems to have managed to get away from his practice to enjoy a good deal of hunting and fishing, and to run his farm at Rowton. Foxhunting was his passion and, living first in Chester, he kept his horses at the Swan Inn, Tarporley; later he moved back to his native Wales and from there would go away to fish at Fairford and to Leamington to hunt with the Warwickshire.

Hunting one day in old age, he happened to overhear two young men say of him, 'The old doctor has a marvellous eye for a gap'. He never went hunting again, but he could not bear to give it up altogether and hunted his pack of beagles from pony-back in the Welsh hills.

Lionel evidently inherited his love of horses from him, though also, he used to say, probably from the fact that it was the custom then to put babies out to nurse, and the woman selected for him was not only the wife but also the daughter of coachmen.

It was usual to put one's sons, after school, into one of the Services or the Church or the Law, and Lionel was intended for the Army. He went to a crammer's in London. He had sketched from a very early age, and now the crammer reported that his pupil seemed more interested in artistic

than in military matters and he was allowed to leave to study at an art school. He never talked very much about those days, except that he was grateful for all he learnt at Frank Calderon's school of animal painting in Baker Street, and from Dr Armstead, the anatomical lecturer there. He learnt his extraordinary speed of painting from press work, some of which was published in *Country Life*.

His first studio was in Holland Street, a previous tenant having been the famous Randolph Caldecott, whose amusing pictures and illustrations were a constant delight to the young of several generations. At that time Lionel's health was not too good and his doctor ordered horse exercise, believing in the old adage, 'Live in the saddle – whoever heard of a bilious postboy?' Naturally his patient was only too willing to follow this advice and lost no time in buying a horse of his own.

In the early days of the century Lionel could ride through London into the comparative country of Hammersmith and Barnes to Richmond Park, and even through orchards in Mortlake. He also rode out of London to a meet of the Surrey Staghounds at Esher. He became a member of the London Sketch Club, which numbered among its members the well-known artists Cecil Aldin, John Hassall, Dudley Hardy and, perhaps the most famous of all, Phil May, of whom Lionel had many amusing reminiscences. But on revisiting the club after the First World War he found only one old friend and never went there again.

Lionel was a keen staghunter, ever since 1902, when he and his eldest brother took two horses down to Porlock to hunt with the Devon and Somerset. One sometimes finds his paintings of

*Kathleen Aldridge, who wrote this chapter, is the wife of Denis Aldridge, the sporting artist, who was secretary of the Quorn for eleven seasons after the end of the Second World War. Previously they had lived in the Atherstone country where they farmed and Denis was secretary to the South Atherstone. Lionel Edwards always claimed that those South Atherstone days were the best fun of all.

deer on Exmoor done about that time, but not until some twenty years later, when he bought his lovely home, Buckholt, near Salisbury, did he start going regularly to hunt on Exmoor, and some of his best paintings were done at that time.

In these paintings he not only captured the very essence of Exmoor but also, through long and patient hours of observation of their forms and habits, portrayed the red deer probably better than any other artist before or since.

We first met Lionel in the early twenties, when we were down on Exmoor for the stag-hunting. We saw a tall figure walk past the Anchor Hotel at Porlock Weir, carrying a huge and very bloody stag's head. Knowing that a hunted stag's head was never given to anyone, we were naturally curious. We learnt that this stag had been killed after an exceptionally good hunt, and that it was all due to Lionel.

That day a stag had not been harboured, and hounds were drawing the open moor. On they went, with no sign of deer, when Lionel's sharp eyes noticed a warrantable-looking head poking out of some fern. Neither the Master nor the huntsman would ever listen to a follower saying he had seen a warrantable deer, but when Lionel went up and told Ernest Bawden of this one, Ernest, feeling he could rely on his exceptional knowledge, took the hounds back to the spot, whereupon the stag jumped up and gave them a wonderful hunt. The head was presented to Lionel, and we often admired it set up and hung on his studio wall at Buckholt.

On Exmoor he usually stayed at Cloutsham Farm, a remote cluster of ancient buildings up on the moor. From there the deer could be seen most days, especially evenings, feeding on the opposite hill and Lionel sometimes painted them from his window. They often came right up to the house, and one old stag roared so persistently beneath the bedroom window that Lionel finally got up and threw his hunting boots at it.

He was a fascinating companion, and a witty raconteur. When he began, 'I must tell you of a funny thing which happened . . . ' he would start laughing himself, such an infectious chuckle that we were already laughing with him before hearing the story.

Some of his funniest experiences happened when staying with people

Below: Lionel Edwards; a sketch by Denis Aldridge. KATHLEEN ALDRIDGE

Overleaf: 'Three-a-side Polo at Simla'. KATHLEEN ALDRIDGE

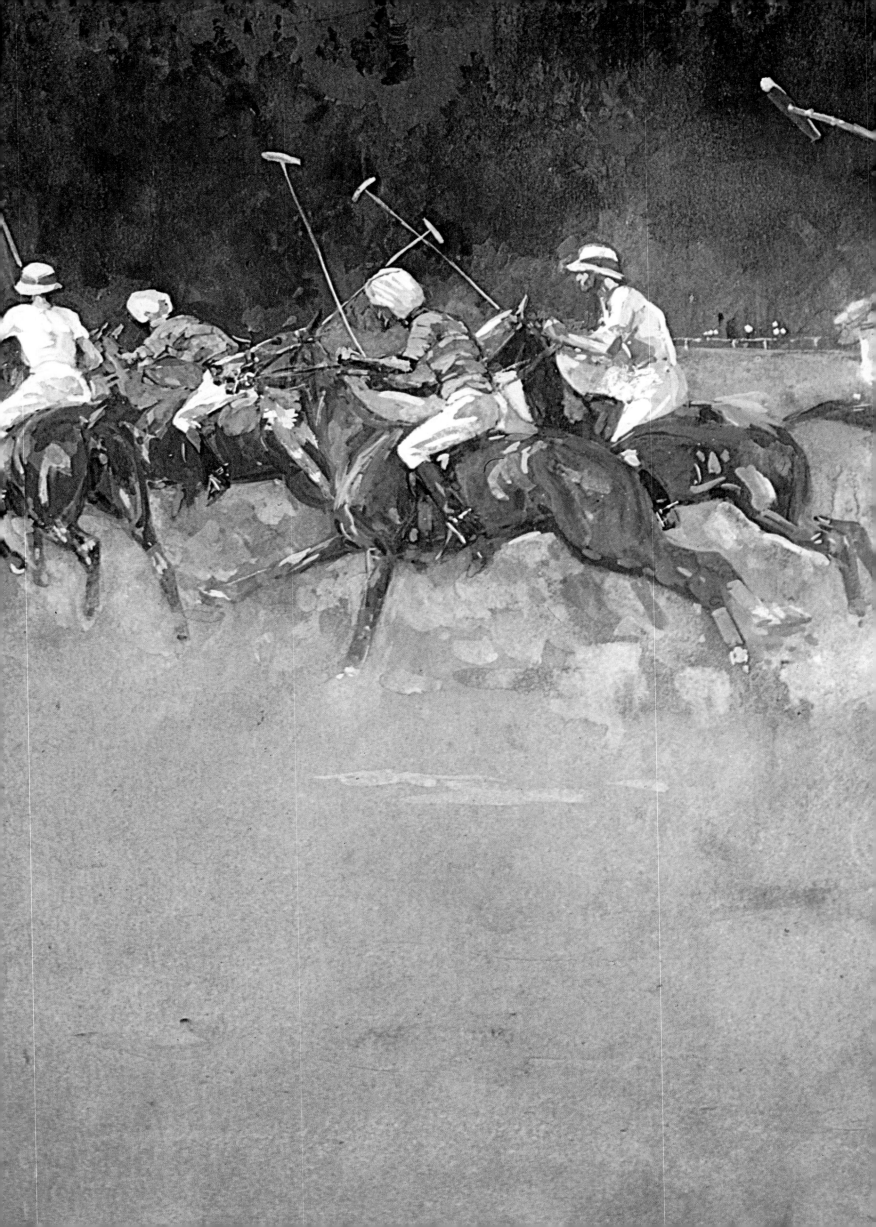

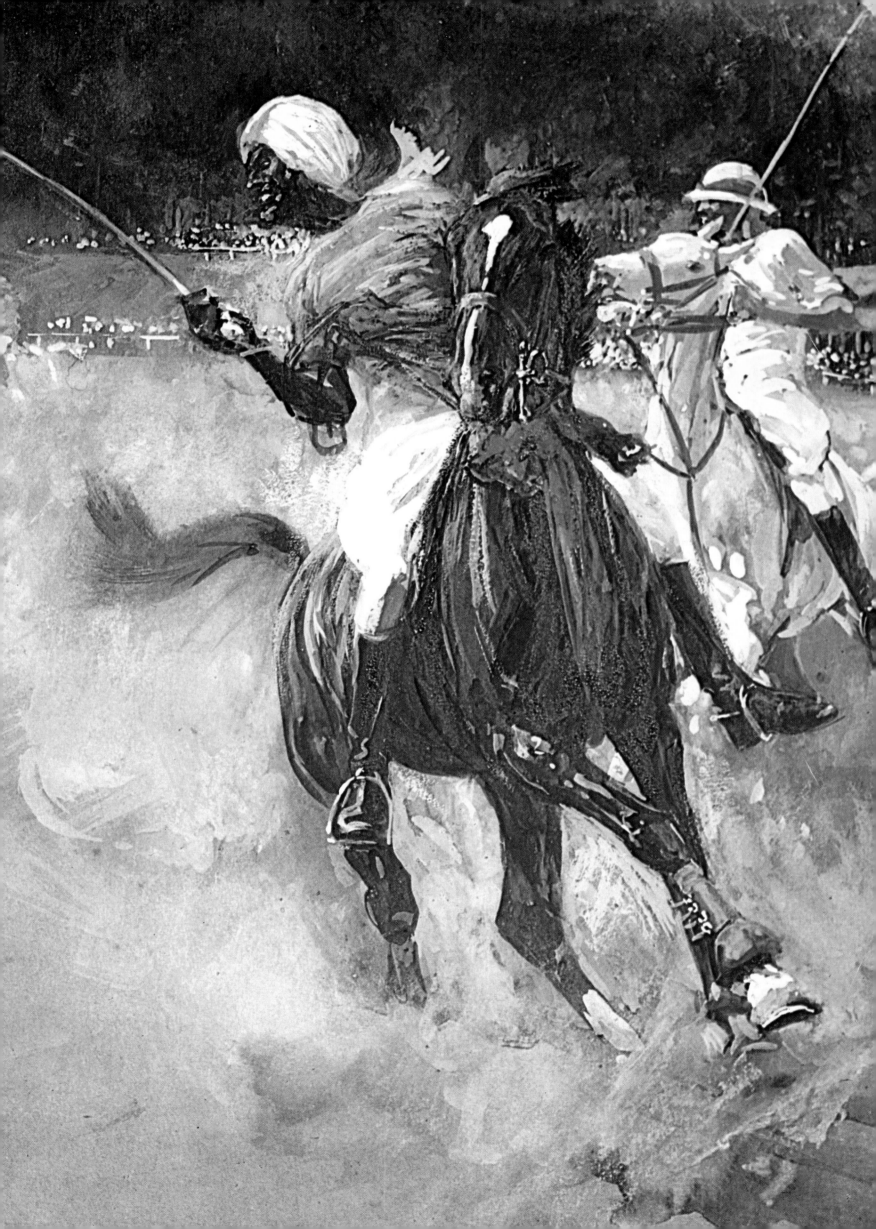

to carry out commissions for their portraits or hunting scenes. He found himself in all sorts and conditions of households and saw the funny side of any situation. He came to us once from a farm in Scotland, having before that sampled the very modern amenities of a millionaire's home, and told us that on going up to bed he had searched in vain for the usual offices. He went down again to ask where it was. The farmer led him to the back door, opened it with a flourish, and said, 'And what more d'ye want? There's all Argyllshire!'

Another time he went to paint the Master of a small pack in the north of England. It was a bachelor household, very well run and with no lack of comfort. A correct and immaculate butler waited on them throughout an excellent dinner of several courses. When Lionel went up to bed he found all his things unpacked and put away and his hunting clothes put out ready for the next day. In the morning after a splendid breakfast he and his host started for the meet. The Master was telling him what an invaluable servant the butler was, 'In fact I have no one else in the house at all. Didn't you think he cooked the

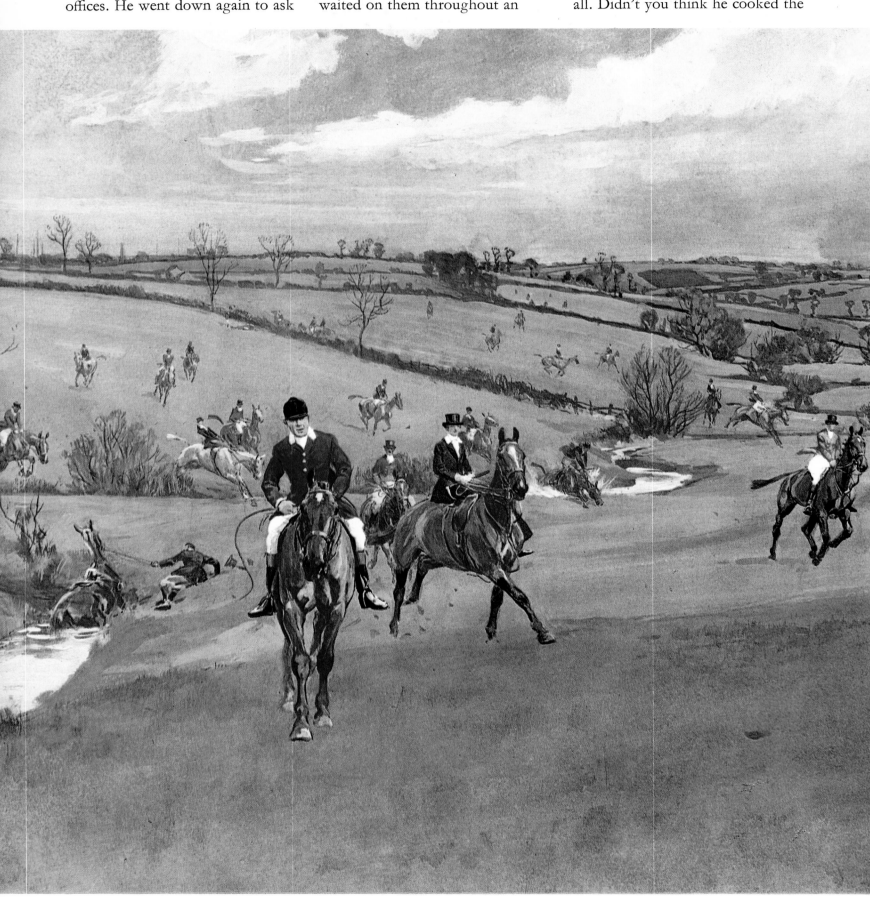

dinner well last night?' Lionel meanwhile noticed something familiar about the first whipper-in, looked again – it was the butler.

Lionel's modest bearing, tall and straight with a small clipped moustache, gave a first impression of a military man rather than an artist. He was gentle, tolerant, worldly-wise, and in every sense of the word a gentleman. His poise did not desert him in need, as on

meeting a certain peer of the realm, in London, with whom and with whose lady he had often stayed. 'You know my wife, don't you?' said the earl. Lionel, rather surprised, said, 'Yes, of course', and turned to greet a woman he had never seen before.

I think he had the most perfect manners of anyone I knew. As he was held in great respect and affection by my children, it was easy to suggest him as a pattern of behaviour at meal times. He never interrupted their chatter, but would await a pause and then impart some fascinating piece of information, often about history, of which he knew a great deal. I was always reminded of one of my father's sayings, 'A child's best education should be around the family dining-table.'

Lionel had never driven a car, so when he stayed with us it fell to my happy lot to take him out for his day's painting. We set out directly after breakfast, with the dogs and a picnic lunch that included a bottle of something to warm him whilst he stood out, often in bitter weather, his canvas clamped securely to his easel in case a strong wind bore it away. He never wore an overcoat and seemed quite impervious to winter weather; even in old age his only concession to the cold was a pair of woollen mittens.

At one time we had a little estate car and when the weather was particularly bad, we opened the rear doors and he set up his easel between them and settled himself with his paints on the floorboards. When I returned from exercising the dogs I was often amazed at how far the painting had advanced. He was an extraordinarily quick worker and I think his wonderful skies were due to the speed with which he 'caught' them. When my husband was out painting with him he often suddenly shouted, 'Quick Denis! Get that sky', and while poor Denis was frantically mixing his paints to obey, 'Oh, now you've missed it, you *must* be quicker.'

One example of his lovely skies is in a painting he did especially for me. I had not known him very long, and being terribly shy looked on him with some awe. I had been given a big grey horse called *Granite*, with a warning from Arthur Thatcher, the Atherstone huntsman, that he took a lot of handling, especially when he bucked, which he did frequently. Learning also that he had never carried a side-saddle, I suggested Denis should have him instead, and he carried him well in spite of the buckings. He was a good-looking horse and Lionel said he would like to paint him with Denis on him and give it to me. 'Come along K, and show me where you would like it done.'

I was so thrilled and astonished that I walked on air with him across the fields to choose my favourite view, asking also for plenty of sky. 'Now stay and talk to me while I paint,' and it was fascinating to watch this lovely portrait take shape.

The magnificent grey horse and the scarlet of Denis's coat stand out against a lowering stormy sky. A last flicker of sun before the gathering storm lights up the horse's side and enhances the vermilion brilliance of the coat. The figures of horse and man give an impression of eager expectancy, one imagines hounds have just spoken and there is the exciting prospect of a run. I have always thought this one of his best portraits, a perfect likeness of both horse and rider, and of course with a special meaning for me.

Years afterwards he painted Denis again, this time on his beloved little brown horse, *Rocket*, as a present for our new home when Denis retired from being secretary of the Quorn. Once again he asked me to choose the background for this lovely portrait.

Lionel was an accomplished horseman and whatever horse he rode went well for him. In all the years Denis knew him he remembers only one occasion when he had a fall. It was years ago, when, staying with us, he was

hunting with the South Atherstone. Hounds had just gone away and the large Field, pushing and shoving to get with them, came to a very big fence with a gate further up the field. Lionel decided to jump the fence rather than await his turn at the gate. As he approached it, his horse at the last minute suddenly decided that *he* preferred the gate, and they quickly parted company. Lionel

did a most amusing sketch of this episode for his *Leicestershire Sketch Book*. On another page are the Aldridge brothers, Denis on *Granite*.

With his great knowledge of hunting, Lionel was meticulous over every detail of horse and rider and got people's seats to perfection, so that, seeing one of his paintings across a room, one knew instantly who the figures

were meant to be. He enjoyed depicting well-turned-out men and women, though he did not give such minute attention to his own appearance, rather following Jorrocks's adage, 'I goes out to please myself, and not to astonish others.'

Lionel's most severe critic was his beloved wife, Ethel. He never failed to ask for her opinion on anything he was painting. He

Above: 'The Cheshire Hunt near Beeston Castle'. TRYON GALLERY, LONDON

would draw a chair up for her, and she would sit for a long time looking at the canvas on the easel before speaking. Then very often she would say, 'That's not quite right Nello, you must alter it.' So highly did he value her opinion that he always did exactly as she said.

In February 1958 Lionel stayed with us for the Melton Hunt Club Cross-country Race, an event which

had been revived after about a hundred years and aroused enormous interest among all hunting people. This was the first occasion of the revival. No one who was there could ever forget that day. We woke to heavy grey skies and about eight o'clock sleet began to fall which soon turned to snow. It was bitterly cold. Denis went off early to collect *Rocket* and rode on to Upper Broughton in a

blinding snowstorm.

Lionel and I followed later and arrived to find a surprising number of competitors, horseboxes, trailers and cars seemingly from all over England, and some roads already blocked. We got out of the car to find visibility down to about a field, and the balloons tethered as

guide marks indiscernible in the gloom. The snowstorm then turned into a horizontal blizzard and we could really see nothing. Lionel, having gone with the object of painting the race, was not going to be deterred by the elements, and announced that he would get out to have a look, and would be just down the road. He vanished into the blizzard and I waited. After a while I began to get rather uneasy. I had caught sight of the race through the blizzard so knew it must be over, and still there was no sign of Lionel. I had visions of him having fallen into a snowdrift or lying covered by snow in a ditch. I began to drive about asking everyone if they had seen him, but no one had. I even tried to penetrate a solid mass of loudly celebrating people in the pub; my anxious voice was lost in the hubbub.

Eventually I made my miserable way home convinced of a disaster. There was Lionel, sitting by the fire, cosily chatting to a friend who had given him a lift, not being able to find me. He had been soaked to the skin, and his precious sketch book reduced to pulp, but in spite of everything he had made a sketch which developed later into a superb picture of the race.

I suppose Lionel Edwards was almost the first artist to portray hunting scenes exactly as one sees them . . . often a dull grey day, with stormy skies, muted colours, pink coats spattered with mud or darkened by rain . . . horses floundering in wet land and hounds so dirty after a hunt in heavy going they scarcely show their markings. How often when out with them one has exclaimed, 'There is a Lionel Edwards picture to the life'! He brilliantly captured the excitement of a hunt, the cold stillness of a snow scene, the thrill of a polo match or the calm beauty of a summer evening. Painting skies gave him great pleasure and he was a master at them. Some years ago, coming away from one of his exhibitions in London, we met an old gentleman coming in. Knowing all the

catalogues were gone, we offered him ours. 'How kind of you, but I have only come to look at Lionel Edwards' skies.'

In his younger days he painted with meticulous care for detail, especially in his watercolours. Latterly his sight was not so keen and he began to paint in a slightly different style, on a larger scale with greater breadth of treatment and less detail. This was especially effective with landscapes, and personally I thought that in his last years he was painting better than ever.

He knew more about the hunting countries of the British Isles than any other living man, having hunted with them and painted them almost all his life. During the First World War his knowledge of the horse was of great value at the remount depot. He frequently turned with great success to painting racing, both steeplechasing and flat. I remember going into his studio at Buckholt and seeing on the easel a large oil painting he was working on of the start of a race at Ascot. The 'Golden Gates' made an impressive background and the whole picture was so bold and vivid it took one's breath away. I believe this painting was never reproduced.

As well as being a great painter, Lionel Edwards was a writer of distinction. He wrote and illustrated a number of books, and apart from his amusing autobiography, *Reminiscences of a Sporting Artist*, they were mainly about hunting and show his considerable knowledge of the history of sport. He also sometimes collaborated with his great friend and fellow artist, Frank Wallace, in both writing and painting, and an example of this is the fascinating book, *Hunting and Stalking the Deer*.

He illustrated *British Racecourses* by B. W. R. Curling, and several books by R. C. Lyle, notably the story of the legendary *Brown Jack*, a volume on the Aga Khan's horses, and one of my favourites, *Royal Newmarket*, that historic

scene, with interesting information about the famous Heath . . . and Lionel Edwards' vivid illustrations bring it all to life, I especially like *Lord Orford and his Stags*, depicting the famous occasion in the mid-eighteenth century when the eccentric Earl was driving his team of four stags from his Norfolk seat, Houghton Hall, to Newmarket at the same time as the Essex Hounds were out. The hounds got wind of

Right: 'The Burton'.
FORES LIMITED, LONDON

the deer and hunted them in full cry. The terrified animals bolted into an inn yard and the big gates slammed shut just in time.

Another lasting memorial to Lionel is in Stockbridge Church . . . a stained-glass window in which his portrait of the famous racehorse *The Tetrarch* appears. This phenomenal horse, known as the 'spotted wonder' because of his curious markings, was probably the fastest horse ever seen on the English Turf. He was trained at Stockbridge by Atty Persse.

Until his last illness Lionel was one of the fittest men we have ever known. Even at the age of eighty he would still walk for miles over the fields, flinging his long legs over the gates like someone a quarter his age.

I imagine there is not a hunting country in the English-speaking world which does not boast paintings by Lionel Edwards . . . we even once found some very early ones in a small hotel in France. His friend Captain Jack Gilbey wrote of him, 'Here was genius'. I believe that he did not exaggerate and that the work of Lionel Edwards RI, that great artist and lovable personality, will become ever more appreciated and sought after as the years go by.

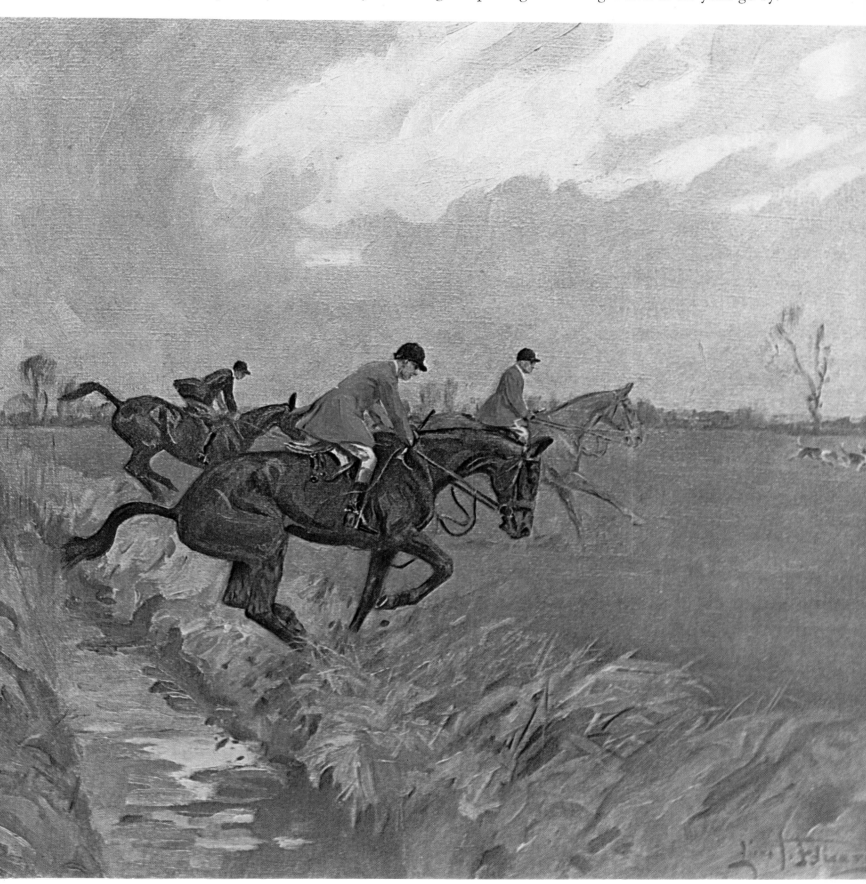

John Skeaping

DURING THE YEARS immediately following the First World War there was an emergence of some remarkable artistic talent. Probably the most unusual of these artists was John Skeaping, who is so well known for his animal sculpture and drawings of horses.

Skeaping's whole life has been tempered by an independence of mind and a refusal to conform. The unusual has always attracted him, and it is very much in keeping with his character that this former Professor at the Royal College of Art and Royal Academician should be found in his seventies rounding up bulls and breaking horses in the Camargue delta of the Rhône, where he has made his home for nearly twenty years.

John Skeaping, a child of precocious talent, was born at South Woodford, Essex, in 1901. His father was Kenneth Skeaping, a portrait painter who had worked in Paris towards the end of the last century. His mother, a professional music teacher, taught him to play the piano, and along with his two sisters he was encouraged to take up ballet dancing. One of these sisters is now a world-famous ballet mistress.

Educated at home, the young Skeaping was able to make an early start in his art training, and first began to practise sculpture at the age of thirteen, whilst at the Blackheath School of Art. His technical grounding was strengthened by his studies at Goldsmith's College, at the Central School of Arts and Crafts from 1917 to 1919, and at the Royal Academy Schools from 1919 to 1920. He took the RA Gold Medal and Travelling Scholarship in 1922, which enabled him to go to Italy.

After his first visit to Italy, he taught for a short time at the Armstrong College, Newcastle upon Tyne, but in 1924 he won the coveted Prix de Rome for Sculpture, and returned to the Italian capital to work at the British School. There he met another talented student, Barbara Hepworth, whom he married in Italy in 1925.

Both shared an enthusiasm for carving in marble, stone and wood, and were members of a group of young artists, which also included the sculptor Henry Moore. They wished to convey the essential solidity of form, and demonstrate the special qualities of surface and texture that belonged to a particular material. These young sculptors were reacting against the practice of previous generations, who had entrusted the execution of large-scale work to commercial stone-cutting concerns, and whose finished work the group considered lifeless. They went so far as to object to the age-old method of modelling in a soft material, such as clay, before casting in bronze. The principle behind their thinking was that a craftsman should express 'truth to his material' by his own direct handling.

Between the wars, Skeaping took an independent line and drew away from the group, which under foreign influence found in direct carving a desire to cultivate abstract forms. He was also showing that he considered the domination of the art world by critics and pseudo-intellectuals to be unhealthy, and that the freedom for which the contemporary groups had struggled in their early days had been abandoned to follow the dictates of intellectuals and theorists. The point that he was making, and to which he has always remained true, is that an artist should do what he honestly feels and wants to

express, and not what he thinks will please the greater public.

Skeaping and his wife exhibited at Tooths Gallery in 1930 – yet their ideas of art were diverging,

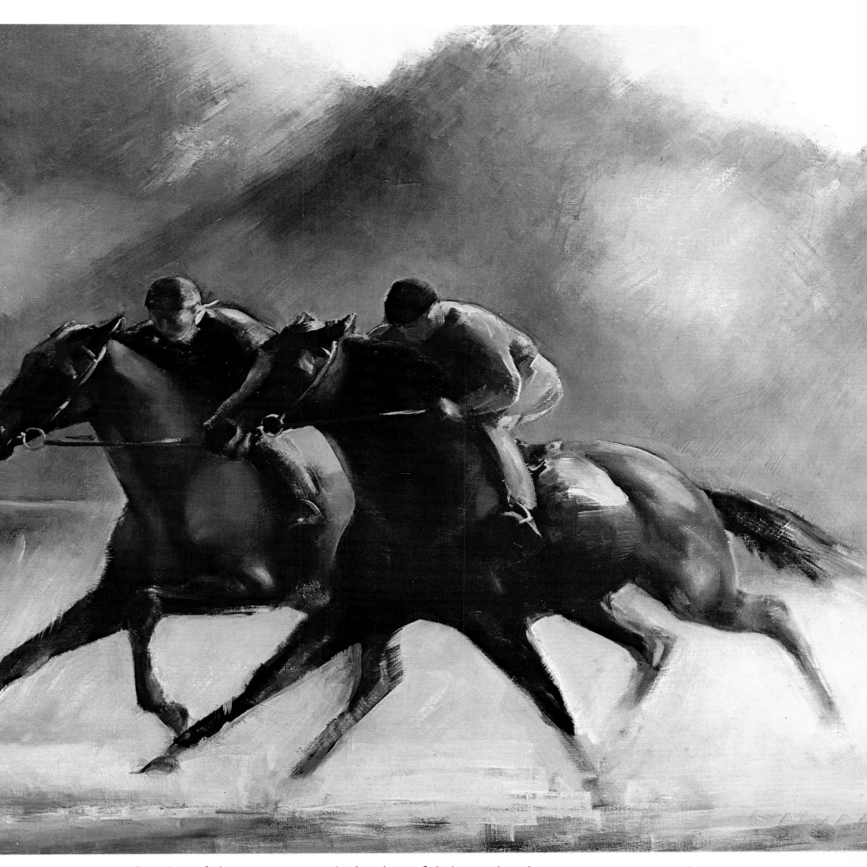

hers in the direction of abstract
form, and his in the essentially
representative world of animals
and sport. This separation of·
interests may well have contributed

to the breakup of their marriage in
1932. Although still associated with
the tendencies of modern sculpture,
Skeaping was gradually to drift
away from the avant-garde artistic

Above: At full stretch.
MAISONS-LAFFITTE, FRANCE

Overleaf: Trotters in action.
ARTHUR ACKERMANN AND SON LTD,
LONDON

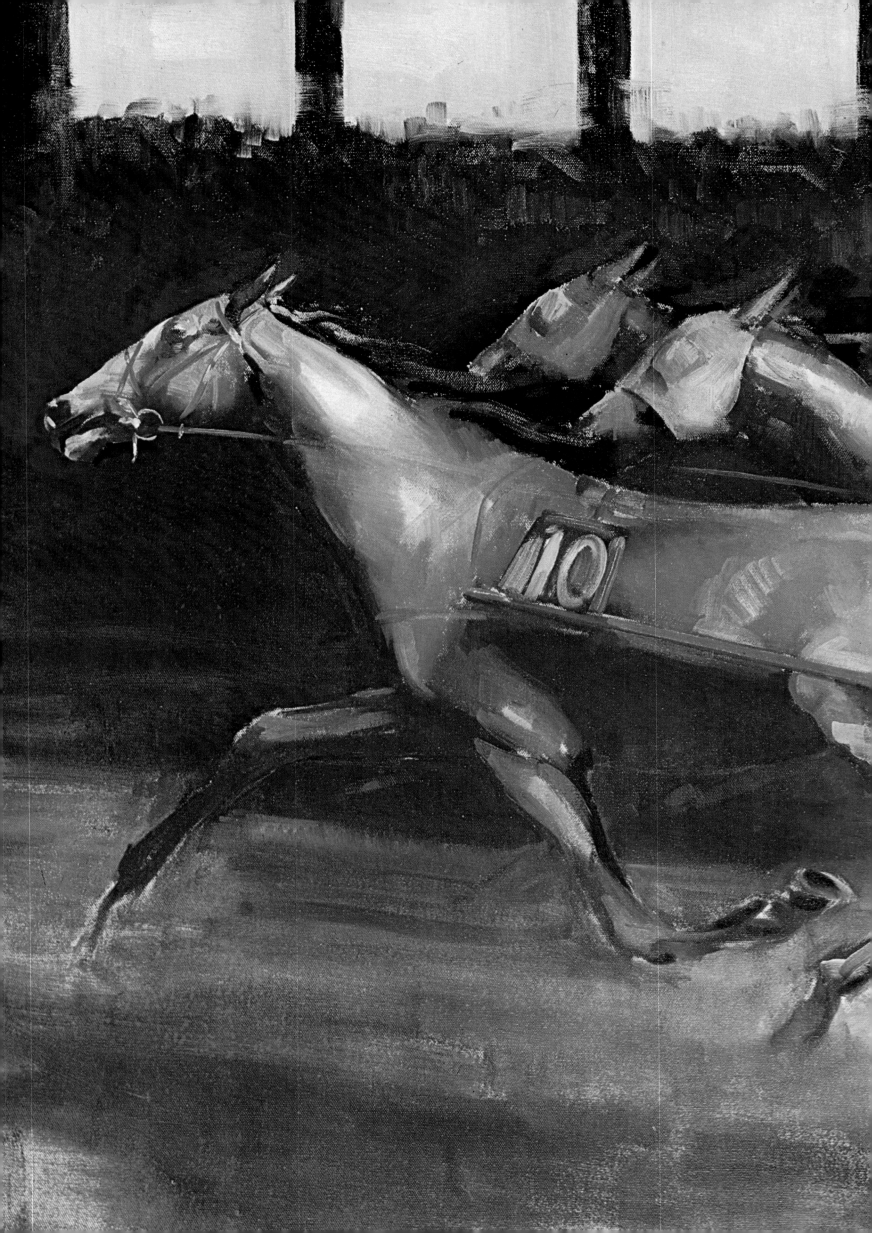

groups of which he had been a member.

His aim as an artist in the 1930s was to develop the vitality and movement of human and animal form, outside the contemporary confines of artistic theory and fashion. In the horse, especially the Thoroughbred with all its characteristics of grace and power, he found his ideal subject. He rode regularly as an amateur steeplechase jockey, and had drawn horses since he was a child. His animal paintings and drawings, as well as his sculpture, rapidly became well known. About 1934, he carved a life-size horse in mahogany and pynkado (a species of ironwood found in Burma) which was erected at Whipsnade in 1937, and is now in the Tate Gallery.

There must be few sculptors in modern times capable of undertaking works on the scale that Skeaping has achieved. The granite carving of an over-life-size human figure, 'Memorial', which was exhibited at the Royal Academy in the 1950s, testifies to his technical skill in this most daunting of materials.

His life-size horses in bronze will remain as fitting tributes to his remarkable gift of capturing likeness and vitality on such a scale. The visitor to Newmarket sees his statues of *Hyperion* and *Chamossaire* overlooking the Snailwell Road. On the other side of the Atlantic, a bronze of the great American champion *Secretariat* is to be seen at full stretch at Belmont Park racetrack. *Brigadier Gerard*, *Mill Reef*, *Fort Marcy* and *Key to the Mint* have been other subjects in recent years.

As a draughtsman, he has an exceptional ability to give an impression of speed and movement with the barest economy of line. His sculptor's eye, with its intimate knowledge of the underlying anatomy, has allowed this technique to develop.

Skeaping has indicated in his popular book *How to Draw Horses* that first one should see the form as a series of simplified solids and then build upon this basic framework.

It is worth quoting his own words on the subject:

A great power of observation is necessary, and a sense of form. The artist must know exactly what the shape of things is, and he must have the technique to be able to reproduce it when necessary. The more an artist knows about animals from every angle the better, particularly the experience of handling them, understanding their ways and behaviour. Above all, he must be devoted to them – not sentimentally bestowing upon them human intelligence and attributes, but loving them for what they are: stupid, cunning, strong, fierce, affectionate, or whatever they happen to be.

However, Skeaping has not been solely an 'animalier', for carving as a feature of architecture has taken up a great deal of his artistic output. His work has been in great demand by architects of churches, colleges and public buildings. In London, examples are to be found at the Dutch Reformed Church and the Imperial College of Science, whose main entrance is adorned by a panel carved by him. The four large angels at the top of the tower of Guildford Cathedral are his also. The United Nations Building in New York has some of his carved decorative work in a series of wood panels in low relief.

But it is for his vivacious drawings and paintings of animal subjects that he is best known, and the way that he manages to communicate the excitement and thrill of the Turf has assured him of an enthusiastic following wherever the racehorse is put to the ultimate test. His drawings of Arab horsemen and the *rejoneadors* of Spain are the natural development of the Romantic movement of the last century, when Delacroix and Géricault found the horse the ideal medium through which they could express themselves.

Skeaping's wartime service was spent in the Special Air Service and the Intelligence Corps, for which

his independent character was well suited. In 1948 he began teaching sculpture at the Royal College of Art, and while on extended leave in 1950 he went on an expedition to Mexico, where he lived amongst the Indian potters of Oaxaca, and was inspired by their culture to write his book *The Big Tree of Mexico*.

His proficiency as a linguist, his remarkably wide experience of different lands and peoples, and his sympathetic, warm and uninhibited personality have made him a most entertaining conversationalist and an excellent teacher. Although he was made a Royal Academician in 1960, he kept his ideals and refused to conform to any group doctrine. Even in his teaching of young sculptors he favoured the naturalism and the study of the figure of his early days – an approach that did not conform with the new ideas of the 1950s.

In leaving Britain in 1959 and taking up residence in his windmill on the Camargue delta, where he appears to hold an open house for his multitude of friends, he has once again shown his urge for new horizons and a full life. This spare and energetic little man, whose appearance belies his approach to eighty years, is part of the wild landscape as he rides out to visit his roaming herd of Camargue horses, or sets off on a fishing expedition. The simple open-air life suits his independent spirit, and maybe his zest for life has found its truest expression in his drawings and sculpture of horses. In communicating the vitality and beauty of this fascinating animal, John Skeaping has enriched our lives, and we owe him a debt of gratitude. In 1977 he published his autobiography *Drawn from Life* – a book written with humour and a deep appreciation of human nature.

Above right: Heavy going – Arlington Park.
ARTHUR ACKERMANN AND SON LTD, LONDON

Right: Fighting it out.
ARTHUR ACKERMANN AND SON LTD, LONDON

Right: Early morning
gallop.
MAISONS-LAFFITTE, FRANCE

Overleaf: 'A Lady
Hawking' by
E. J. H. Vernet
(1789-1863), the member
of the well-known French
family of painters who
was known as 'Horace'.
BY KIND PERMISSION OF THE
WALLACE COLLECTION,
LONDON